P9-DDZ-061

# OIL PAINTING
## *for the* SERIOUS BEGINNER

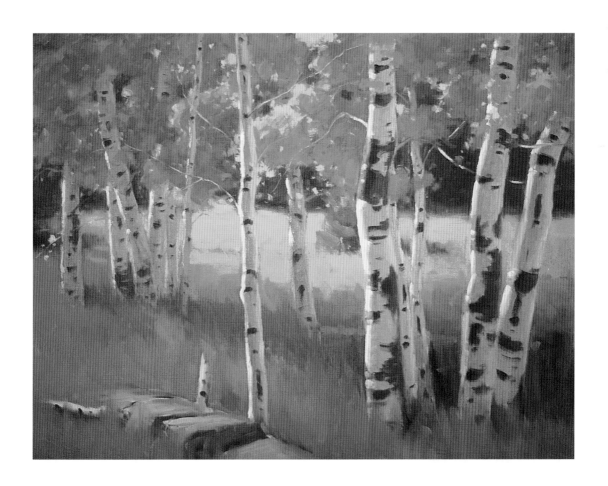

# OIL PAINTING
## *for the* SERIOUS BEGINNER

### Steve Allrich

WATSON-GUPTILL PUBLICATIONS/NEW YORK

**TO KARRI, FOR MAKING EVERYTHING EASY, AND FOR BELIEVING IN ME.
AND TO COLIN AND ALEX, FOR KEEPING ME ON MY TOES . . .**

Thanks to Candace Raney for providing me with the
opportunity to do this book; to Marian Appellof for putting
it all together; to Areta Buk for the clarity of her design;
and to Robbie Capp for her sensitive and judicious editing.

*Frontispiece:*
**ASPENS**
Oil on canvas, 22 × 28" (55.8 × 71.1 cm).
Collection of the artist.

*Title page:*
**LATE AFTERNOON, TUSCANY**
Oil on canvas, 18 × 30" (45.7 × 76.2 cm).
Collection of Robert and Joyce Bramwell.

Edited by Robbie Capp
Designed by Areta Buk
Graphic production by Ellen Greene
Text set in Adobe Garamond

All photographs by Karri Somerville

Copyright © 1996 Steve Allrich

First published in 1996 in the United States by
Watson-Guptill Publications,
a division of VNU Business Media, Inc.,
770 Broadway, New York, NY 10003
www.watsonguptill.com

**Library of Congress Cataloging-in-Publication Data**

Allrich, Steve.
    Oil painting for the serious beginner / Steve Allrich.
        p.    cm.
    Includes index.
    ISBN 0-8230-3269-8 (pbk.)
    1. Painting—Technique.  I. Title.
    ND1473.A45    1996
    751.45—dc20                                  96-15303
                                                 CIP

All rights reserved. No part of this publication may be
reproduced or used in any form or by any means—
graphic, electronic, or mechanical, including photocopying,
recording, taping, or information storage and retrieval
systems—without written permission of the publisher.

Manufactured in Hong Kong

First printing, 1996

5  6  7  8 / 03  02

**About the Author**
A graduate of the American Academy
of Art in Chicago, where he studied
with Eugene Hall, Steve Allrich has been
exhibiting his art and teaching drawing
and oil painting since 1983. He is
currently represented by the Blue Heron
Gallery in Wellfleet, Massachusetts. As
firm believers in working directly from life,
he and his artist wife, Karri, enjoy taking
frequent painting trips together. Many
of his lush portrayals of European and
western United States settings are shown
in these pages, as are his New England
landscape paintings done near Brewster,
Massachusetts, where Steve and Karri live
with their two sons, Colin and Alex.

# Contents

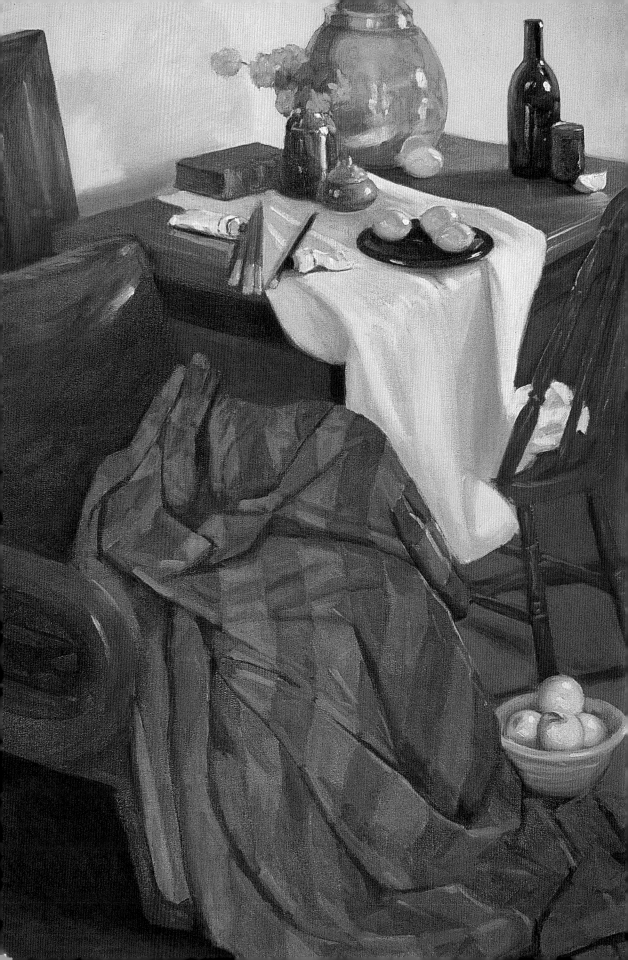

# Introduction

The fact that you're reading these lines means that you're serious about becoming a good painter. As artists, we all start at the same place—the beginning. Now, after years of development as an artist and instructor, I've tried to put into words the most important things I've learned about painting. In this book, I hope to simplify the process for you—by presenting the fundamental principles behind good painting and detailing the technical means you have at your disposal to help you create expressive and dynamic oil paintings.

## WHAT MAKES A GREAT PAINTING?

In response to the above question, one of my teachers, Eugene Hall, answered, "Look at a million paintings, and paint a thousand paintings, and then you'll know." I groaned, thinking he was being evasive. I wanted a much more instructive answer. Now I understand the wisdom of his reply. There *is* no concrete way to define what precisely constitutes a great painting or how an artist creates one. With fine artwork, the whole is greater than the sum of its parts. In the presence of a great painting, we can certainly identify those qualities that we admire in it, but that doesn't really get to the heart of the question: Why does it affect us the way it does? The intangibles of fine art can only be grasped by continuous exposure to wonderful paintings. Study and compare them. And as an artist yourself, you'll find that the more *you* paint, the more insight you'll gain into what constitutes good artwork.

**INTERIOR WITH STRIPED CLOTH**
Oil on canvas, 40 × 30" (101.6 × 76.2 cm).
Courtesy of the Blue Heron Gallery.

Still lifes and interiors present unlimited subject matter. I'm inspired by haphazard arrangements that I come across in my house or studio, often using them as the basis for a painting. Here, I was particularly interested in the way the stripes heighten the folds and flow of the cloth as it drapes across the chair.

Because only a relative few of us actually pursue this path seriously, art is somewhat of a mystery to most people. But despite the intangibles, there *are* certain criteria by which you can judge paintings—yours and others'—differences in style and taste notwithstanding.

First: Is the painting technically sound, does it have a well-planned design, is the drawing strong, are the values and color good? Second, and more important: Is the painting evocative, does it provoke a strong response, grab you in some inexplicable, even spiritual, way and hold your interest? Do you feel compelled to go back and look at it again? If the answers to these questions are *yes,* then chances are you are beholding a *good* painting.

The relationship between these two aspects of painting—the technical and the spiritual—is a fragile one. Many artists believe that developing a sound technique is more of a hindrance than a benefit, that it interferes with the artist's ability to be expressive. Others become so absorbed in technique that technique *becomes* the message. My feeling is that there is lots of middle ground. Technique, while important, is not the most essential or most engaging aspect of painting. It's a tool, a language. You should strive to become proficient enough in the vocabulary

of painting that you don't have to think about it, so that you can concentrate on what you have to say.

This is one of the paradoxes of painting: You achieve a painting, which may provoke a very emotional response, through technical means—say, by starting with lines that indicate shapes or by placing a lighter color against a darker one to convey light. These technical means—the ability to draw, to handle a brush with understanding, to discern color and value, to design a picture—constitute the language you have to learn in order to paint well. Try to become so comfortable with your materials and with the lexicon of painting that you eliminate any interference between your head and your hand.

When asked who his favorite actor was, Humphrey Bogart replied, "Spencer Tracy, because you can't see the wheels turning." Paint so well that no one can see the struggle that may have gone into your work. Make your painting look effortless, like it blew onto the canvas—even if you really *did* struggle with it.

**THINKING LIKE A PAINTER**

One of the great difficulties in learning to paint lies in trying to change the way we think and see, because we have to do both to become artists. Although I had

**LATE CLEARING**
Oil on canvas, 16 × 22" (40.6 × 55.8 cm).
Collection of Barbara and Paul Lavrakas.

Late afternoon is just about the best time of day to paint outdoors. Warm light and long shadows are conducive to strong, emotional paintings.

looked at and thought deeply about trees for many years, I couldn't paint them very well when I first tried. Part of the reason is that it's quite impossible to replicate a tree, and a little bit crazy to try. What we learn as artists is that we have to paint our *idea* of the tree. We must view the tree as an abstract shape of a particular color or colors, and determine how it relates to other abstract shapes in the design of our painting. What we really do when we paint is take the three-dimensional world and arrange it into areas of color on a two-dimensional surface. This is the first challenge to the serious beginner: Before you worry about making the tree look real, you must translate it in your thinking to shape, color, and value. To do that, you must filter what you see to find the basic elements that will convey your idea of the tree on your canvas.

Much of what we need to see in order to paint is not what we are aware of in normal seeing. For example, although we are very familiar with faces and have probably looked at them every day of our lives, how many of us could draw a convincing nose? When asked to do so, beginning art students invariably draw a stereotypical, almost cartoonlike rendition with two vertical lines above two dark dots for nostrils. Such drawings have nothing to do with the structure or form of the nose or the way it catches light and shadow, those very aspects that are necessary to portray a convincing nose.

As an artist, the more you paint, the more you'll learn what you need to look for. Once you are convinced that form, for example, is important, you begin to look for the kind of information you need to portray it. All of the information is there. You just need to learn to see it. Think of each bit of information as a piece of a puzzle, which, when assembled on your canvas, will convey form, texture, light, and all of the other components of the visual world.

## BECOMING A GOOD PAINTER

There is a saying among artists that you can judge a painter by the miles of canvas he or she has covered—a statement that affirms the advice I've given above—that the very act of painting is the best way to learn. There are really no shortcuts. But it's not enough to merely use up canvas. Becoming an artist involves a commitment to study, to make choices, and to develop as a person. Read about artists and their lives. Go to museums and study paintings. Think about what it is precisely that you admire in a particular artist's work, and try to analyze how those paintings were achieved. For example, if you

are drawn to the colors in a particular landscape, try to determine how those individual hues were mixed, how they relate to one another, and why they affect you the way they do. If you admire a painter's brushwork, get right up to the canvas and see if you can figure out how the artist applied that paint. Then go home and set up *your* easel.

Recognizing and understanding what you admire in a painting—the first step in acquiring your own taste in art—will enable you, with hard work, to adapt those qualities to *your* canvases. That is how you'll develop your own "style"—by learning from many artists whom you admire, incorporating this, discarding that, according to your developing preferences and temperament. Learning to paint is more about increasing your power of observation and your understanding and knowledge than it is about learning tricks or techniques.

Fine painting presents another challenge: to work with a certain degree of abandon—what I would call, paradoxically, "controlled abandon." I mean, while maintaining an analytical approach to your work when you paint, try to immerse yourself in your subject, and react to it in a spontaneous way. Try not to think about what you're doing while you're doing it. Have faith that what you know will come out in the painting. *Trusting your intuition and allowing yourself to react emotionally to your subject will ultimately cause your best work to surface.* At the same time, however, you must constantly make decisions and analyze what you're doing. You start with a line to indicate a form in your subject. Then you add another line. Now you have a decision to make: Do these two pieces of information relate to each other correctly? If they do, then you add another piece of the puzzle. If they don't, you make an adjustment. On one level, a good painting is a series of good choices. Understanding what constitutes a good choice can be confusing, but it becomes increasingly clear with experience.

So when I paint, I try to maintain a balance between my spontaneous reaction to the subject and my need to make analytical decisions as I work. One of my teachers used to sum it up this way: When you apply paint to your canvas, lose yourself in the subject and the process. When you back up periodically to look at your work, become analytical and impersonal about it, and decide if you're headed in the right direction.

## DEVELOPING AS AN ARTIST

When I first began to paint, I had no idea how important art would become to me or how it would

change my life and be a key part of it. Our paintings are a reflection of who we are. For better or for worse, our taste, priorities, level of commitment, ability, and much more show up on our canvases.

The artists we admire most also influence our paintings, and in my case, actually complicated my development as a painter because so many different kinds of painting appeal to me. I love the meticulous and precise seventeenth-century Dutch genre painters—Jan Vermeer, Jan Steen, and others—as much as I like the exuberant Thom Thompson and his fellow Canadian painters who worked early in this century. But my greatest praise is reserved for very direct, spontaneous painting that is, at the same time, articulate. If I could own any painting, it would be one by Joaquin Sorolla, the brilliant turn-of-the-century Spanish painter, best known for his light-filled canvases of figures on a beach, oxen pulling ashore boats with billowing sails, and other vibrant scenes. But I would also "settle" for a work by any of these nineteenth-century painters: a favorite American artist, John Singer Sargent; Anders Zorn, a great Swedish painter; or the fine Australian artist Arthur Streeton. The paintings of each of these great artists and any number of others embody a fluid, direct, intuitive response to their subject, made possible by flawless technique and impeccable taste.

Among the many contemporary artists I most respect are Richard Schmid, whose depictions are wonderfully eloquent; Clyde Aspevig, whose textured, fluid canvases always have a strong sense of the abstract; and Trevor Chamberlain, whose atmospheric, painterly work I have only recently discovered. One of the chief virtues of looking at high-quality artwork is that it shows you what is possible. Art is not produced in a vacuum. Don't be afraid of losing your individuality by letting yourself be influenced by work that you admire. Each of the painters I've named had heroes (and their heroes had heroes), yet their work is totally distinctive and individual. Whenever I see compelling art, it fuels my resolve to work harder and improve my own painting.

## DIRECT PAINTING VERSUS GLAZING

There are two overall approaches to painting: direct or glazing. The contemporary artists I've cited above are all direct painters, the method I've chosen for my work—as the result of both my love of such work, which tends to be loose, spontaneous, and expressive—and my temperament. By *direct painting* I mean, first, that I intend to finish the painting in a single sitting *(alla prima),* and second, that after the block-in, the brushwork I apply is by and large meant to be the final brushwork. There may be some layering of paint or reworking of particular areas, but if I can say what I have to say in ten brushstrokes instead of twenty, the results—for me—are invariably better. This manner of working requires intense concentration and a very clear understanding of what you hope to accomplish; without a strong *concept,* it's easy to get lost, and make a mess of things. For me, though, direct painting is very satisfying.

The antithesis to this way of working is *glazing:* the application of transparent layers of pigment over a carefully executed, often black-and-white, underpainting. This method will be discussed further in Chapter 3.

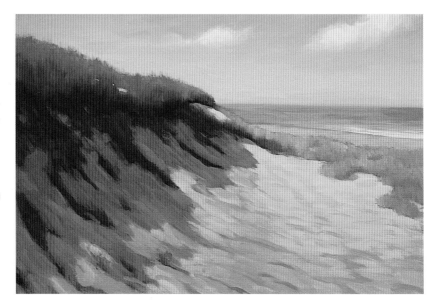

**OVER THE BLUFF**
Oil on canvas, 24 × 36"
(60.9 × 91.4 cm).
Private collection.

Areas of similar value and color are very clearly massed together in this painting. If you squint your eyes to lose the detail, the pattern becomes clearer. None of the darker values within the sunlit area of sand compete with the darks in the shadow area. There is a clear separation between the values in the shadow and those in the light.

I would guess that all exceptional artists, regardless of method or approach, have in common a commitment to and sheer love of their craft, and a willingness to work unceasingly. Sargent's capacity for hard work was legendary. For me, loving painting is the key, because then it doesn't seem like work. What I enjoy most is standing in front of a subject and translating it into paint on canvas. The great nineteenth-century American painter and teacher Robert Henri said that the purpose of painting was not to produce a picture, but to achieve that particular state of mind that one can attain *while* painting. I'm convinced that if you allow yourself to feel that way, good work will follow.

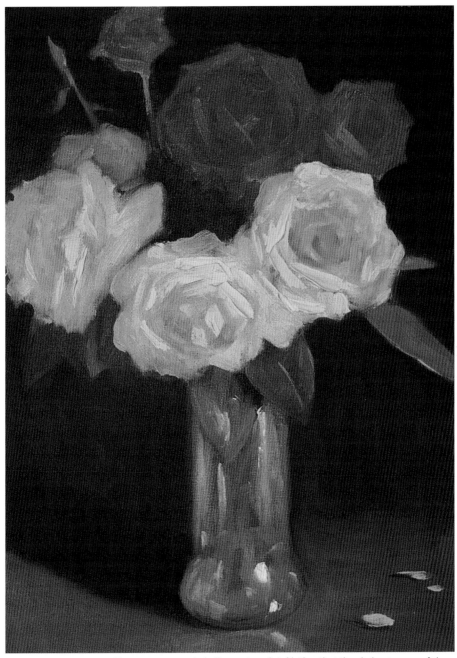

**SEPTEMBER ROSES**
Oil on canvas, 16 × 12"
(40.6 × 30.5 cm).
Private collection.

Flowers are a real challenge to paint. Notice that the darkest areas of the yellow roses are light and warm. If these shadows are too dark, they will destroy the flowers' feeling of delicacy. I extended a leaf off the right edge of the canvas to offset both the strong shadow cast by the vase, and the small pink rose and bud in the upper left part of the arrangement.

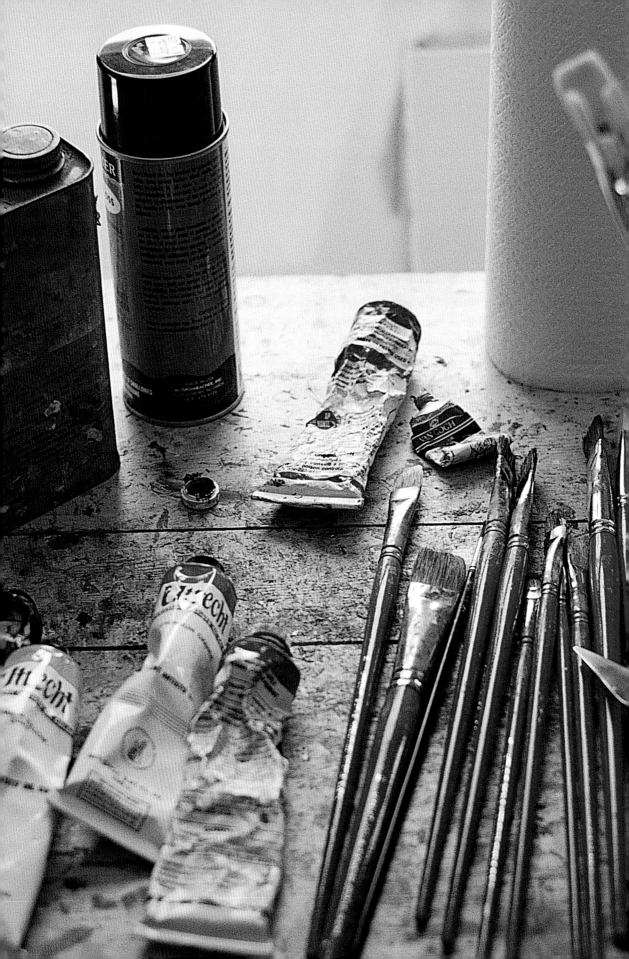

# Materials

Like so many aspects of painting, the materials an artist uses represent preferences developed through experience. The best way to figure out what's right for you is by trying something yourself. Teachers will show and tell about their choices and the reasons behind them. As a student, you might follow some of their suggestions, incorporate the ones that work best for you, and discard the ones that don't. Over time, you'll become sensitive to subtle differences in canvas, paint, and brushes and decide which among the myriad available suit your individual needs. Initially, you may have to take others' recommendations on faith, but as you progress, you'll develop definite likes and dislikes. Taste varies widely; ten artists are likely to use ten different palettes of color, yet all may do wonderful work. Just remember that all fine artists were once beginners and did what you will do: experiment, and, through trial and error, adapt materials and methods to your personal style.

I am not an expert on materials by any means, but there are several books that offer comprehensive guidelines. The most thorough is probably the classic by Ralph Mayer, *The Artist's Handbook of Materials and Techniques* (Viking Press, New York). I've never had a question about materials whose answer I couldn't find there—including the advantages and disadvantages of their usage. Another good and very thorough reference is *The Oil Painting Book* by Bill Creevy (Watson-Guptill Publications, New York).

My worktable, in its normal state. My brushes and paint are within easy reach—I don't have to search for them when I'm painting. I try to be orderly, but in the heat of painting, I'm generally pretty messy. Also on the table are a palette knife, a roll of paper towels, a spray can of retouch varnish, and a can of turpentine.

# Paint

You'll need only eight tubes of oil paints to get started. From these, you can mix any color you need. I primarily use Utrecht paints (a brand that has its own outlets in several major cities), but there are other fine labels from which to choose that are widely available, such as Winsor & Newton and Grumbacher. Avoid "student-grade" paints. They don't have as much pigment in them, so it's very difficult to mix the color you want. But Utrecht is good-quality paint at a very good price. The colors are strong—their cadmium yellow light has as much tinting power as any yellow I've used—and available in large "pound-size" tubes. They don't make a wide variety of colors, but that's not a problem for me, since I use a somewhat limited palette, a modification of the one I used in art school. Over the course of several years, I have eliminated three colors from that range (more about this in Chapter 2), and now use the following colors:

- **Titanium white.** A good, all-purpose permanent white, it's very opaque, so it covers and mixes well.
- **Cadmium yellow light.** A medium-value yellow, Utrecht's version of this color is slightly darker in value than many other brands of cadmium yellow light. It's very warm, mixes well, and has plenty of tinting power. I can mix a cool, lemon yellow from it very easily by adding white, so I don't put a cool yellow on my basic palette. I can also cool and gray it down to reach yellow-ochrelike colors (I don't think yellow ochre mixes very well, so I took it off my palette years ago). It's also the source of all my greens when mixed with the blues and black on my palette.
- **Cadmium orange.** I've recently started using this wonderful color again after having taken it off my palette several years ago. It's good for toning down greens—a touch of it helps create many warm greens, but won't gray them to the degree that cadmium red light does—and for mixing a variety of warm grays.
- **Cadmium red light.** A strong, versatile color that blends well, the Utrecht version is warmer than some other brands, yet still mixes a range of cool, gray-violet tones. It's just the right temperature and value for me. I also use a touch of cadmium red light to gray down greens a bit.
- **Alizarin crimson.** This very dark, cool red has a lot of blue in it. I don't use it very much, only when I need a real purple or violet that's beyond the reach of cadmium red light. Historically, it has not been considered to be entirely permanent, but modern versions are generally thought to be acceptable under normal conditions. If this is a concern to you—if you tend to use this color extensively— you might want to use rose madder instead.
- **Cerulean blue.** This warm, opaque blue has *lots* of tinting power, so it should be used with discretion. It's a great color for clear blue skies, especially near the horizon. It also makes intense, warm greens and blue grays. If I need a warm green, I generally start with cerulean blue.
- **Ultramarine blue deep.** A cool, transparent blue that's great for skies in different mixtures, it also provides the base for a wide range of grays, and makes cool, relatively gray greens. It's not an overpowering color, so you can use it in a number of ways.
- **Ivory black.** A great color that nonetheless must be used with understanding. It makes an almost limitless array of wonderful grays and greens, as well as deep, transparent darks when mixed with cadmium colors.

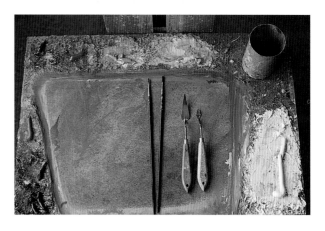

Here is my palette, with the colors set out around the perimeter. Counterclockwise from lower right: titanium white, cadmium yellow light, cadmium orange, cadmium red light, alizarin crimson, cerulean blue, ultramarine blue deep, and ivory black. I moved my titanium white down to make room for my turpentine cup, which I kept knocking over. It doesn't matter how you lay out your colors, as long as you do it the same way all the time. Before I begin working, I scrape off any paint from the previous day that is contaminated with other color, and put out a generous amount of fresh paint. I also try to keep the mixing area as clean as possible. In the center are my two palette knives and two small sable round brushes.

# Mediums and Solvents

A medium is a liquid with which paint is mixed to achieve certain effects. Depending on which ones are used, oil mediums can thin or thicken paint, give it transparency or gloss, or accelerate drying. Solvents are also used to thin paint and clean brushes—gum turpentine being the most usual and strongest solvent.

Artists tend to have strong preferences when it comes to mediums, and a variety of different formulas can be found. Many artists use linseed oil; for a time, I did, too. I've also used a mixture of five parts turpentine with one part stand oil and one part linseed oil. This was great to paint with— it gave the paint a nice, fluid consistency—but left the surface too glossy for my taste. Other recipes call for the addition of small amounts of damar varnish, damar resin, or cobalt drier. More complex formulas also exist, such as Maroger Medium, which is made by saturating linseed oil with white lead and mixing it with mastic varnish. I've tried several formulas, and have always returned, after a time, to straight turpentine, which I think has several advantages. First, most of the turpentine you use will evaporate, leaving nearly pure pigment on your canvas, which will make your paintings more permanent and easier to care for over time. Second, anything you add to your paint will dilute its purity and strength somewhat, and linseed oil in particular causes a certain amount of yellowing over time. Third, although some formulas make the paint more buttery, so that it allows you more fluidity with a brush, I think you can achieve the same effect by using more paint, which is almost always an advantage. Finally, straight turpentine is the simplest medium to use, especially for outdoor painting, when you want your materials to be as uncomplicated as possible. But remember, since turpentine is flammable and has toxic fumes to which many people are allergic, use it carefully, sparingly, and in a well-ventilated area when painting indoors.

Though not as strong as turpentine, mineral spirits is another solvent for thinning paints and cleaning up. Weber's Odorless Turpenoid is a popular brand.

Finally, if you'd prefer to avoid turpentine and use water as a solvent, try water-miscible oil paints— Grumbacher's Max line.

### RETOUCH VARNISH

Retouch varnish is an intermediate varnish to restore gloss to dry oil paint, for use when you want to continue working on or reworking areas of a dry painting. It contains much more turpentine than a final varnish (see below), so it doesn't leave the painting with a permanent gloss. When a painting dries, it often does so unevenly, and certain areas may appear dull or flat while others may look glossy. Retouch varnish will impart a uniform gloss to the entire painting, making it appear as though it is wet. If you try to work on a dry painting without it, you may have trouble matching colors, because the color you apply will usually dry darker than the rest of the painting. I use spray damar retouch varnish, which allows you to apply a uniform, thin layer easily. Use it sparingly and with adequate ventilation.

Damar (a natural substance) and several synthetic varnishes come in undiluted form for use as a final varnish, which is applied to protect the painting from dirt. Instead of lodging on the paint surface, dust lands on the varnish and can be wiped off easily. Final varnish comes in a matte, semigloss, or high-gloss finish. A final varnish can always be removed with the proper solvent, often a mixture of turpentine and a small amount of alcohol.

# Canvas and Other Supports

There are many surfaces to paint on, so try to find one suited to your approach to painting. Most painters use cotton or linen canvas. I use a medium-texture, medium-weight cotton duck canvas that weighs about twelve ounces per square yard. Generally, the rougher the texture, the heavier the canvas. Weights can vary from nine ounces or so per square yard for very smooth canvas to seventeen ounces or more for a roughly woven surface. The weight and texture of the canvas should compliment your style of painting. For example, an artist whose work is very detailed would probably choose a very smooth surface, finding that a rougher surface made fine brushwork impossible.

I prime and stretch my canvas myself. I find that commercially prepared—primed and stretched—canvas doesn't have enough tooth, or grain, for my taste. My approach to painting is very direct, and calls for a grainy surface, which seems to hold the paint better. I block in my canvas with a thin, mostly transparent layer of paint that must accept subsequent layers almost immediately. To put down a color over my block-in without picking up the color underneath requires a surface with a certain amount of texture and absorbency.

I occasionally use linen canvas (which is more expensive), mostly for smaller paintings. Although many artists swear by it, I find linen a more difficult surface to work on. It receives the paint in a different manner—it's slicker to varying degrees than the cotton I use—and the paint slides around a bit more, so my block-in doesn't "set up" the way I like, which can throw me off. In terms of durability, however, it's unbeatable, and definitely worth a try, despite its expense.

Commercially prepared canvas panels, popular with students because they're relatively cheap, are actually quite difficult to paint on. Aside from being of questionable life span, their surface is very slick and doesn't accept paint well. Even a thin wash to block in a painting seems to just sit on the surface, taking forever to set up. If you put down a brushstroke on top of it, you're likely to pick up what's underneath. I also prefer the give and feel of stretched canvas; it just seems like a more inviting surface to work on. (I do, however, take canvas mounted on panels on painting trips, when space is a consideration.)

Oil paint can be worked on many other surfaces: Masonite, wood, primed paper, metal, and glass are supports that are also used.

## STRETCHING AND PRIMING A CANVAS

Wooden stretcher bars are sold individually and come in many lengths, with ends mitered and grooved so you can assemble them easily yourself and tailormake any size canvas frame you need. For example, proportionally, one of my favorite dimensions for a horizontal landscape is 16" (height) by 22" (width), so you'd buy a pair of each of those length stretchers and put them together. Then, using a staple gun, you affix your bare canvas to the assembled stretcher frame.

Before you can apply oil paints to a support, you need to prime it to protect the surface and make it more receptive to paint. In the traditional method, the stretched canvas is first sized with an animal hide glue to seal the fabric's fibers, and then coated with a primer, or ground, of (usually) white paint that's low in oil content, such as lead or titanium white. Another traditional oil painting ground is gesso, a combination of rabbit-skin glue, chalk, and white pigment.

Today, many artists, including myself, prime their canvases instead with acrylic "gesso," a polymer emulsion paint that is nothing like genuine gesso. Acrylic gesso dries very quickly to form a strong, hard ground that is resistant to moisture, thus eliminating the need for a preliminary application of sizing. It is also impervious to the acidic action of oxidizing oil paint.

I prime canvas with two coats of acrylic gesso. Depending on the brand, the gesso can be thinned down with water to a more manageable consistency. There is no formula, since all brands are slightly different. You have to find the right consistency by trial and error. Too little gesso, and your surface will absorb the paint too much; if you turn the canvas over, you'll see the paint bleed through to the other side. Too much gesso covers up the canvas texture and creates a slick, greasy surface that doesn't accept paint properly. As a rule, therefore, two or three thin coats are better than one thick coat, which is also more likely to crack. I use a three-inch house-painting brush to apply it. The first coat needs to be scrubbed in to make sure it completely covers the fibers of the canvas, and then brushed out. I usually brush the first coat in one direction and the second in the other, so that it reinforces the tooth of the canvas. Make sure to allow sufficient drying time between coats. Drying time is slowed down by cool, damp weather, but overnight is always sufficient.

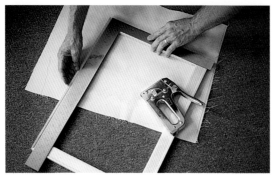

**Step 1.** Stretching canvas. I use a carpenter's square to make certain that my stretcher bars are at perfect right angles before I affix the canvas. For larger sizes—22 × 28" (about 56 × 71 cm) and up—using a heavy-duty staple gun, I usually put two staples in each corner to keep the stretcher stable when pulling the canvas over it. For even larger sizes—larger than 30 × 40" (about 72 × 101 cm), I use heavy-duty stretchers, which normally fit together so tightly that shifting isn't a problem.

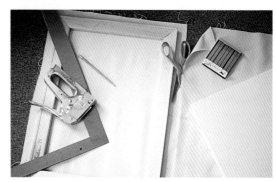

**Step 2.** When I want to cut canvas to size, I roll it out on the floor and lay the assembled stretchers on it. I usually do at least five or six canvases of different sizes at a time, and try to arrange them so that I waste as little canvas as possible. Allow about an inch and a quarter overlap all around; for example, for a canvas of 8 × 10" (about 20 × 25 cm), you'll need to measure 9$\frac{1}{4}$ × 11$\frac{1}{4}$" (about 23 × 28 cm)—the extra margin needed to go over the stretchers. Then mark the canvas with a pencil, and cut.

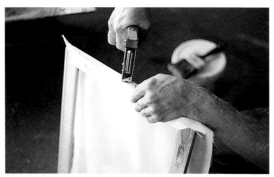

**Step 3.** Put a staple in the center of one side, making sure you have an equal amount of overlap on all sides. Pull the canvas tight, and put a staple in the center of the opposite side. If you have trouble making the canvas taut enough, use stretching pliers, specifically made to grip and pull canvas. Put a staple in the centers of each of the other two sides.

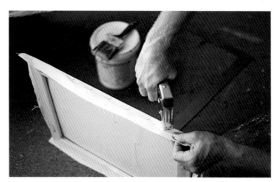

**Step 4.** Work from the center outward, pulling the canvas slightly toward the corners as you go. Affix a few staples in each direction on the diagonal, about two inches apart; repeat on the opposite side, then on the remaining two sides. Work your way to the corners, a few staples at a time, then go to the opposite side. If you work all of any one side without tightening opposing sides, the pressure from pulling the canvas tight can force the stretchers out of alignment, and your canvas won't be square.

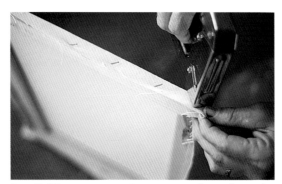

**Step 5.** When you get to the corners, tuck one flap under the other (like making a bed, or so I'm told) and staple.

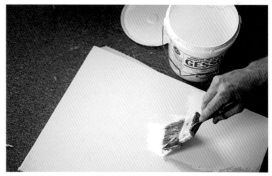

**Step 6.** Use a large house-painting brush to apply gesso. When applying the first coat, be sure to scrub the gesso in so that it coats all the fibers. You can experiment with different textures by leaving brushstrokes in the gesso, by applying it with a palette knife, or by using a combination of the two. I like to reinforce the canvas weave with the brushstrokes of the gesso.

# Brushes and Knives

Brushes fall into two categories: hard and soft. Hard brushes are stronger, made of bristle (hog hair), and are cheaper than soft brushes, which are made of fur (sable being the most expensive). However, brushes made with synthetic nylon fibers are often as soft as sable and more resilient, and are far less costly.

For direct oil painting, I highly recommend bristle brushes. They're relatively durable and resilient, with a spring that allows you to use substantial amounts of paint, and apply it freely. Bristle brushes almost force you to work broadly. Sable brushes, on the other hand, are better suited for glazing or finish work. They should be avoided in the early stages of a painting, since the tendency is to get too "fussy" with them.

I use bristle brights, usually #2, 4, 6, 8, 10, and 12. The *bright* refers to the shape of the working end of the brush, which is almost square. ("Flats" are longer and more rectangular; "filberts" have a rounded, rather than a squared-off, end.) I like brights because they have a little more spring than the longer flats, and I can paint more vigorously with them. After a couple of paintings, the corners get worn down, and they basically turn into filberts. (Worn-down brushes can be used for more specialized purposes.) The rounded edges of a filbert-shaped brush give a softer edge to individual brushstrokes. So I'll usually have a new and a used brush of each size on hand. I use the new brush, with its squarer end,

more for blocking in or if I need a very emphatic brushstroke. Then, as the painting progresses, I'll also use an older, more worn brush, especially when a softer edge is required.

I also have a couple of small round sable brushes on hand, usually #6 and 8, that form a fine point in the event that I need a very thin line or an especially precise bit of detail. Often, though, I'll work on several paintings without ever using a brush that small. I use my sable rounds most often for 8-×-10" or 9-×-12" paintings, but even with such small canvases, I use these brushes sparingly.

## PALETTE KNIVES

Palette knives have a number of uses. They can be used, of course, for painting. They can be used for delivering paint to the canvas or for lifting unwanted paint off it, and for scraping down areas that you want to repaint. They can also be used to clean off your palette. I prefer a knife with an inverted handle, with a triangular blade about two inches long. A knife this size will fulfill any of these purposes easily and efficiently. I also have a smaller version of the same knife, which I carry with my outdoor supplies. Exercise caution when scraping off areas on your painting and when cleaning your palette; the knife can slice your canvas or finger easily. They actually get sharper as time goes on, especially if you use them to clean your palette.

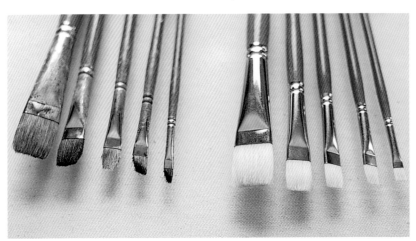

Used and new brushes. These brushes are all bristle brights; the new brushes, from right to left, are #4, 6, 8, 10, and 12. With use, the edges become worn down, and then can be used in specific ways. The #2 and #4 on the left are very worn—notice that one side of the brush has become more worn than the other—useful for working very fine edges. In fact, once the edges of the brush get a little worn, they are generally better for working edges.

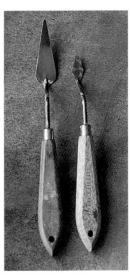

My favorite palette knives.

# Palette and Other Necessities

My palette is a 16-×-24" piece of Masonite (trademark for a fiberboard that's smooth on one side, rough on the other), which has been treated with linseed oil (details below). Masonite makes a great, very durable, palette. Its treated surface, once broken in, is like glass. It's very easy to clean, its brown tone is well suited for color mixing, and it's inexpensive. I buy a 4-×-4' piece of Masonite and cut it into six 16-×-24" pieces, which provides me with two or three years' worth of palettes (I have one for my studio and one for outdoor work). As time goes on, the mixing area, despite my best intentions, seems to get smaller and smaller, until I don't have a sufficiently large space on which to blend colors.

Masonite needs to be sealed, because it's too absorbent as is to mix oil paint on, so I saturate it with linseed oil, by pouring a generous amount onto the smooth side, then wiping it in over the entire surface with a paper towel. When the linseed oil has soaked entirely into the surface, I repeat the process as needed—usually at least five or six times—until the board won't absorb any more oil. Then it's ready to use. It takes a couple of weeks to break in, during which time it will absorb a little of the oil from your paints when you mix. But if you clean your palette frequently and thoroughly with turpentine as you use it, it will speed up the seasoning process. Once the palette is broken in, it makes an ideal surface on which to mix paint.

While I prefer Masonite, other materials can be improvised for a palette: a slab of wood, a sheet of glass, a piece of heavy cardboard. Disposable paper palettes come in pads of various sizes, contoured at one end and with a thumb hole for easy handling. When you've used up one sheet, you just discard it and go on to the next.

**PALETTE CUPS**

I use a twelve-ounce soup can to hold my turpentine. The small cups sold in most art supply stores are really too small. You should be able to pour a good one and a half to two inches of turpentine into your cup, so that you can completely immerse the bristles of your brush without disturbing the sediment that settles on the bottom. Some artists use two cups, one for cleaning brushes and another for a medium (or clean turpentine to be used for painting).

**RAGS OR PAPER TOWELS**

You should always have a good supply of rags or paper towels on hand for cleaning your brushes and palette, and occasionally, for wiping down an area of your painting. I prefer paper towels, since they're readily available. (When painting on location, remember to take along a bag in which to collect your disposables.) A product called Art Wipes, made by Winsor & Newton, is great for getting paint off your hands.

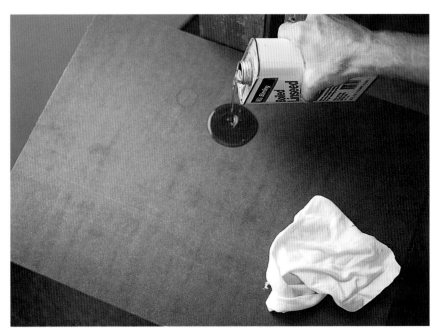

Preparing a palette. I pour a liberal amount of linseed oil on the smooth side of a Masonite sheet, then rub it in with a rag or paper towel until the entire surface is coated. This process must be repeated several times in order to seal the surface. Once the palette is seasoned, it's like glass, and has a neutral, medium-value tone which I find ideal for mixing colors.

# Easels

Having a good, stable support to work on, whether outdoors or in the studio, is a must. You have enough to think about confronting your canvas without worrying about it wobbling when you try to apply a precise brushstroke. Many good studio easels are available—it's basically a matter of how much money you want to spend. Unless you paint huge canvases, a moderate-size easel is adequate.

For outdoor work, a French easel is hard to beat. It folds to a compact size, has compartments for paint and other paraphernalia, and can be set up very quickly. The legs can be adjusted individually, so you can keep your easel level on uneven ground. Most types will accept a canvas up to about thirty inches in height, which is certainly large enough for most outdoor work. If this easel, full of supplies, is too heavy for you, consider the half-size French easel, which is considerably lighter. It's not as sturdy, though, and is better suited to smaller canvases.

I also use and recommend a pochade box for small, outdoor paintings *(pochade* is French for quick sketch). A pochade box is a small, self-contained painting kit; mine accommodates a 9-×-12" panel, although they are available in other sizes, both smaller and larger. Its lid is grooved to hold your painting surface—the grooves will hold a piece of Masonite or a canvas mounted on a panel (but not on stretchers). The open box uncovers the palette, which acts as a lid for a storage area that's large enough to hold small tubes of paint, a palette knife, and a small jar of medium. Pochades are often made with a threaded hole in the bottom, into which you can attach a tripod. Its real virtue is that it's small, light, and very inconspicuous. I often sit with mine on my lap, and have painted several times on busy streets without attracting undue attention. When you're finished working, you close the lid, and the painting folds, protected, inside the box.

Painting on location, using a French easel. I can be set up and ready to paint in just a couple of minutes with this easel. French easels are reasonably sturdy, especially when you're using smaller canvases; they get a little wobbly when holding larger ones (24 × 36" or more), especially as the easel gets older. Notice that mine is turned so no direct sun falls on my canvas.

Painting on location with a pochade box. I've positioned the box so that my canvas panel is out of the sun, and it also throws a shadow across my palette, creating the same kind of light on both my painting surface and palette. I work with the lid (palette) open enough to fasten a small turpentine holder on it. When finished painting for the day, I clean the grooves that hold both my painting surface and palette, so that paint doesn't cake up in them. If I don't, my palette can stick fast in the closed position, and my panels won't fit into the lid grooves.

# The Studio

Although most artists' work spaces fall somewhat short of being ideal, a studio doesn't have to be huge or elaborate to enable you to work comfortably and productively. The important thing is to have a place to work that is devoted solely to artwork if at all possible. Anyone who has had to set up an easel in the living or dining room and take it down every night can tell you that the procedure gets tedious very quickly. Having a space in which you can *leave* things set up—where you can leave a still life set up for days if necessary—is a real boon. If you don't have a spare room in your house for a studio, any room that has adequate light can be converted into a temporary studio by throwing a drop cloth on the floor and rearranging the furniture. It's a lot of work setting it up and tearing it down, but sometimes, when you're beginning, it's your only option. Many of my students have used basements for studios, often with the aid of color-corrected lights. You can also look into renting a space, perhaps with fellow artists to bring down the cost. A local art school or center might be willing to let you use space for a nominal fee.

I share my studio with my wife, who is also a painter. Our room is roughly 15 × 30', large enough for two studio easels, two worktables, several bookshelves, a large table for still-life setups, a couple of chairs, and a rack to hold paintings and frames. It has two windows facing south, which is not ideal, since the quality of light changes a lot over the course of the day. (North light, which is very constant and relatively cool, is generally considered the best studio light.) But we have both adjusted to it, and it's certainly adequate. I usually situate my easel about ten feet from the window. There's plenty of light on my canvas—no direct sunlight, of course—and I can back up far enough to look at my work. Still lifes can be set up anywhere, including in front of the window, so easels and worktables are often moved as needed. I also like to paint the studio itself as an interior, so I'm always moving tables, chairs, and other paraphernalia around, looking for interesting arrangements of shapes.

## NATURAL VERSUS ARTIFICIAL LIGHT

In general, I try to keep only natural light on my canvas and palette, but sometimes it's necessary to turn on an incandescent bulb as well. Usually, the combination of natural light with a soft incandescent glow is pretty good to paint by. I just make sure the light isn't shining too brightly on my canvas, and I never paint when artificial light constitutes the primary light source in the studio. Painting under artificial light influences the way you see and mix colors. My first year in art school, I once worked on a project until early in the morning, my only light source being a warm, incandescent bulb. When I took my painting to class the next day, I was horrified by the color I had used! The shadows were garish purple and the lights way too orange—it hurt my eyes to look at it. I had to rework the entire painting under natural light.

If you must paint without natural light, get color-corrected lights that simulate natural north light. I also take the time to look at my painting under different kinds of light while I'm working on it, so I can see it with a fresh eye, and with no glare. I have two spots where I set developing paintings to consider them: One is brightly lit, so that I can judge color, and also back up fifteen or twenty feet; the other is more dimly lit, so that I can judge values. In the darker light, the color isn't as pronounced and thus has a lesser impact, making it easier to concentrate on the value relationships in the painting.

## HEALTH PRECAUTIONS

Working under safe conditions in the studio is also an increasing concern. I finally switched to odorless turpentine, and we have both a fan and an air cleaner in the studio, which filters and recycles the air several times an hour. Another problem, getting paint on your hands, is just about unavoidable, although more and more people seem to be wearing thin rubber gloves. I dislike wearing them, and try instead to use Art Wipes, which are great for getting paint off, and I also wash my hands frequently. Most art supply catalogues offer a wide variety of products—from odorless turpentine and gloves for painting, to air filter systems—to help make your studio safer.

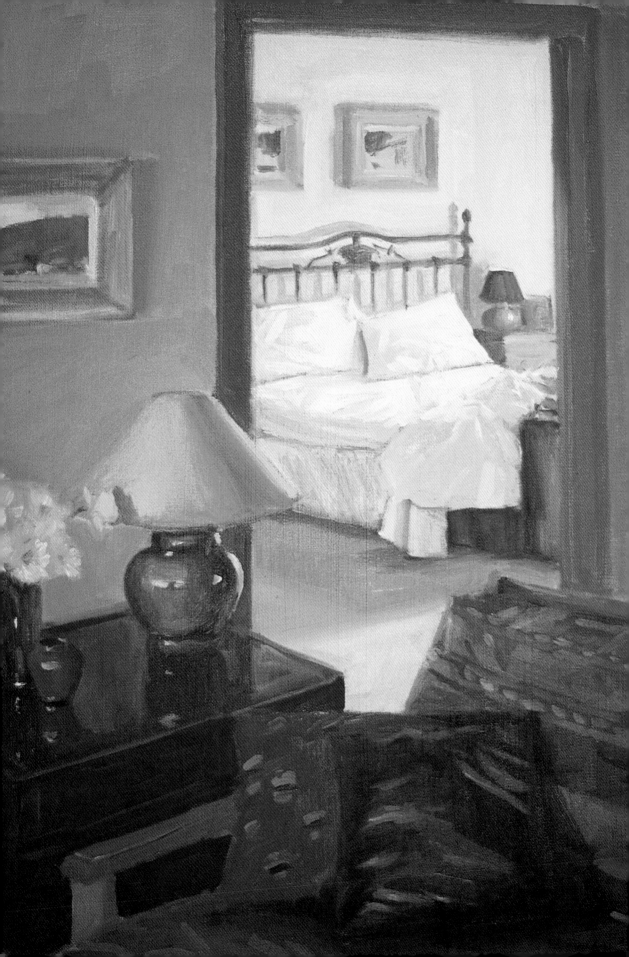

# Fundamentals

To be expressive, to create oil paintings that accurately convey your feelings about a subject, you must learn the language of painting—the means by which artists use paint to communicate. Scribbling frantically on a piece of canvas may be therapeutic, but it doesn't communicate, except in the broadest sense. To learn this vocabulary, to learn the methods used to paint an effective, articulate painting, you have to start with the fundamentals: drawing, color, value, and composition.

In this chapter, I'll discuss drawing as the foundation of painting, explaining why it's essential to visualize and establish the elements of your painting quickly and accurately and how to do it. For most artists, learning to use color expressively is one of the most exciting aspects of learning to paint. Here you'll learn how to use the contrast between warm and cool colors to create a feeling of light; work with a limited palette to create myriad different hues; make use of black effectively; and create a variety of wonderful greens from the other colors on your palette. You'll learn to understand, recognize, and use color values. And you'll learn to use patterns of light and dark, negative shapes, and bold, abstract patterns to establish strong compositions.

**INTERIOR WITH BLUE LAMP**
Oil on canvas, 24 × 18"
(60.9 × 45.7 cm). Private collection.

Before you begin a painting, try to visualize it on the canvas, although not necessarily in a literal sense. Imagine the shapes actually having form and weight and a presence on your easel. Many artists feel that a painting is already there on the canvas, just waiting to be brought out.

# Drawing

Drawing for the sake of drawing and drawing as a basis for painting are two entirely different things. Drawing is, of course, an art form in itself, and many artists think it is the purest of all the visual arts. But it also provides a foundation for painting, in the sense that it enables you to learn about form and space and light and dark, without the difficulty and distraction of color. In fact, a typical nineteenth-century art-school education began with students drawing from plaster casts taken from classical Greek sculpture. From there, they graduated to drawing from a live model. It was only then, after at least two years spent drawing, that students were allowed to begin to paint. A thorough knowledge of values (that's why they worked in black and white) of the human form was presupposed when a student first entered the painting studio. Paintings through the first three quarters of the nineteenth century are certainly usually characterized by flawless draftsmanship, but often at the expense of spontaneity and vitality, which were to become increasingly central concerns to painters as time went on. For this reason, the next generation of painters in essence rejected a lot of classical "academy" work and education, because so much of it seemed hopelessly rooted in the past. The debate as to whether such a rigid, meticulous education stifles creativity continues to this day.

Drawing as a preliminary step in the painting process is for me a kind of shorthand. It's used to indicate the placement of the painting's major elements, and to show a sense of the flow and direction of its composition. I may use only a few lines for a painting with just a few major shapes, or a more detailed and complex drawing for a more complicated composition. What I want to see in my drawing is an indication of form; how things relate to one another; and how space is divided up.

I draw directly with paint, using a small bristle brush, so I won't be tempted to get overinvolved with detail as I might if I used a pencil or charcoal. I personally don't do much in the way of preliminary sketching either, such as thumbnail sketches to resolve compositional problems, though many artists do. I don't want to solve the whole painting in the drawing. I want to make sure that there is a continual sense of discovery in the painting process. What's important in this preliminary stage is that you get things the right size and in the right place before you begin applying paint.

Drawing, among all the fundamentals of painting, comes closest to being the cornerstone. It's impossible to hide poor drawing; it will be pervasive in the final painting. Conversely, there is a feeling of "rightness" to the final forms and structure when a painting is well conceived and well drawn. This sense of good drawing has nothing to do with an impressive amount of polish or minute detail. In fact, I'm more inclined to admire the draftsmanship in work that's a little rougher and more spontaneous—in which the brushstrokes are more highly visible— since the artist has made a bold statement and left it, without embellishment, as a record of his or her emotional response to a subject.

**STANDING FIGURE**
Charcoal on paper, 18 × 11"
(45.7 × 27.9 cm).
Collection of the artist.

This was a five-minute sketch done at an uninstructed workshop. The purpose of quick sketching is to capture the gesture or essence of the pose, and to force you to work rapidly, getting your eye and hand to respond to the subject without interference from your brain.

Since drawing is one of your most important tools, having it at your command is essential. Nothing's more frustrating than struggling with the drawing of a form while both light and time slip away. There is a flow to the development of a painting that begins with the drawing and that ideally continues uninterrupted as you work. I'm convinced that the best way to learn to draw well is to draw from a live model. Drawing the figure well is one of the greatest challenges to an artist's skill. While there is some margin for error when drawing almost anything else (if a tree limb is in the wrong place, no one is likely to notice), there is little where the human figure is concerned. Any error draws great attention to itself. Therefore, my feeling is that if you can draw a convincing figure, you can draw anything. So practice figure drawing; it will serve you well when you draw and paint landscapes and still lifes.

At the American Academy of Art, we had a three-hour life drawing class every day. The class began with quick poses, usually no more than one minute each—just enough time to get the gesture of the pose—and progressed to three- and five-minute poses. It's amazing how much you can get done in five minutes! The class ended with a two-hour pose, which was often carried over to the next day. This day-in, day-out regimen of drawing from life was, I think, the most valuable learning experience I could have had. I can't stress too often that drawing and painting as frequently as you can are the best ways to refine your skills. Get into the habit of working every day. Many art centers offer drawing workshops, often without instruction, which provide an opportunity to draw the figure for a nominal fee. It's definitely something worth seeking out.

In the first stage of drawing, I position the major shapes of the painting. With a brush, I establish diagonals that broadly define these shapes, breaking up the surface into abstract areas. The large triangular shape on the right-hand side will dominate the composition.

In the next stage, I fit the elements of the subject into this pattern, loosely shading in some areas to give the forms a sense of volume. This provides me with enough information to begin painting.

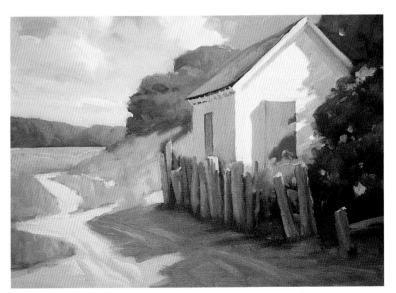

**TRURO BOATHOUSE**
Oil on canvas, 16 × 22"
(40.6 × 55.8 cm). Collection of
Joseph Andrews.

The finished painting should fulfill the concept that was indicated in the drawing. The large triangular shape containing the boathouse and its large cast shadow still dominates the canvas. Use your drawing to suggest your concept, then paint that concept.

# Color and Value

Color is one of the most exciting, emotional, and personal aspects of painting. An artist's response to color is a highly individual one. Although most people see color in basically the same way, interpretation and use of color may vary greatly from painter to painter. One artist may use color in a very literal way, recording the effects of light and atmosphere as he or she experiences them. Another might take the existing color and change it to fit a particular scheme or to create a specific mood. Color is a tool, one of the most expressive and versatile at our disposal. What is clear is that ten artists painting the same subject will likely come up with ten different ways to interpret that subject's color.

Value is the component of color that measures its lightness or darkness on a scale ranging from pure white to pure black. We will review value in detail below.

Two other components of color are hue, which refers to the color itself, as it appears on the spectrum, nature's rainbow; and saturation, which is the strength or purity of the color. The temperature of a color is relative, and may change according to context (more about this later), but in general, colors are either cool (blue, blue green, blue violet) and appear to recede from a picture plane, therefore suggesting depth; or colors are warm (red, orange, yellow) and seem to advance, to be in front on a picture plane.

Although this tendency is generally true, you should base your color choices on observation. One of my favorite motifs is to place the foreground in shadow (cool) and put my primary light (warm) in the background. It's helpful to understand and refer to these terms, but in a practical sense, it may be more instructive to discuss the whole color—how we see, interpret, mix, and apply it—since that's what we work with when we paint.

Values for *Autumn Lane.* For the orange color family, the values range from the sunlit side of the white building, which has a touch of cadmium orange in it reflected from the trees, to the dark just to the right of the building. The subtle blue violet ranges from the very light—the shadow side of the building—to the darks in the tree trunks. Limiting the number of colors in your painting can help make identifying values easier.

**AUTUMN LANE**
Oil on canvas, 14 × 18"
(35.6 × 45.7 cm).
Private collection.

Isolating and identifying values in nature can be quite difficult. Although this painting seems colorful, there is really not much variation in color. It's basically orange and subtle blue violet, with some green. There is, however, a broad value range for each color family.

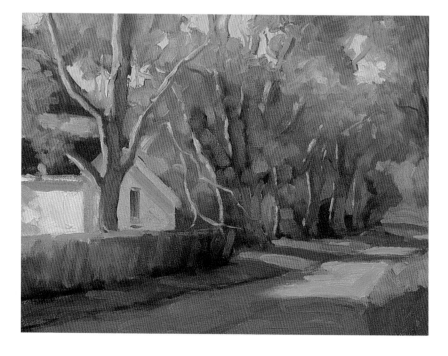

# WORKING WITH VALUE

Learning to see and translate values correctly is one of the most difficult tasks facing a painter. It's also one of the most crucial—even more important than color, and more difficult to judge. In fact, many of history's great painters haven't been primarily concerned with color. Sargent, whose color was superb, considered himself first and foremost a painter of values. His canvases photograph beautifully in black and white because his emphasis on values was so dominant.

To convey your expressive ideas to the viewer and have your painting read the way you intend it, your values must be right on the money. One reason value decisions are difficult is that color makes such a profound and emotional impression on us, it's hard to isolate its value when confronted with that color in its totality. In everyday life, few of us have had or will ever need to determine where a particular color might be situated on a black-and-white scale. Put that color in the context of a landscape, where it's surrounded by a myriad of other colors, and this task seems even more daunting. But since it's the *relationship between values* in a painting that's important, the context in which value exists is actually what makes its determination easier. In other words, if you're trying to judge the value of a particular green in a landscape, compare its value with that of other greens nearby. *Comparison* is really what value is about. If you can identify five different values of green in that setting, then you have five additional pieces of information to help you judge the value of the particular green you're *evaluating*.

One of the best ways to identify the value of a color is to understand its position on a value scale. For most purposes, a scale of roughly five values, ranging from white with a tint of color, to pure pigment, is sufficient. (Pure pigment does not necessarily mean unmixed color; in a case where white might be mixed into the darkest mixture, it is done to bring out the color.) Take a painting, isolate a particular color within it, and then construct such a value scale for that color. The value of the color you have chosen will fit somewhere on the scale. Seeing a full range of values of this color will make it easier to gauge how light or dark it really is. More often than not, that color will appear in different values within the same subject. If so, these values will also fit within the scale you have made. The fact that you can compare different values of the same or similar colors will make your evaluations easier.

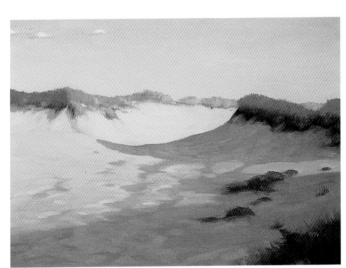

**IN THE DUNES**
Oil on canvas,
16 × 22"
(40.6 × 55.8 cm).
Private collection.

This chart shows a value scale for the five principal colors of this painting, as they occur, roughly, from top to bottom. The top row shows a range of about five values for the mixture of cerulean blue with titanium white, with a touch of cadmium red light used for the sky. The areas contain progressively less white as they go to the right, with the area on the far right containing no white at all. The value of the color mixture for the sky falls within this value scale as indicated. It's very close to the second-lightest value on the scale.

The mixture for the color of the sand in shadow (the bottom row) contains ultramarine blue, cadmium red light, and titanium white. The tendency too often is to make shadows very dark and gray. Isolating the value of this shadow makes it clear that it is really more of a middle value, and its color is quite strong. The darkest darks within the shadow also illustrate how comparatively light it is, and contrasting the shadow with the yellow sand makes it seem even more blue violet than it really is.

## HOW VALUE CHANGES AFFECT COLOR

The addition of white to any color or color mixture changes not only its value, but the color itself. Since white is considered fundamentally cool, it actually cools a color as it lightens it, in effect creating a different color. This seems very straightforward. What is slightly deceiving is how different a color mixture can look just by adding white to it. Sometimes, too, it takes a little white to bring out the nuances of a very dark value. For instance, mixing ultramarine blue deep with alizarin crimson creates a color of such dark value that a little white is needed to bring out violet in the blend. Being aware of the subtle differences in color temperature that the addition of white can cause will add variety to your color blends.

## PAINTING IN DIFFERENT VALUE RANGES

Most paintings take advantage of a fairly wide range of value. The contrast and impact of a very light value placed against a dark one can be quite appealing. When painting a still life or interior, you can create that contrast by choosing appropriate objects and lighting. If you're painting a landscape, you can usually find strong contrast and wide value ranges anytime the sun is shining brightly. Still, your selectiveness of subject matter is an important factor. Choosing a white house in bright sunlight against dark foliage, for example, sets up an especially wide range of values—providing a lot of information for you to work with. Although such contrasts can

make judging values easier, since evaluation involves comparison, you are then challenged to organize this information so that it is not confusing.

At other times, a narrower range of values may be called for, either because the subject matter demands it, or because you determine that a limited value range may be more effective in conveying your concept. In nature, such situations occur frequently: overcast days, especially; or indoors, when there's no artificial light source or direct sunlight. The absence of really dense darks and bright lights makes for a softer, often more "pastel" feeling. Many painters adopt a narrow value range, either in a low or high key, to convey a mood. A "low key" painting is one in which the lights are deliberately brought closer in value to the darks. The painting is darker overall, and its mood may also be darker and more somber. Conversely, in a "high key" painting, darks are brought closer in value to lights. Often in such cases, the darks all but disappear. The subject is therefore adapted to a predetermined value scheme in which contrast is minimized to enhance the mood of the painting. Many American Impressionists, including such painters as Daniel Garber, T. C. Steele, and John Twachtman, often utilized very narrow value ranges in a high key to evoke a particularly idyllic mood—such work is usually characterized by a wonderful glowing light. To paint in a narrow value range requires especially accurate color and value judgment, because there is so little margin for error, but the results can be very evocative.

MELTING SNOW
Oil on canvas, 16 × 22"
(40.6 × 55.8 cm).
Private collection.

There is a wide range of values here, from the sunlit snow—titanium white with a touch of cadmium yellow light—to the dark interior of the shed to the left, a mixture of ivory black with a little cadmium red light. Notice that the snow in the immediate foreground is slightly darker, grayer, and much cooler than the snow near the building. Note also that similar values and colors are grouped together, helping to simplify a complex subject.

**AUBETERRE**
Oil on canvas, 9 × 12"
(22.9 × 30.5 cm).
Collection of the artist.

This painting was done around noon on a very sunny day. The bright stones reflect light everywhere, even into the shadows. Observe how light the cast shadows are on the fronts of buildings. As a result, the painting has a high key, and the value range—for me—is relatively narrow. I relied on the actual, natural value range for this painting, organizing and unifying the lights into a pattern that I felt would enhance the feeling of overall brightness.

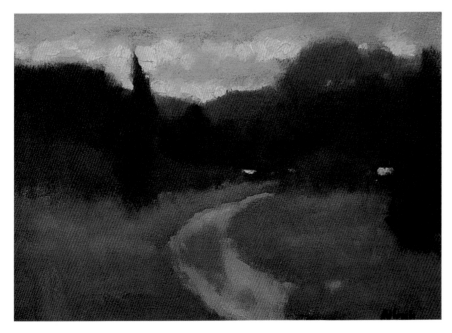

**DUSK**
Oil on canvas, 9 × 12"
(22.9 × 30.5 cm).
Collection of Karri
Somerville.

This painting, in contrast to *Aubeterre*, depicts light at the end of the day, so a much lower, darker key was used. I exaggerated the landscape's dimness, especially the field in the foreground, bringing the values throughout the painting closer together. In this case, I made a conscious decision to change the existing value scheme to better suit the concept of the painting.

# The Basic Palette

Mixing color is one of the great pleasures of painting. For me, there are few things more exciting than painting from life, reacting to color in a spontaneous, intuitive way. In order to respond to your subject in such a manner, you must be able to mix a color without thinking about it. Like anything else, this involves practice. It also requires an understanding of color properties, the way they mix, and the range of possibilities your palette provides.

Finding a palette of colors that works for you is a matter of experimentation and discovery. Very few artists use exactly the same palette and brand of paint. Some use as few as three or four pigments, others as many as twenty or more; some would prefer to find tubes of every esoteric color instead of mixing them. Develop your own way of thinking and working, and find a palette that makes sense to you and enables you to paint the kind of paintings you have in mind.

Choosing a somewhat limited palette requires use of all of your colors effectively. When I modified my palette, as mentioned earlier, I eliminated three colors from it: yellow ochre, burnt umber, and viridian green. In the case of the first two, I found that I just wasn't using them. I'd squeeze them onto my palette, then scrape them off unused a few days later. I was making more vibrant mixtures, achieving the kind of color I wanted, with cadmiums and ivory black. In the case of viridian, I had so much difficulty mixing greens when I first started painting outdoors, that I decided impulsively one day to take it off my palette (one of the best things I ever did—more about that later).

To summarize my palette colors, reviewed earlier in the section about choice of paint, my palette now consists of a warm and a cool blue—cerulean blue and ultramarine blue deep; a warm and a cool red—cadmium red light and alizarin crimson; cadmium orange, cadmium yellow light, ivory black, and titanium white. In effect, then, I have a warm and cool of each of the three primaries.

## TAKING ADVANTAGE OF BLACK

Black has an undeservedly bad reputation. People tend to think that it leads to dark, muddy paintings, but it certainly doesn't have to be that way. It's really a wonderful color, and when used properly, with discrimination, will enable you to mix many vibrant and unique colors. The trick is to think of black as a *color*, just like any other on your palette,

and not as something you use to darken other colors. Think of *creating* color with black, not darkening color. Utilized in this manner, black can open up a whole new family of color mixtures. Since I don't have green on my palette, ivory black is indispensable to me mixed with different amounts of cadmium yellow light, often with either a little cerulean blue or ultramarine blue deep, to make a variety of excellent greens. In addition, black mixed with cadmium red light or alizarin crimson (or with either cerulean or ultramarine blue) creates a wide array of beautiful warm and cool grays.

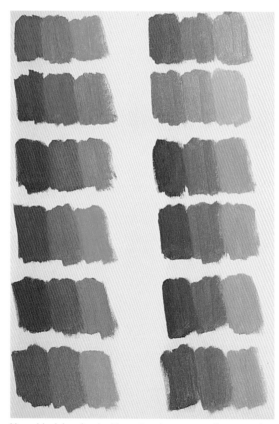

Here, black is mixed with each color on my palette, starting with cadmium yellow light, with white added to show the resulting color in three values. There are two sets of color mixtures for each color of my palette: In the first mixture, cadmium yellow light predominates over ivory black. In the second (column 1, row 2), the amount of black has been increased. The next two sets of colors (column 1, rows 3 and 4) show similar mixtures of cadmium orange with ivory black. Then comes black with cadmium red light (column 1, rows 5 and 6), alizarin crimson (column 2, rows 1 and 2), cerulean blue (column 2, rows 3 and 4), and finally, ultramarine blue (column 2, rows 5 and 6). Note how shifting the weight toward either one of the colors in the mixture creates an entirely new set of colors.

## BALANCE YOUR PALETTE USAGE

If I'm painting well, I find myself using all the colors on my palette, not overusing any specific ones or mixtures. I try to avoid complacency in my color mixing. All of the pigments on my palette are pretty strong (ultramarine blue deep probably has the least tinting power), so I must be able to use them effectively and tastefully if I am to avoid garish color. Developing the ability both to gray colors and to mix the precise color you're after is absolutely essential. Even though I like to exaggerate color somewhat, I very seldom mix a green, for example, without adding a touch of red or orange to the mixture to gray it down a bit, take some of the rawness out of it, and help relate it to the rest of the colors in the painting. Becoming aware of all the mixing possibilities that your palette presents takes time, a willingness to experiment, and a certain amount of diligence.

## SOME GENERAL TIPS FOR MIXING COLOR

- Judge a color by looking at the colors around it, not by staring directly at it. Your eye will get used to a color if you stare at it too long, and you'll lose the essence of it trying to fine-tune it. This is especially true of shadows. If you gaze at them too long, they'll appear lighter and more colorful than they really are. Keep your eyes moving and use your peripheral vision.
- Don't overmix. Use the least number of colors you can when mixing a color; using more than three can get you into trouble.
- Don't always reach for white first to lighten a color. Often you can begin by using another color on your palette instead. An art-school instructor once made me do a painting without

using white. It wasn't easy. Adjusting my values accordingly, I made pure cadmium yellow light my lightest light. (You should try it too, especially if you have trouble with chalky color.) In essence, any pigment that is lighter in value than the color you're mixing will lighten it (with lighter color mixtures, however, white is sometimes your only option). With a warm color, think about adding cadmium yellow light *first,* for example, and *then* adjusting the mixture with white or another color. Making color charts will help you to use white intelligently, by alerting you to the other possibilities your palette presents.

- Start with the predominant color in your mixture and add other pigments to it slowly and thoughtfully, so the mixture doesn't get away from you. For example, if you're creating a color that's very light in value, put out quite a bit of white, and gradually add color to it. If you need just a touch of a color in a mixture, put that paint on your brush and place it on your palette *next to* your mixture, then carefully introduce just a bit into the mixture. As one of my teachers used to say: Make haste slowly.
- Think of and use black as a color, not as something you use to darken other colors.
- Use plenty of paint. If you use too little, you'll spread it too thinly when applying it to the canvas, and end up with muddy color. Squeeze out more paint than you think you'll use, and you'll probably use it.
- Squeeze out all the colors on your palette before you start. Don't try to determine, by looking at your subject, whether or not you might use a certain color. If you put out all your colors, you might surprise yourself and use them all.

When you're mixing a color, bring the components together carefully, in a controlled manner. Don't be stingy with paint or with the space you give yourself to mix a color on your palette.

# Color Charts

One way to develop competence at recognizing and mixing color is to make and refer to color charts. Their usefulness is in introducing you to new and subtle shades and showing you ways of arriving at colors that otherwise you might not have thought of. It's easy to fall into the habit of using the same color combinations over and over, especially if they work well in a given situation. It's also easy to become infatuated with one particular color and use it too often, when a variation might work better.

These charts require you to mix five values of every color combination on your palette. Forcing yourself to create very specific nuances of color will increase your sensitivity to values in nature and help you to break down your subject into an effective range of lights and darks. You'll also learn a lot about individual colors and their tendencies. For example, you'll quickly discover the relative tinting powers of all the colors on your palette, which will help you to have better control of your mixtures.

You'll be surprised at how a subtle shift in the relative amounts of components in a mixture can result in such radically different colors. Since I paint with comparatively few colors, I have to utilize their full potential, so I must see the total range of mixtures available to me. You, too, will find that making and referring to color charts points your attention to the almost limitless possibilities your palette offers for mixing new colors, and alerts you to the need for precision in order to create the exact colors you're after to make your paintings alive and distinctive.

By making a grid with masking tape, I've divided the canvas panel shown below into one-inch squares. I use a palette knife to mix and apply the colors. This chart is for cadmium yellow light. Following the same procedure, you can make color charts for cadmium orange, cadmium red light, alizarin crimson, cerulean blue, ultramarine blue, and ivory black.

Fill in the top square with cadmium yellow light, right from the tube. Next, fill in the bottom square with a mixture of titanium white with a *touch* of cadmium yellow light in it. Mix a value of cadmium yellow light with titanium white midway between the top and bottom values, and fill in the middle square; the second square with a value midway between the first and third squares; and finally, the fourth square with a value midway between the third and fifth squares. You now have five values for cadmium yellow light, ranging from pure color to white with a hint of color. If it takes several attempts to get an even progression of values, the palette knife makes it easy to scrape off a mistake and reapply clean color.

The top square of the second column contains a mixture of cadmium yellow light and cadmium orange, with cadmium yellow light predominating slightly. The bottom square contains white with a touch of this mixture. The remaining squares are filled in the same sequence as the first column, so that you have an even progression of five values of this mixture. Make sure that you mix enough of the color initially for all five squares, since it's difficult to match the color exactly if you have to mix more.

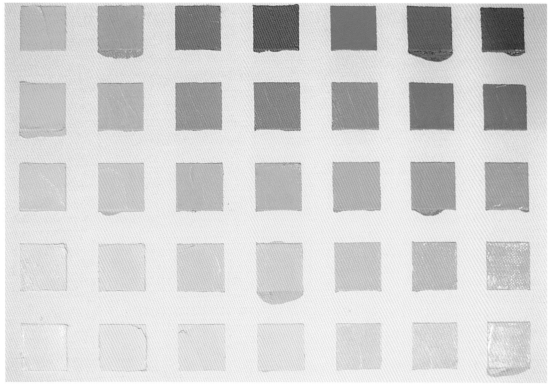

The rest of the columns are filled in the same manner, as each color on the palette is mixed with cadmium yellow. In each case, cadmium yellow light should predominate slightly over each subsequent color on your palette. Let the panel dry for a day or two and carefully peel off the tape. You now have your first chart, a table of thirty-five color mixtures in which cadmium yellow light predominates in mixtures with each of the other colors on the palette.

CADMIUM RED LIGHT +
ULTRAMARINE BLUE

ULTRAMARINE BLUE +
CADMIUM RED LIGHT

You can mix a surprising range and number of hues using any two colors from your palette just by varying the proportion of one color to the other in the mixture. At left are a few such examples, with two values of each combination shown. The colors in both columns were created with the same pairs of hues but in differing amounts; the first color listed in the label beneath each swatch is the predominant one in the mixture.

CERULEAN BLUE +
CADMIUM ORANGE

CADMIUM ORANGE +
CERULEAN BLUE

ALIZARIN CRIMSON +
CADMIUM YELLOW LIGHT

CADMIUM YELLOW LIGHT +
ALIZARIN CRIMSON

IVORY BLACK +
CERULEAN BLUE

CERULEAN BLUE +
IVORY BLACK

33

# Recognizing and Mixing the Colors You See

Identifying colors in nature is endlessly fascinating and challenging. At first, it may seem totally overwhelming when you're confronted with myriad colors that seem to change every time you look at them. But with time and practice, you'll get the hang of it. The key to recognizing a specific color actually lies in studying the colors around it. It's a matter of analyzing that color in terms of value, temperature, and saturation in comparison with the colors nearby.

For example, when painting the tree in *Maple Tree, Autumn,* I had to ask myself: Is the value of the light part of the tree lighter or darker than the value of the sky? How does it compare with the value of the grass in sunlight? Is the value of the tree in shadow similar in value to the shadow in the foreground? If so, is it warmer or cooler in temperature? Asking yourself a series of increasingly specific questions about how one color relates to others in the landscape will help you identify that color.

The next step is to determine which colors from your palette you will actually mix to get that particular color. Here again, taking an analytical approach will make your job easier. First decide which two colors you can mix together to approximate the one you're after. Ask yourself: Which primary is dominant in this color? And then: How does this color differ from that primary? For example, let's say you want to mix the foreground shadow color of the snow in *Low Tide, Winter.* I see the shadow as being essentially blue. Since it's a cool blue—compare it to the blue in the sky and the water, which are warmer because they each have some yellow in them—I start with my cool blue, ultramarine. The shadow is in the midvalue range, about halfway between the value of the dark rock above it and the sunlit snow around it, so I add titanium white to obtain the approximate value. As I lighten the color, it becomes clear that the mixture is too blue. I add a small amount of cadmium red light to gray it just slightly (cadmium

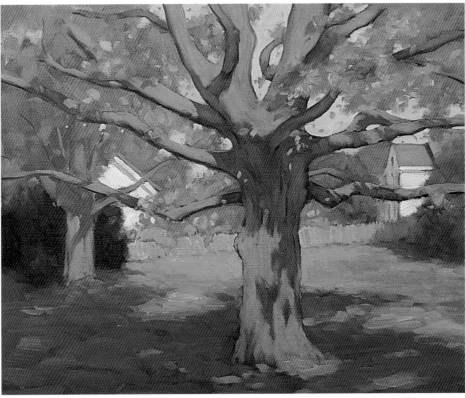

**MAPLE TREE, AUTUMN**
Oil on canvas, 20 × 24"
(40.6 × 60.9 cm). Courtesy
of the Blue Heron Gallery.

Notice that the shadow across the foreground reads as a single dark shape, even though there are many subtle color changes. The hues within that shadow are similar in value, and each one has a hint of the color adjacent to it in its mixture, in order to make the shadow seem more homogeneous.

orange will gray it too much, and alizarin crimson will make it too violet). Notice that I first identified the color as belonging to the family of a primary color—blue—and then compared it with other colors in that family. Similarly, I compared the warm yellow-orange color that lines the distant shore with both the grass in the foreground (basically, the same color seen over distance, so it's lighter in value and less saturated than the foreground color) and the color in the light areas of the rocks. The remaining colors in the painting are determined in the same methodical way.

## SEEING COLOR IN TERMS OF THE PRIMARIES

A wonderful early-twentieth-century Russian painter, Nicolai Fechin, maintained that an artist must visualize all colors in terms of the three primaries— yellow, red, and blue—to achieve truly luminous paintings. I have come to believe in this theory. Focusing on primaries is in keeping with the way our eyes actually perceive color; with the nature of paint and its properties; and most often, it leads to clean, vibrant color. Frequently, when identifying

and mixing a color, students will try to be too specific too soon—intent on painting the "brown" or "bluish gray" that they have visualized—and they end up with mud. It's much better to think of the color in general terms first, recognizing its primary component, and then get progressively more specific.

For example, is a particular shadow red, yellow, or blue? If it's blue, how does it relate to the blue of the sky? If it's grayer than the sky, is it a warm or cool gray? If it's a cool gray, would I be better off using ultramarine blue than cerulean blue? The way you compare and break down the color determines what colors you use to achieve it. Try to recognize the predominant primary in the color first, and keep the essence of that primary in your final mixture. In other words, if you see a shadow that is predominantly blue, don't be afraid to exaggerate the blue somewhat, and make sure that your final mixture reads as blue. Don't forget, though, that this blue may actually appear gray in relation to the sky or other blues in your painting. It must still relate correctly to those other blues and to the rest of the colors in your painting.

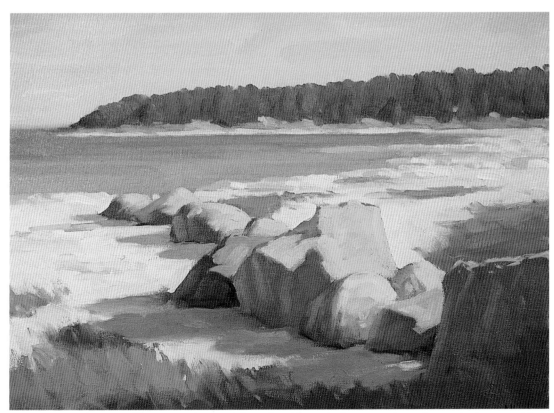

**LOW TIDE, WINTER**
Oil on canvas, 16 × 22"
(40.6 × 55.8 cm). Courtesy
of the Blue Heron Gallery.

The contrast between the various blues—in the water, sky, and snow shadows—and the complementary yellow oranges makes for a very luminous aura, despite the fact that there isn't a lot of color used here. The foreground shadow, with its dominant blue, finds unity with other midvalue hues in the yellow-orange range nearby.

# Mixing Greens

Landscape painters probably have more trouble with green than with any other color. When I first began painting outdoors, I was totally baffled by green. Nothing that I had encountered in the studio prepared me for my first attempts at spring and summer landscapes. They were often completely overwhelming, containing an infinite number of greens, which I felt powerless to distinguish.

But this vast range of a family of color actually provides the key to solving such a problem. Again, it's a matter of comparing the color you are trying to identify—in this case a green—with other greens in your subject. The differences among these greens can all be broken down to variations in value, temperature, and saturation. These determinations will then tell you what colors to mix to achieve that color.

The first step for me is to compare the green I am trying to mix with the brightest "green green" I can make, a mixture of cerulean blue with cadmium yellow light. If the green I'm trying to achieve is lighter in value, I can try adding white, which will make the mixture cooler, or more yellow, which will make it warmer. If it's darker, I have a variety of choices. Adding either cerulean or ultramarine blue will make it darker in value, and cooler (cerulean will make it relatively warmer than ultramarine). Adding either cadmium orange or cadmium red light will make it warmer and grayer. Adding black will make the green more olive, and darker. I can also start with cadmium yellow light and ultramarine as a base, for a green that is not quite so intense and

relatively cooler, or with cadmium yellow light and ivory black. Then I decide how to proceed from there.

It's a matter of changing one variable at a time. Start with a mixture of the two colors you think will most closely approximate the one you're trying to mix, and then decide on your next move: lighter or darker in value, cooler or warmer in temperature. One of the virtues of a simplified palette is that each color will change a mixture in a fundamental, specific way in terms of value and temperature. If you thoroughly learn the behavior of all your colors and how to take advantage of each one, using a limited palette won't be a handicap. There shouldn't be any color mixture beyond your reach. Once you've blended a particular green, compare it with others in a similar manner. It's a very straightforward, analytical process with which you should become so familiar that it becomes second nature.

I've noted earlier that I don't have green on my basic palette. I stopped using viridian many years ago, and the impact on my painting was immediate. A new sense of life and variety came into my work, since I had to think about, analyze, and then mix every green I used. I had gotten into the habit of starting with viridian every time, and found that after a while, I wasn't really looking carefully at the greens in the landscape. Having to mix every green from scratch made me really *look* at colors, which was so beneficial and enjoyable that I never put another green back on my palette. It's easy to get into a rut when you paint a lot. Look for ways to shake yourself up to keep the experience fresh and exciting.

Many of my greens start out with cerulean blue and cadmium yellow light, to produce a bright, warm green. If I want to gray that hue, I pull in a little cadmium red light, introducing it gradually into the mixture until I have the shade I want. If I want to lighten (and cool) the mixture, I add white in the same manner.

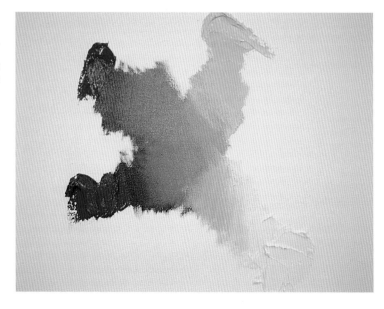

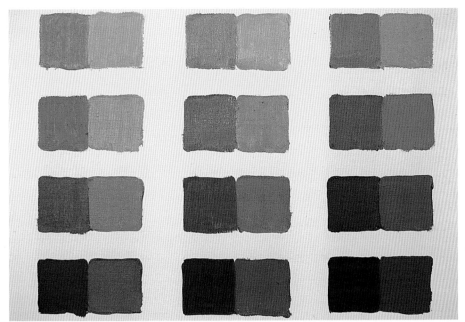

This chart shows some of the greens I can mix by adding cadmium yellow light to, from left to right, cerulean blue, ultramarine blue deep, and ivory black. There are two values of each mixture. In the first row, cadmium yellow light predominates in each mixture. In the successive rows, the weight of the mixture progressively shifts away from cadmium yellow light toward the other colors. These twenty-four colors represent a fraction of those available through these simple mixtures. Shifting the relative amounts of the two colors in a mixture can provide an almost infinite number of colors.

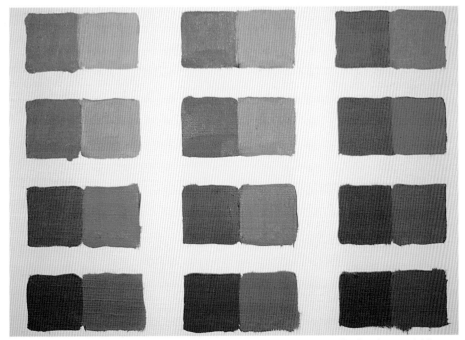

The first row in this chart shows two values of a mixture of cadmium yellow light with, from left to right, cerulean blue, ultramarine blue deep, and ivory black. The second row shows the same color mixtures, with a little cadmium orange added. In the third row, a little cadmium red light has been added, and in the fourth, a little alizarin crimson. Adding a little more yellow or a little less blue changes the color in a specific way, in terms of value, temperature, and saturation. With four variables (cadmium yellow light, cerulean blue, cadmium orange, and titanium white, for example), the possibilities increase exponentially.

# Mixing and Using Grays

The word *gray* may imply drab, indeterminate color to some, but to the artist, it must denote precise hues of very definite value and temperature. Many artists have constructed entire paintings around a range of gray. Sargent used gray masterfully and more extensively than you might imagine, given the radiant look of his paintings. Most people think of gray as being the product of black and white, and indeed, black mixed with white does make a gray. But let me emphasize, for the artist, *grays are also produced by mixing complementary colors together.* Various mixtures of blue with orange, green with red, and yellow with violet all make wonderful grays. Depending on which component predominates in the mixture, these hues can be either warm or cool. Obviously, a vast number of both warm and cool grays can be produced by adjusting the ratio of the two complementary colors with varying amounts of white.

## GRAYING OTHER COLORS

Grays exist everywhere in nature—in fact, most colors we see are grayed down to some extent. It's probably easiest to judge a color's grayness by comparing it with pure pigment. If you're confronted with a bright yellow, such as daffodils that you want to paint, put a glob of pure cadmium yellow light (the brightest

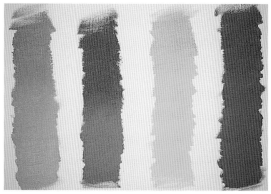

Grays can be luminous and vibrant, as seen in some of the color mixtures I used in *Edge of the Woods,* shown below. The swatch at left is a gray mixed from ultramarine blue, cadmium red light, titanium white, and a touch of cadmium yellow light; I used this in the shadow areas of the two lightest trees. Second from left is a gray mixed from ivory black, cadmium red light, titanium white, and a touch of ultramarine blue; I used this in the shadow area of darker trees. The third swatch, a mixture of cadmium yellow light and titanium white with touches of cadmium orange and cerulean blue, is the color I used to paint the sunlit grass areas. The swatch at right is a warm gray mixture of ultramarine blue, cadmium orange, and titanium white; I used it to block in the shadow color of the yellow grass, then added brushstrokes of green and yellow to vary the color somewhat and to change value.

**EDGE OF THE WOODS**
Oil on canvas, 18 × 24"
(45.7 × 60.9 cm).
Collection of the artist.

This painting is really based on a variety of subtle warm and cool gray hues and their complementary relationship with yellows in the grass and two lightest trees.

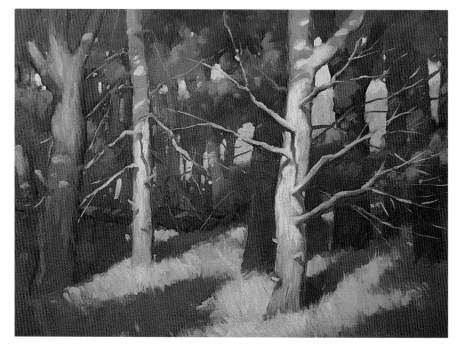

I mixed these grays from the complementary, or near-complementary, colors on my palette. The top of each swatch leans toward the warm component in the mixture, while the bottom leans toward the cool component. The left-hand swatch is cerulean blue mixed with cadmium red light, plus white. Cerulean blue has enough yellow in it to be nearly complementary to red. Adding a little cadmium yellow light to the mixture would gray it slightly more. The swatch second from left is composed of ultramarine blue deep and cadmium orange, plus white. The third swatch is ultramarine blue deep and cadmium red light, plus white. These two colors produce beautiful gray violets, which I use quite often. Cadmium red light is very versatile; it has enough orange in it to be nearly complementary to cerulean blue, yet has a strong enough cool (blue) component to make cool gray violets when mixed with ultramarine blue. If I want to gray them a little more to lessen the violet feeling, I add a little cadmium yellow light. The right-hand swatch is a mixture of violet (made from ultramarine blue deep plus alizarin crimson) and cadmium yellow light, plus white.

yellow you can make) on your brush and compare it with the flowers. Chances are it will need to be grayed down if only just a bit. A color can always be grayed to the desired degree by adding the appropriate amount of its complement. While I tend to exaggerate intensity in general, I think it's still important to be sensitive to the relative strength of colors, to be consistent, and to recognize that some colors do need to be grayed so that not all are equally bright. Intense colors appear so partly by virtue of the grayed ones around them. Though you may exaggerate, you must still save your brightest colors for those things in nature that *are* brightest, and tone down other hues accordingly.

Having pleded the case for restraint, however, I must also say that I think it can be somewhat dangerous to think too much in terms of graying colors. It's easy to end up with a listless painting. It's often better to establish a brighter key for a painting, and make your grays and grayed colors that much brighter so that they coordinate within the color scheme you've established. This is not really a contradiction. Whatever key you paint in, your colors must relate to one another properly, and your grays must still read as grays. As a practical application, you can exaggerate contrast and brightness at the focal point of a painting, and lessen contrast away from it by graying colors slightly, and moving values closer together.

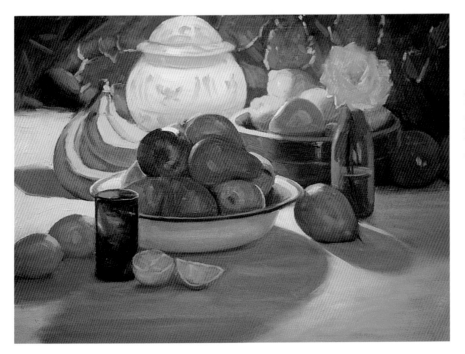

**STILL LIFE WITH BANANAS**
Oil on canvas, 18 × 24"
(45.7 × 60.9 cm).
Collection of the artist.

Most of the greens and all of the reds here are in shadow, and are therefore grayed appropriately. The central bowl of fruit in shadow really allows the bright color behind it to shine.

# Using Color Effectively

As important as it is to be able to identify colors and mix them accurately, the way you place color is just as important. The palette of a particular painting—the combination of colors the artist uses throughout the painting to achieve a total effect—is more important than any individual color. An experienced painter can take the muddiest color and build a good painting around it, because skilled artists know that a color isn't right or wrong until it's in a context. Titian is supposed to have said that he could paint a figure from mud, if he could choose which colors to put around it. It's important to select the right color, but it's more important to put the right colors next to it.

For the most part, I try to react intuitively to color. When I set up a still life, I arrange objects that are compatible in terms of size, texture, and color, and then react as spontaneously as possible to them. Color decisions have already been made to a certain degree even before I start: the colors of the objects selected for the still life. Of course, I often make adjustments and change things as I go along. But for me, the excitement comes from reacting to the situation, appreciating and interpreting light,

the collection of shapes, the range of colors. One of my favorite approaches to still life is to emphasize one color or family of colors—say blue, blue green, and green—and then include some of that color's complement—in this case, orange red. Using these analogous colors—blue green and its immediate neighbors on the color wheel—ensures harmony, and the use of a complement adds vibrancy.

Painting a landscape is somewhat different, in that I search for an existing arrangement of colors and shapes instead of creating one. But once I begin to paint, the process is pretty much the same. Outdoor painting presents subjects that generally fall into two categories: things that are paintable pretty much just as they are; and things that suggest an idea on which I can base a painting, once I embellish it with a lot of invention. In the first case, I generally rely on the color scheme that's there. My reasoning is that nature's palette drew me to the landscape to start with, so tampering too much with the color of the arrangement may diminish its effectiveness as a painting. However, I don't hesitate to make changes when necessary. In the second place, I might see a wonderful shadow pattern that is not in a

Complementary colors in *Looking Towards Italy*. The top row contains the range of greens in the painting; the second, the range of reds, which are complementary to the greens. The third has blues, used mainly in the background as complementaries to the rooftop oranges. The bottom row contains the yellow in the sunlit sides of the buildings and also the complementary violet in the buildings' shadows.

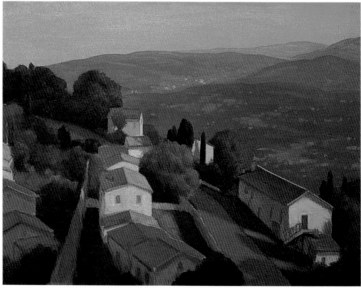

**LOOKING TOWARDS ITALY**
Oil on canvas, 16 × 22" (40.6 × 55.8 cm).
Courtesy of the Blue Heron Gallery.

This spot in the southeastern corner of France was a natural: wonderful color, a variety of forms, and a great opportunity to show depth. Dominant colors are in the blue-green family, complemented by oranges and reds of the sky and buildings. The sky actually had a lot more blue in it, but I chose to accentuate the warm, red component to enhance this complementary feeling.

**LOCUST TREES, WINTER**
Oil on canvas, 9 × 12"
(22.9 × 30.5 cm).
Collection of the artist.

The orange of the locust trees is complementary to the shadow hue of the foreground snow. The rest of the color here is fairly neutral, allowing this play of warm against cool to carry the painting. I put a little yellow in the sky so its tone would be distinct from that of the snow shadows. Nature presents wonderful color harmonies, once we become sensitive to them through focused observation.

**WINTER STREAM**
Oil on canvas, 12 × 16"
(30.5 × 40.6 cm). Private
collection.

You don't have to use a lot of extravagant color to convey luminosity. It's the combination of colors that's most important. Here, the yellow in the sky is the only highly saturated pigment in the painting; other hues are quite muted. The interjection of a bright color in a gray field can be very effective.

particularly interesting or paintable context, so I'll have to create the context by choosing colors and shapes that I feel will complement the central idea. It's not unusual to have to invent things or change elements of a landscape quite drastically to adapt them to a painting.

For instance, I often not only invent activity in the sky, but also change the color of the sky in a landscape. It's difficult to convey the utter brilliance of sunlight through the colors on your palette, so I think one must "lie" a bit to capture its radiance. The great nineteenth-century painter and teacher William Merritt Chase said that the most tiresome pictures were those that belabored truthful details. What he meant was that copying everything in front of you isn't good enough; you have to select and interpret as you paint, being willing to do whatever it takes—including a certain amount of exaggeration—to translate what you see into a bolder, more vibrant reality on your canvas.

Since I love painting light and shadow, I most often paint on sunny days, and clear blue skies can get a little boring after a while. So sometimes I'll paint the sky a color that will best complement the predominant hue in the landscape. Other times, I'll exaggerate a tone I see in the sky. In the morning, in particular, you can see hints of myriad colors, especially near the horizon. I'll isolate one or more of those colors—pinks, pale violets,

and yellows are all very visible—and make it much more prominent.

One of my teachers used to say that all color is no color. In other words, if you have equally bright color everywhere, the brightness is actually negated, and the color becomes ineffectual. The viewer doesn't know where to focus, the painting looks confusing, and its design becomes difficult to read. That's not to say that a painting can't have an overall brightness, or richness, or that strong color is a bad thing. But a spot of pure or bright color is almost always more effective in an area that has been toned down somewhat. Brightness needs something to contrast against, something to play off of. So be selective with color. Use brights to punctuate a calm area in a painting. You shouldn't be timid about using bright color, but you shouldn't be afraid of using grayed or subdued color either.

## SETTING UP CONTRASTS WITH WARM AND COOL COLORS

There is nothing quite like a painting that conveys a believable feeling of light. Although many factors contribute to the creation of such a painting, none is more important than the use of contrasting warm and cool colors. John Singer Sargent utilized this principle to great effect, particularly in his watercolors. His paintings, often featuring complex subject matter, are simplified by the use of a reduced number of

**DUNE SHADOWS**
Oil on canvas, 16 × 22"
(40.6 × 55.8 cm).
Private collection.

I like looking across and beyond a shadow to the light. The contrast between a sunlit patch of sand and the bluish cast shadow below it is a crucial element in this painting; warm and cool complements create a feeling of luminosity. An exaggeration of the predominant primary color in each of these areas enhances the feeling of light. Note, too, that even though I refer to the shadow as blue, it looks quite gray when compared to the sky.

colors and values, yet are so luminous that they almost defy color analysis. Edward Seago, a twentieth-century British artist who created many fine seascapes, used the same kind of simplification. His paintings often contain as few as four or five values and very limited color, frequently ochre brown contrasted with a complementary blue violet. Both Seago and Sargent took advantage of the vibration that occurs when a warm value is placed next to the correct cool value to create a very palpable feeling of light.

The warm colors on my palette are those I associate with sunlight: cadmium yellow light, cadmium orange, and cadmium red light. The cool colors, which I more commonly associate with shadow, are alizarin crimson, cerulean blue, and ultramarine blue. If I place the correct value of the warmest color on my palette—cadmium yellow light—next to the correct value of blue violet—a very cool color, and the complement of yellow—it creates a vibration, due in part to the tendency I noted earlier of warm colors to appear to come forward, and cool colors to recede. Our eyes interpret this vibration, which occurs when both the value and temperature of the adjacent colors are just right, as light.

If you envision and design your paintings as collections of shapes of contrasting warm and cool colors, they will not only be more luminous, they'll also be more cohesive. Think about simplifying your designs so that your paintings depict one light area against one shadow area. You can often consolidate divergent shadows into one area, or disregard shadows that break up the lights too much.

One of the most effective, widely used ways to compose a painting is to choose one color or family of colors to dominate the picture, then use that color's complement as an accent. Especially in the case of a complex composition, this arrangement organizes subject matter in a coherent, easily readable way—often in the form of a cool shadow area against a warm light, with one or the other predominating.

Note that while the terms have been used here, it's somewhat misleading to refer to colors as being warm or cool in an absolute sense. In painting, references to cool and warm are always relative. It's strictly a matter of context. We may refer, generally speaking, to a certain yellow mixture as warm, but in the context of a particular painting, it may actually be relatively cool, or at least cooler than it appears on your palette. And a color that appears cool in one situation may actually appear warm in another. When you put one color next to another color, they have an effect on each other and jointly create a context that changes with the addition of further color. Thus, you can't really judge the correctness of a color mixed on your palette until you put it on your canvas, in the context of a particular painting.

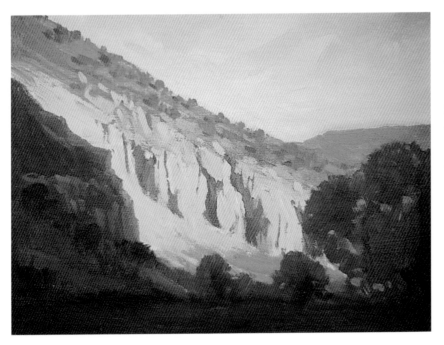

**SOUTH OF SANTA FE**
Oil on canvas, 9 × 12"
(22.9 × 30.5 cm).
Collection of the artist.

The gist of this painting is its contrast between strongly lit background and cool foreground. The warm color of the foreground rocks (warm in the context of cool foreground) helps to link foreground to background in terms of color; without it, the cool greens in the foreground might seem foreign and unrelated to the rich background. If your shadow is predominantly green and your light mostly red, make sure to include a little red in the shadow area, and a little green in the light.

# Composition

When a painting really grabs you from a distance, one of the elements you're responding to is its composition. A strong design (I'll use the words *design* and *composition* interchangeably) is the backbone of any good painting. Design is the arrangement of the major shapes on your canvas and the way the space is divided up. Perhaps the most abstract element of painting, good design is difficult to define exactly. But when the underlying design of a painting is good, the painting just *looks right*. It's usually easier to pinpoint when something's *wrong* with a composition. There are classical rules governing design, but I think it's better to develop an intuitive sense of what works for each particular painting. I again

emphasize that the more you paint, and study great paintings, the stronger your sense will be of what makes a good composition. Still, there are a few basic thoughts to keep in mind when composing your painting:

- Avoid placing your focus of interest too close to the center of the painting.
- Divide your canvas into areas of unequal size to create more dynamic paintings. Think about making your painting an arrangement of shapes that will create a sense of tension and energy.
- Horizontal lines produce a static, placid feeling, while diagonals inject energy into a painting. Either one may be appropriate. Decide on a

This block-in shows the subject reduced to a collection of abstract, geometric forms. Large, diagonal shapes dominate the foreground, while smaller, mostly horizontal ones comprise the background, producing a feeling of depth. The dark shapes of the middle-ground trees bring much-needed verticals to a mostly horizontal composition, add drama, and help push the background into the distance.

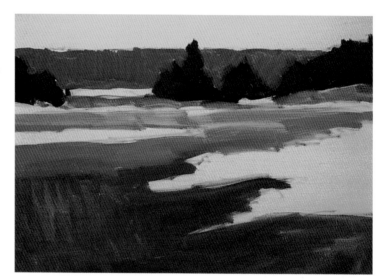

MARSH, EASTHAM
Oil on canvas, 12 × 16" (30.5 × 40.6 cm).
Private collection.

Note that development of the painting doesn't diminish the strength of its major shapes of the block-in. Although color and value changes have occurred throughout and some texture has been introduced, the abstract pattern has not been altered in the completed painting. Maintaining these shapes is what gives the painting its strength.

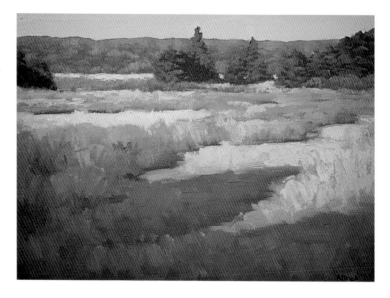

concept and the feeling you want to convey, and choose accordingly.

- People "read" paintings from left to right, so avoid placing all of your interest on the left side of the canvas, or the viewer's eye will have no reason to continue across the picture plane. Think about placing an area of primary interest to the right of center, and then drawing the viewer back to the left. You want to control the way the viewer's eye moves across your painting.
- Avoid tangents, since they attract undue attention. Also guard against placing an important element of your design too close to the edge of the canvas.

To design a painting, you have to think in terms of shapes, or rather, arrangements of shapes. While the composition of a good painting looks natural, and even unplanned, its structure is probably based on a methodology concerning the way shapes of color and value are arranged. Among such techniques are: establishing strong abstract patterns; understanding and utilizing negative shapes; creating light and dark patterns; and massing areas of similar value.

## ESTABLISHING A STRONG ABSTRACT PATTERN

Your primary concern when you start a painting should be to establish a strong abstract pattern. Break down your subject matter into a collection of shapes that can be conveyed on a flat surface. Draw a few lines on your canvas to indicate the placement of the major shapes of your subject. These lines should divide the canvas in an interesting and pleasing way regardless of what they represent.

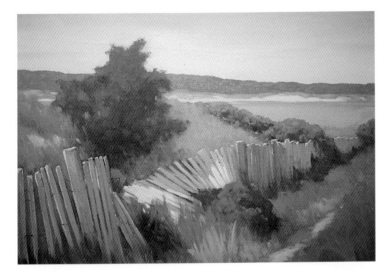

**POWER'S LANDING**
Oil on canvas, 16 × 22" (40.6 × 55.8 cm).
Private collection.

The strong diagonal of a dilapidated fence is a central element of this painting. It takes the viewer's eye out to the distant sliver of water by virtue of the diminishing fenceposts. The path running along the fence reinforces this diagonal. The painting has more depth and dynamic attraction than it would have had the fence run straight across the canvas.

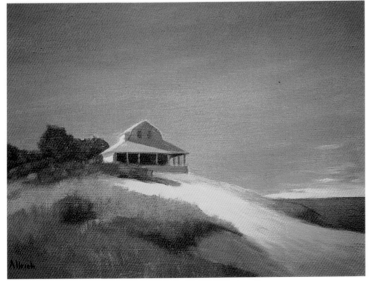

**NORTH TRURO**
Oil on canvas, 12 × 16" (30.5 × 40.6 cm).
Private collection.

The house and dramatically lit sand below it unquestionably form this painting's center of interest. Since they are left of center, I felt I needed an additional focus on the right side, so I invented a slice of yellow light in the sky at the horizon. Without it, I think the viewer's eye gets stuck on the left side of the painting. There were probably several other ways to solve the problem—this solution just occurred to me as I painted it.

Don't be in too much of a rush to make things "real." If you're painting an apple, first make it a spherical shape that relates to other shapes within the rectangle of the canvas.

As an exercise, take some paintings that you admire and simplify them into abstract shapes. You'll be surprised what a strong abstract quality good representational art has. Look at the work of Jan Vermeer, Joachin Sorolla, or Winslow Homer. Homer's work, in particular, relies on the relationship of large, abstract shapes, many of which seem relatively undeveloped and deceptively simple, yet they have enormous power. These shapes are very carefully conceived; they relate to one another perfectly. Homer's work is anything but simple; it's a testament to his knowledge and deep feeling for life. Sorolla's exuberant brushwork and complex subjects often disguise the underlying design of his work, yet his paintings remain fundamentally abstract. And look closely at the way Vermeer painted the design of a cloth in any one of his interiors. What from a distance appears to be an exact duplication of reality is actually a succession of increasingly small, abstract shapes. If you can look past the complexity and sophistication of the work of these great painters, you will find the underlying abstract quality that gives their work its strength.

This canvas is divided basically into three abstract shapes of unequal size. Squint your eyes when viewing your subject to lose details and make yourself aware of what Robert Henri called "the big shapes."

Most of the painting's activity takes place within this central shape. But in terms of composition, activity within the shape is not as important as the relationship between it and the other major shapes.

**BOUNDBROOK**
Oil on canvas, 16 × 22"
(40.6 × 55.8 cm). Courtesy of
the Blue Heron Gallery.

The finished painting retains its abstract quality, and the three major shapes are still intact. Although a lot is going on within the triangular shadow area, it still reads as a large, unified shape. The light areas of sky and sand are relatively quiet.

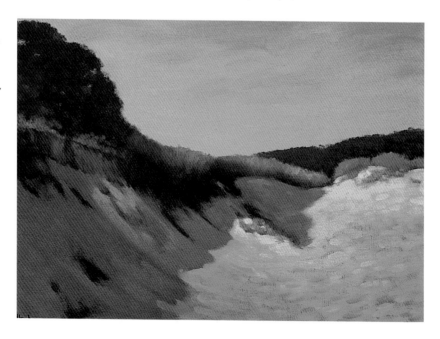

## NEGATIVE SPACE

Negative spaces are the spaces around objects. In a sense, they actually define the objects—which are the positive spaces in a painting—since they provide silhouettes of all the positive space. Like positive shapes, negative spaces have very definite shapes, so they must be considered as elements in your composition. In fact, the abstract shapes of negative spaces are just as important as the shapes of the objects in your overall design, and should never be arbitrary or haphazard. Take as much time designing negative space as you do the objects in your compositions. Your awareness of their importance will make your paintings stronger and more cohesive.

## LIGHT AND DARK PATTERNS

Organizing your painting into definite and distinct sections of light and dark is one of the most effective and dramatic methods of composing. Such areas exist in nature, often in patterns that are

Here, the light areas represent the negative space in *Winter Shed*. These abstract shapes help to define the shed and trees in the foreground by providing a silhouette of light. The design of these shapes, which may look arbitrary, was actually very carefully constructed to complement the positive shapes in the foreground. Note also that these light shapes relate to one another in an interesting way.

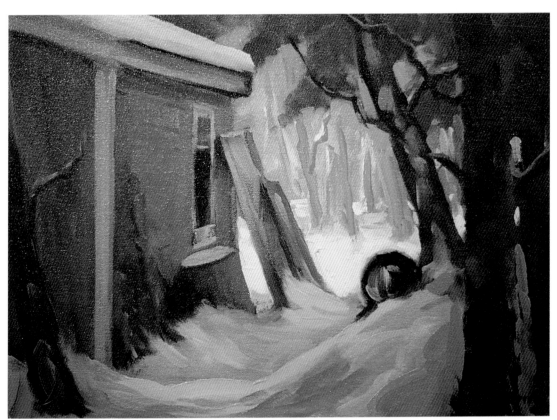

**WINTER SHED**
Oil on canvas, 12 × 16"
(30.5 × 40.6 cm).
Collection of Del Filardi
and Harriet Rubin.

All of the definition in the light-filled background has been minimized by making the values there very close. The lightness of the trees has been exaggerated. That relates their values more closely to those of the snow, so they will be differentiated from the trees in the foreground. My aim is for the value range in the background to be distinct and separate from that of the foreground. The negative space of the background is thus allowed to define the positive shape of the shed and trees in the foreground.

paintable just as they are. Just as often, though, you must reorganize the information in front of you into an attractive and cohesive pattern. Usually, this means simplifying your subject. Think about breaking up the space of your canvas into three or four major shapes of unequal size, and making your subject fit into that format. Connect your darks, arranging them, where possible, into a single, unified shape that relates to another unified shape of lights. It's important to have either the light or the shadow predominate in a painting. They shouldn't be of equal importance, in terms of either the area they occupy or their intensity.

You may also have to invent areas of shadow, or change the shapes of existing shadows to strengthen the pattern, as will keeping separate value ranges for foreground and background. Remember that your subject matter is only raw material for your painting, and that you must be willing to take liberties with it. Creating a good painting—and changing things as necessary for the sake of the painting—is more important than painting a literal version of your subject for no specific reason other than "that's the way it looked." Whatever your subject, you should first abstract and arrange it into a collection of shapes that form an interesting design.

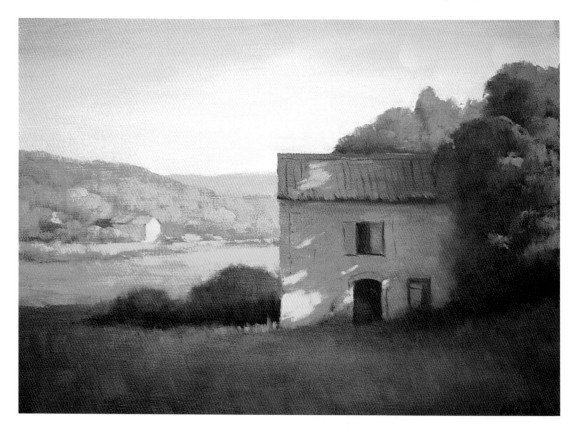

**FARMHOUSE, FRANCE**
Oil on canvas, 12 × 16" (30.5 × 40.6 cm).
Collection of George and Mary Webbere.

The strength of this painting lies in a vivid contrast between foreground and background. Thus the light on the trees in the shadowed foreground is still darker than anything in the light background. To unify the painting further, I threw a shadow across the entire foreground, though it was actually in sunlight. Strong dappled light on the farmhouse injects just the right amount of interest and activity into the foreground. In the study to the right, note the clear distinction between the shadow and light areas, and that the painting reduces to just four major shapes. The complex silhouette of the dark foreground is, for me, a pivotal aspect of this painting.

## MASSING VALUES

One of the most effective ways to ensure a successful composition is to mass together areas of similar value. If an artist's work looks strong from across the room, he or she has probably taken advantage of this idea. Failing to consider this aspect of design can lead to paintings that are confusing and difficult to read.

Massing values entails organizing your composition so that areas of like value are linked to one another, rather than occurring in a haphazard fashion. You must either find or create these connections. Try to join areas of shadow with one another rather than scattering them across the canvas. If you're painting

a shadow, don't interrupt it with lots of lights. Any areas of light within a shadow should be dark enough for them to stay within the shadow, so they won't compete with the lights. I usually block in shadows with a uniformly dark value, and then paint any lighter areas within them slightly darker than I see them, to convey the feeling that they belong within the shadow. And conversely, you shouldn't interrupt light areas with any darks that will compete with the shadows. The rule is that no dark in a light area should be as dark as the lightest light in a dark area. It sounds confusing, but what it means is that you have to keep the values of any light areas different

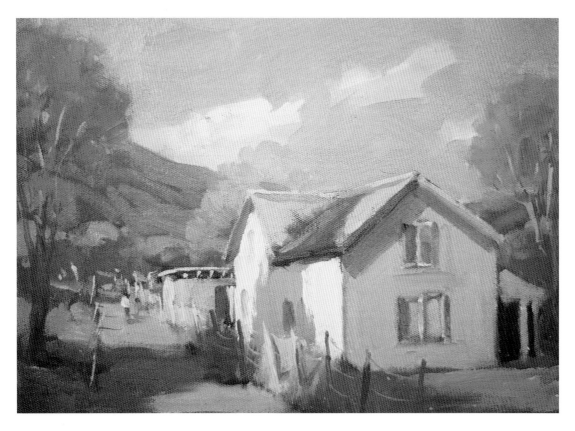

**AFTERNOON, TAOS**
Oil on canvas, 9 × 12" (22.9 × 30.5 cm).
Collection of the artist.

With so much going on here, the challenge was to simplify the design by organizing shadows and light into a comprehensible pattern. The block-in to the left shows the light-and-dark pattern and abstract nature of this design. Organizing an intricate arrangement of shapes often involves taking lots of liberties with the subject. Start with a very strong idea, then make your subject conform to it. Notice how the darks are connected, how the shadow thrown by the tree on the left continues across the road and onto the house. It is then joined to the shady side of the house by the shadow from the eave. That shadow, in turn, is connected to the dark in the background.

and distinct from those of shadow areas. If you were to take a black-and-white photograph of your painting, the light areas would contain, for example, values one through four, and the darks, values five through eight. It's particularly important to keep light areas clear and uninterrupted. To ensure this, I often make the value range in a light area narrower than I see it by lightening any darks within that section.

Remember that these and other "rules" are just guidelines, and that the exception *proves* the rule. Successfully breaking a "must" can be enormously satisfying, and will make it apparent why the rule works in most cases. Anytime someone tells you that you should never do something (in regard to painting), you should ask, Why not? Then think seriously about doing just that. Even if you can't pull it off, chances are it will add to your understanding of the principle involved. See if you can make a design

work even when you suspect that it can't. Probably it's just because you're attempting something new and unfamiliar, something you've never recognized in your work before, and it doesn't conform to your expectation of what constitutes a "proper" composition. It's when you throw caution to the wind that you're most likely to do something memorable. Painting requires a paradoxical frame of mind. Every time you pick up a brush, you should try to do the best painting you've ever done—but at the same time, you shouldn't concern yourself with the possibility of doing a bad painting, or really even care. I'm convinced that if you focus only on your enjoyment of the process of painting, good work will follow. Learn all you can about painting, but when you set up and begin to paint, forget all the rules and lose yourself in the process. React to your subject and trust that what you know will come out on the canvas.

**FROM A HILLTOP, SPAIN**
Oil on canvas, 12 × 16"
(30.5 × 40.6 cm).
Private collection.

There is a very clear distinction here between the color and values of the foreground and those of the background. The foreground triangle masses together middle- to dark-range values, while the background groups lighter values. The rocks in the foreground, which look quite light, are still slightly darker and warmer than the lights representing buildings in the background.

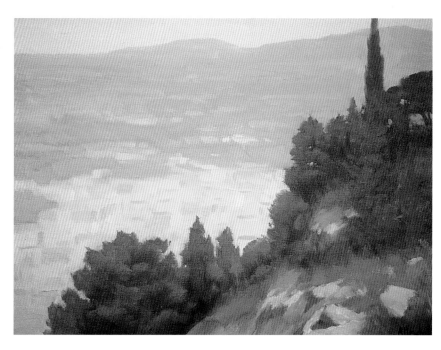

The range of values and colors in the background of *From a Hilltop, Spain* is represented by the top row here. The bottom row shows the range of values and colors in the foreground. There is a very clear difference between the two sets of colors. Those in the foreground are more highly saturated and much darker in value than those in the background. The foreground reads as a single mass that comes toward you; the background as a unified area that recedes from you.

# Finding a Unique Approach

One of the most satisfying aspects of painting is developing a sense of uniqueness in your work. You can achieve this in a number of ways: by the way you apply paint to the canvas; by your choice of subject matter; by conveying a feeling of light or mood that's provocative; and by creating compositions that are out of the ordinary. Sometimes the most unusual subjects—those that are most difficult to recognize—are the simplest ones. The pattern created by a shadow falling on the side of a building can be just as compelling a subject to paint as the Grand Canyon (and perhaps even more exciting). If you tell viewers how beautiful the Grand Canyon is, you're not telling them anything they don't already know. But if you paint something mundane in a provocative way, you may really surprise the viewer.

When you find a subject that appeals to you, think about a more unusual way to paint it. Walk around it, take it in from different angles, or think about painting it at a time of day when the light may be more unusual or advantageous. Look for ways to make simple subjects extraordinary.

All of these aspects of composition are interrelated; one flows right into another. Establishing strong light and dark patterns is based on the idea of massing together areas of similar value. The concept of basing your paintings on abstract patterns is directly bound to an understanding of negative shapes. It may seem disjointed in the beginning, as if there are too many different things to think about at once, but gradually, you'll find the connection linking all of these ideas.

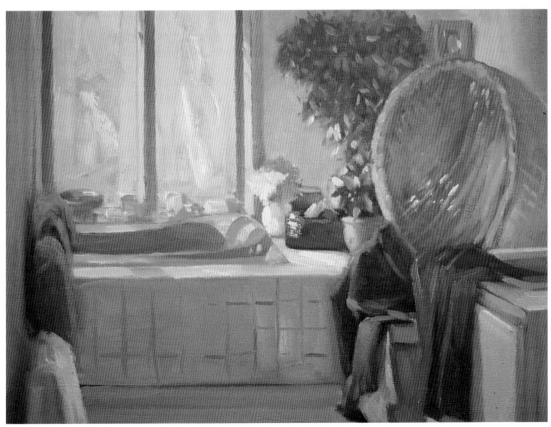

**THE WICKER CHAIR**
Oil on canvas, 14 × 18"
(35.6 × 45.7 cm). Courtesy
of the Blue Heron Gallery.

Although a bathroom may seem an unlikely choice of subject, this room is actually quite paintable. If you learn to think in terms of light and shadow being the subject of your painting, anything becomes potential subject matter.

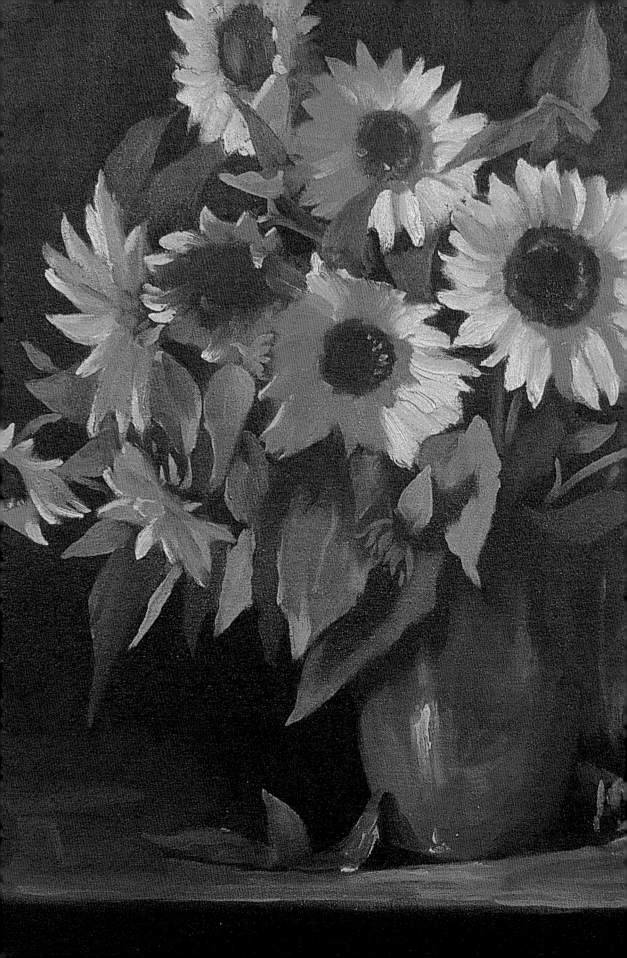

# Getting Started

Now you're ready to get to work! Armed with a familiarity with your materials and an introduction to the fundamentals of oil painting, you're ready to put brush to canvas. You've got an exciting idea for a painting—be it a landscape or a still life. This chapter takes you through the entire process, explaining how and why to tone your canvas, how to sketch in your idea, then how to block in your painting. Several techniques for applying paint will be investigated, including painting wet-into-wet, glazing, and tips for developing your own unique style of brushwork. You'll learn how to achieve a variety of edges—one of the keys to doing "painterly" work—and how to keep your color clean.

**SUNFLOWERS (DETAIL)**
Oil on canvas, 22 × 24"
(55.8 × 60.9 cm). Courtesy of
the Blue Heron Gallery.

This arrangement of sunflowers was so massive and spectacular that I wanted to give the impression that it could not be contained within the dimensions of the canvas. Notice also that the flowers along the edges are slightly smaller and cooler in temperature than the prominent, central grouping, and that they tend to turn sideways to the picture plane. This enhances the feeling of naturalness and conveys a sense of space.

# Painting from Life

The essence of painting for me is reacting in an intuitive, spontaneous way to my subject. There's nothing quite like painting a landscape outdoors or painting a live model. Anyone who's done either, who's got "the bug," will tell you that there's a sense of excitement and immediacy in working from life that just can't be duplicated by painting from a photograph.

Painters who work from life love the process, the almost mystical give and take between artist and subject that's so remarkably palpable, they will endure whatever difficulties seem to accompany it: insects landing on your wet canvas; people asking directions; wind, cold, sudden rain; models who can't hold a pose or who don't show up. These nuisances almost become part of the process, like setting up your easel,

and you can certainly learn to put up with them. The payoff—coming up with a painting that in some way captures a feeling of life—is well worth it.

Working from life also provides you with more of the kind of information you need to produce a good painting. Subtle reflected light, nuances of color in a brightly lit area, and accurate shadow color are all likely to be missing from a photograph. So, unless you have a lot of experience painting from life and *know* that these things exist, and how they relate to one another, your canvases will lack the spark and veracity associated with good landscapes and figure work. Photographs can also distort perspective, as well as color. So I don't usually recommend painting from photographs until you have a lot of experience painting from life.

**WINTER DRIVEWAY**
Oil on canvas, 22 × 28."
(55.8 × 71.1 cm).
Private collection.

I could never have achieved this painting indoors. There are many subtle variations in the color and value of the snow which I'm certain wouldn't have shown up in a photograph. I took some liberties with the placement of the trees along the driveway and changed the color of the house in the background. There's an excitement I get from painting outdoors that is really impossible to duplicate working from a photograph.

**SEATED FIGURE**
Oil on canvas, 12 × 9"
(30.5 × 22.9 cm).
Collection of the artist.

This small study of a posed model was completed in about an hour. Painting from life will imbue your work with an unmistakable sense of immediacy and authenticity.

# Subject Matter

The most important thing to remember about subject matter is that *anything* can be appropriate for a painting's theme. Rembrandt painted sides of beef; William Merritt Chase painted still lifes of fish; and I even know a painter who put false teeth in a picture. These artists all understood that what they were painting was form and space, light and shadow, and the subjects they chose had qualities that appealed to the painters' eyes, not necessarily because the subject matter (fish or false teeth) was inherently important to them. If you can convey these qualities—form, space, light—it doesn't really matter *what* you paint; your canvases will find an audience.

People respond to paintings that have spark, that say something truthful about an artist's unique reactions to personal experience. When you capture some aspect of life about which you feel deeply, people respond to your work. A great painting uses sound technical means to convey profound feeling, and has a sense of both the particular and the general, the intimate and the universal. George Inness's nineteenth-century landscapes have a wonderful sense of place, even though many of them portray imaginary settings, or contain elements from many different sources. Yet people say that they recognize these places, even though they may not actually exist. That's because Inness described some aspect of our experience with such competence and feeling that it is instantly familiar to us—light breaking through clouds, a gathering storm, or just the poignancy of stillness. Follow his example by finding subjects that you care about. Then, with

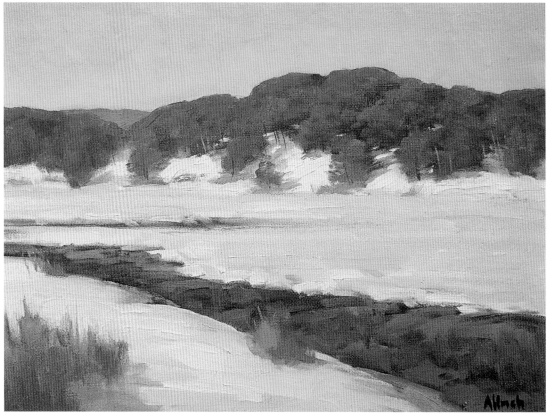

**WINTER**
Oil on canvas, 12 × 16"
(30.5 × 40.6 cm).
Private collection.

Think of your concept first in general terms, and then more specifically. In this painting, for example, I was first struck by the luminous quality of light on the snow. Then I noticed the difference in value and temperature between the light on the foreground snow, and that on the inclined plane of the background hill. The winter sun, which is low in the sky, strikes the inclined plane more directly, but skims across the horizontal foreground plane. Being sensitive to differences such as these will give your paintings a feeling of authenticity.

practice, you'll have technique at your command to express your feelings on canvas.

## PAINTING A CONCEPT

It's very important to begin with a strong idea of your subject and know what aspect of it you want to express. Don't paint a tree; paint the feeling of light falling on the tree; or paint the interesting abstract shape of the tree; or the dark silhouette of the tree against a white house. *Think* about your subject and why you want to paint it. The trick is to identify exactly what excites you about it, and then paint it. Make the viewer share the excitement you felt when you first saw your subject. If you think in terms of painting the *idea* of your subject, what's important about it, you'll work with a sense of direction, and you won't get bogged down in details. Paint what excites you first; state it very boldly, then refine it if need be.

## DECISION MAKING

From the first mark you put on canvas to the time you put your finished painting away, you will be making decisions. With each line or brushstroke, you must exercise judgment, asking yourself two questions: Does this new piece of information I've added relate correctly to what was already on my canvas? Does it take me in the right direction, toward the fulfillment of my concept?

Develop the habit of treating each brushstroke as an informed choice you've made; then correct any bad choices as you go along. Mistakes have a way of compounding themselves. If something doesn't ring true or is taking you in the wrong direction, wipe it off immediately and try again. Don't let yourself get used to a mistake or think you'll be able to fix it later. Any incorrect color or shape will influence each step you take from that point on. Adjust *as you go,* thereby making your painting a series of *good* decisions.

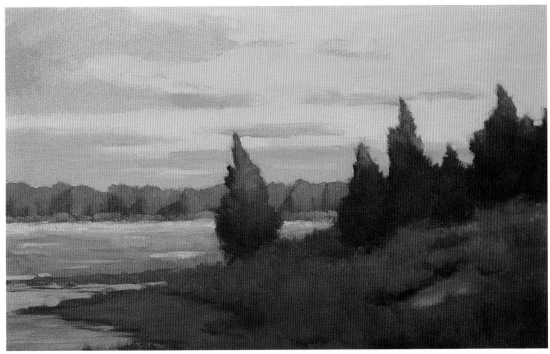

**LATE AFTERNOON, AUTUMN**
Oil on canvas, 16 × 22"
(40.6 × 55.8 cm). Courtesy
of the Blue Heron Gallery.

As I was working on another painting, I noticed this scene out of the corner of my eye and watched as the small hill gradually became covered in shadow, until only the tips of the trees in the middle ground received any light. The way the sun lit up the marsh and distant stand of trees also appealed to me. I went back the next day armed with this image, which I had been contemplating until I knew clearly how I wanted to approach it, then did this landscape. I felt almost as though I were painting the scene from memory.

# Toning the Canvas

Whether I'm painting indoors or out, and regardless of subject matter, I always begin by toning the canvas—spreading a wash of paint thinned with turpentine on the primed canvas. I use a warm tone of a middle light value. If I start with a tone that's too dark, I end up having to adjust my color, getting it lighter and lighter as I go along. The exact tone that I end up with tends to be uneven, as you can see from the way I apply paint—and I like it that way. I usually have toned canvases of varying sizes on hand, and pick one best suited to the picture I have in mind. Although I may tone a canvas on location, I often prefer to use already prepared ones so that I don't have to wait for the surface to dry. If you apply tone to your canvas outdoors in cool or damp weather, it will be slow to dry, and your brush may pick up some of this underlying color when you apply paint over it. The result is muddy color, especially in sky or other light areas.

## ADVANTAGES OF A TONED GROUND

Tone covers up the white of a primed canvas, which can be misleading in a developing painting. You can put a very bright light—a color that might well be a focal point in your painting—on a white canvas and it will barely show up, leading you to conclude that the color is wrong because of its lack of impact, when it's really the context in which it's been placed that's misleading you. Similarly, other values, if judged against white, can look darker than they would in the context of the painting, or against a toned ground.

The tone of the canvas is, for me, much better to judge values against. When you're looking at your subject, trying to gauge value and color, you're looking at tones, not white; so why not put a tone on your canvas to start with, to make those judgments easier?

You can use the canvas tone to convey light areas of your composition in the block-in. If you put a relatively dark value down against this light tone, you can get an immediate sense of the pattern of light and dark developing, and begin to see a suggestion of form. Thus it enables you to establish your painting design before dealing with the intricacies of color and opaque paint.

Allowing the tone to show through here and there in the finished painting provides unity. If the same warm tone shows through in both sky and grass, for example, it suggests a common light source and a unity in the color of light. Letting a warm tone shine through any cool area will also add luminosity to your painting. A warm, orange tone shining through cool, blue shadows on snow provides an exceptional glowing feeling. Similarly, a warm, reddish tone beneath any green area will make those greens vibrate with light. So if you're painting a subject with lots of intense green, try a canvas with a slightly darker, redder tone. The viewer may not even notice these complementary-color areas showing through. The eye actually sees these tones individually at a distance, but the brain interprets them together as a vibration that reads as luminosity.

Toning the canvas. With a large brush, I scrub color thinned with turpentine into the canvas. I usually use cadmium yellow light, cadmium orange, or cadmium red, and sometimes a little ivory black or ultramarine to gray the mixture slightly. The tone varies somewhat from canvas to canvas. I wipe the paint down with a paper towel, covering the canvas. I'm careful not to press too hard, which will cause the canvas to press against the stretchers, leaving indentations. Sometimes I add a little turpentine to the paper towel to make the paint easier to spread or to thin it if the tone is a bit too dark.

Once the canvas is covered, I wipe away excess paint and turpentine, leaving it stained with a warm, light value, then I tap or blow on it gently to remove any bits of paper towel that might be clinging to the surface.

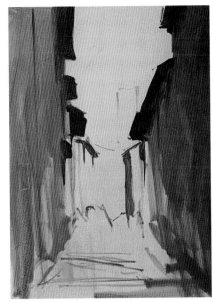

**Step 1.** For the block-in of this street scene, I begin by filling in dark shapes, representing the sides of the buildings in shadow.

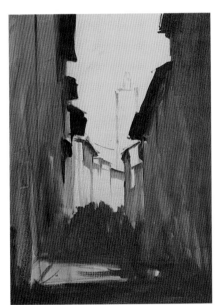

**Step 2.** I continue blocking in shadow areas. I'm not as interested in color as I am in establishing a pattern of light and dark that I think is interesting and attractive. Notice how the canvas tone reads as light, which helps me design the painting.

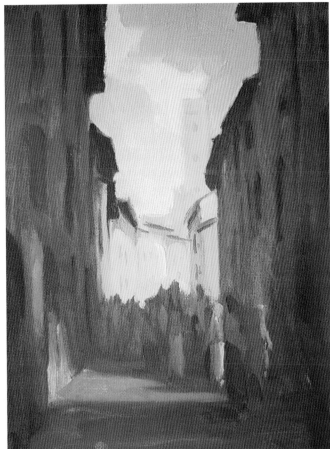

**Step 3.** Applying opaque paint to light areas of the block-in, I want to establish these lights before working on figures silhouetted against them. I try not to concentrate on shadows without putting some lights against them. That way, it's easier to judge their relative value.

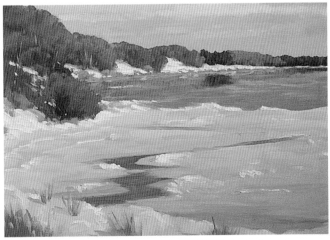

**TOWN COVE**
Oil on canvas, 16 × 22" (40.6 × 55.8 cm).
Private collection.

The warm tone of this canvas shows through in several places, but perhaps to greatest advantage in the foreground. The contrast between this tone and the cool colors in the snow intensifies the feeling of light in this painting.

# Sketching In Your Subject

When I draw my subject, I try for a simple, accurate placement of my major shapes on the canvas—sketched in with thinned paint. These shapes should define the overall, abstract design of the painting. It's very important to have a clear understanding of your picture's composition at this point, and to state it concisely, before you start applying opaque paint. If you rush through this stage to get to the "good" part—putting on paint—you'll probably end up scraping it off a couple of hours later. No amount of polish or detail can rescue a bad composition, so spend enough time with the drawing to get it the way you want it.

To expand on a point made in the Fundamentals chapter, you shouldn't draw extensively or in great detail, but what you do put down should be accurate. Sketch in enough information so that you can see the overall design and identify particular objects before you begin applying paint. A complicated subject depicting many objects or a lot of activity might require a more involved drawing, but keep in mind that your sketch is a blueprint of what will follow. Don't get so detailed that you become attached to your drawing. If you do, you'll likely be worried about ruining it, and end up being overly cautious when you paint. If you like your drawing that much, put it aside for later consideration and start another painting.

I draw with a #2 bristle brush, using a warm value of paint—often cadmium orange with a touch of ivory black—darker than the tone of the canvas, but not so dark that I will have difficulty wiping it off if I need to make corrections. I thin the paint with just enough turpentine to allow it to flow freely, enabling me to be fluid with my brush. Too much turpentine and the paint becomes soupy; the line will be too diffused and imprecise. The idea is to get the position of the big shapes right, so you need a fairly accurate line. But you don't want too much detail, because you're going to be blocking in the painting with a fairly large brush, going for the big shapes first, and anything too detailed will soon get covered up anyway.

When you draw—and paint—get in the habit of holding the brush near the end, not by the ferrule (the metal collar). You want to be able to see what you're doing, and you don't want to smudge what you've done. Hold your brush, as my instructor Eugene Hall used to say, as you would a bird: tight enough so that it won't fly away, but not so tight that you'll crush it. Stand as far away from your canvas as you can when you paint. That way, you'll be better able to see the entire surface and judge what you're doing, and be less likely to get bogged down or lost in any one area. I try to stand at arm's length as much as I can, though I sometimes find myself creeping toward the canvas for more precise work.

Before you begin to draw, try to picture your subject on the canvas. Think about how you can use just a few lines to state your theme, dividing the canvas into three or four major shapes of different sizes that relate to one another in an interesting and attractive way. Remember that the impact of these shapes as seen from a distance is probably the first way viewers will experience your painting. So you must always be conscious of how your major shapes relate to one another throughout the development of your painting. Be thinking of your canvas as a whole, even as you work on its individual sections. Beware of getting so involved in any one area that you neglect or distort its relation to the whole picture.

In drawing, too, go from the general to the specific, from the simple to the complex. If you're drawing a difficult shape, first reduce it to a geometric form or an assemblage of forms, if possible. To draw a wine bottle, for example, begin with a long, vertical rectangle, topped with a half circle (the shoulder of the bottle), which is in turn topped with a thinner rectangle (the neck of the bottle). Get the general shape and proportions correct, then make specific alterations to refine and merge your geometric shapes into a drawing of one particular wine bottle.

There is too much turpentine in this mixture to draw satisfactorily. The line is too vague, imprecise, and so soupy that it's lifting the tone off the canvas in places.

This line quality is much better, more accurate, and makes a more emphatic statement. You must experiment to get just the right amount of turpentine in your mixture.

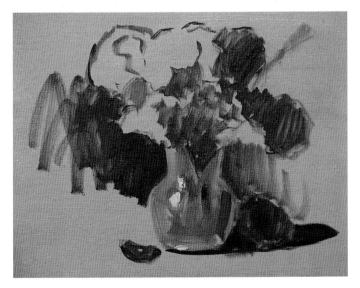

The initial stages of the block-in further define the drawing. The background darks solidify the vase and begin to give form to the flowers. I often continue to draw with my brush well into the development of the painting, so there may be no precise moment when one step ends and another begins in a painting.

# Blocking In and Developing the Painting

The block-in lets you state your pattern quickly and establish a color base onto which you can work subsequent layers of color as the painting develops. I often block in an area with a tone that's slightly darker, and often warmer, than the anticipated final color, intending that some of this underpainting will be allowed to show through. This can be especially valuable if I apply a lighter, cooler color over this area. The viewer sees this layering of warm and cool colors simultaneously, and interprets it as luminosity. Essentially, you begin by filling in your major shapes, working broadly, always thinking of the painting as a whole. Your concern here is not detail or nuance, but establishing a clear pattern of light and dark shapes to ensure that your picture content will read correctly from a distance. It's really the foundation of the painting, to be elaborated on as you continue to work.

Start with thinned paint. Use enough turpentine to wash in color quickly and broadly. In general, try to stay away from white—which makes paint opaque—at this stage. It's much more difficult to make corrections with opaque paint than with transparent paint.

Use a fairly large brush. For an 18-×-24" painting, for example, start with a #10 or #12 bristle bright. It's large enough to discourage any temptation to get too precise, but will still allow you to be accurate. You can use the brush edge if you need to be more precise, but at this point, you really shouldn't be painting small details. In fact, the longer you stick with a larger brush, the better your results will be.

Your brushwork should go from the general to the specific, from big shapes to progressively smaller shapes. Block in large areas of shadow—don't worry about incidental interruptions in them. Work from dark to light. With oils, it's easier to put a light hue over a dark one than the reverse, which generally leads to muddy color. Make use of the tone of the canvas to represent light areas while you establish darks with transparent color. Once you're satisfied with the pattern, think about developing light areas with opaque paint.

Establish a strong pattern and stick with it. The development of your painting should never weaken its design—it should enhance it. When working in a shadow area, make sure that whatever light or activity you put there always stays within the shadow. If it begins to compete with the light, it will confuse your design.

Once I've blocked in my painting, I begin working on the center of interest, usually an area containing a lot of contrast. Establish your main focal point immediately. It's easier to judge strong contrast than subtlety, so start with an area of high contrasts of light and dark and get it nailed down right away. If you develop your center of interest first, then you can relate the rest of the painting to it. You might finish the painting's main focus to a greater degree, and show progressively less finish as you move away from it. But if you begin with peripheral areas and take them too far, it's often difficult to make the focus of your painting stand out the way it should.

There aren't always clear divisions between the stages in a painting. I often use the first steps of the block-in to refine my drawing, and sometimes I'll complete an important area of the painting before I've entirely finished the block-in. Every painting progresses in a slightly different manner. It's a good thing that it does, because I think it would be extremely boring to follow a precise formula for each and every painting, to know in advance exactly how you're going to approach it. Sometimes I'll look at my subject and have absolutely no idea how I'm going to paint it. But then I'll pick up my brush and just put something down, and ideas will begin to come to me.

While the preceding sections contain many tips on method, don't confuse method with formula. Students often look for precise, "paint-by-number" formulas. Such rigidity will only lead to a dead end. Instead, approach each painting as a fresh experience, with a unique set of problems to be solved in their own way. What worked for yesterday's canvas might not necessarily work for today's. Experience brings a degree of familiarity with the way paintings evolve in general, but this can be both good and bad. On the one hand, you must guard against staleness and predictability in your work; on the other, you gain the confidence to experiment, to take a chance and go beyond what you know. So it's slightly misleading to present the painting process as a series of specific steps to be followed. That tells only part of the story. Such steps provide a way to break down and analyze the process, and should really be regarded as jumping-off points to encourage you to find your own manner of working.

**Step 1.** For centuries, apples have been featured in still lifes probably more than any other fruit. Like numerous artists before me, I often incorporate apples in my still-life compositions, as you'll find in the pages ahead. My subject for this study is a single apple and the shadow it casts on a table. Even a setup as simple as this can prove challenging to the painter. Using a fairly large bristle brush and thin paint, I start my block-in on a toned canvas with a freely drawn circle for the apple and a partial oval for the shadow it casts.

**Step 2.** I transform my circle into a sphere by shading one side of it. Continuing to work broadly, I also add color to the cast shadow shape and introduce a strong background tone, which immediately heightens focus on the subject through the strong contrast of light against dark. In blocking in my subject, I work from the general to the specific. As I paint, I imagine that I'm sculpting the apple's form, making it solid first. If you were actually sculpting an apple, you'd construct its general shape, then its particular shape, then make the indentation where the stem grows, and finally, put on the stem.

**Step 3.** In painting, we use light and shadow to sculpt the apple. As an apple curves slowly and evenly, so must our modeling of it. We convey form by first placing the correct value and color of shadow against the correct value and color of light, then by introducing a halftone between them to help make the form turn, and finally, by working the edges so that the apple relates properly to the background. Contour can also be emphasized by introducing hints of highlight, as I've started to do here by lightening the apple's center slightly.

**Step 4.** Detailing the top of the apple, now I've defined its indentation and stem. I bring in a stronger highlight, adding more vitality and warmth, and also suggest a subtle reflection of the apple onto the dark surface of the table. As a last step, when you're completing an apple study, think about what distinguishes your particular apple from others. In terms of color, brushwork, composition, light, and shadow, even a single apple can have a personality of its own and become an appealing little painting to delight the eye.

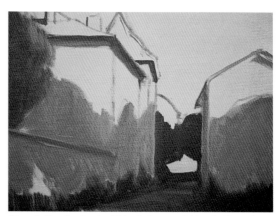

**Step 1.** My block-in for this painting of an architectural subject begins with the major compositional shapes. Since architecture is involved, I make my drawing a little more detailed than it might be otherwise. Next, I establish some darks to reinforce the drawing and help bring out the form of my subject.

**Step 2.** Continuing to fill in darks, scrubbing in the paint quickly, I keep the paint transparent in the shadows—first, so that it will dry quickly, allowing me to lay color on top of it as the picture develops—and second, so that it will contrast with opaque paint in the light areas. The pattern of light and dark, which is the foundation of the painting, has emerged at this point.

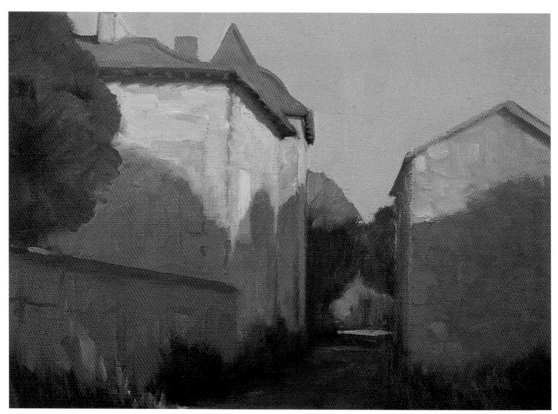

**TWILIGHT, FRENCH FARMHOUSE**
Oil on canvas, 12 × 16"
(30.5 × 40.6 cm). Courtesy
of the Blue Heron Gallery.

The development of your painting should enhance, not alter or diminish, the strength of the pattern you establish with the block-in. I've worked some color and texture into shadow areas, but they have been changed very little since the block-in. The paint in the building shadows remains transparent, in contrast to the more heavily applied paint in light areas.

# Wet-on-Wet Painting

Almost all my work is done wet-on-wet (also called wet-into-wet)—which simply means not allowing for any drying time between applications of paint. As a painting method, it suits me perfectly. I work very quickly and directly, finishing most things in one sitting. I've learned to love painting this way, taking advantage of the way pigment behaves under these circumstances. One brushstroke is worked directly on top of or into the brushstroke or layer of paint beneath it.

Another method of oil painting is the time-honored technique of glazing. In this approach, instead of mixing two colors together directly to make a third, you layer one over the other separately, using the paint in a transparent manner. The eye optically blends these colors together to produce the desired hue. For example, a blue glaze over a yellow area results in a green tone. This procedure requires that areas dry completely before you can apply subsequent glazes. Depending on the weather, this can take up to two weeks or more, so a painting can take months to complete. Obviously, this totally different and fairly complex way of painting demands meticulous planning and great patience, but it's just different, not necessarily more difficult. Although I have nothing but admiration for painters who work successfully in this manner, I have no desire to pursue it myself.

While working wet-on-wet presents some problems and takes getting used to, it also has its advantages. Unlike glazing, this style of painting is the ideal method for artists who want to produce fresh, spontaneous paintings. I like to react quickly and intuitively to my subject; I don't have the time or temperament to let a layer of paint dry before I continue. This technique allows for fluidity. You'll find that once you get a layer of paint down on your canvas, usually in the form of the block-in, the paint you subsequently apply will flow more easily, since it has a layer containing oil beneath it. The more paint you apply, the more fluid you can be.

Edges are easier to control with wet-on-wet application. If you brush paint across an edge into an adjacent area of wet paint, it will mix with that color, softening the edge. A strong edge can be achieved by loading your brush with paint and applying pressure to the leading edge of the brush. Likewise, reducing the amount of pressure you apply with the brush will soften the edge.

This method also allows you to mix color right on the canvas. If you have a substantial amount of paint on both your canvas and brush, you can brush one color into the other, and mix them to whatever degree you like. The advantages to this method are twofold: First, it can result in very clean, even intense color, and interesting surface effects; and second, it allows for more spontaneity. You have less control, so surprises are likely to occur—happy ones, very often.

You must, however, be on guard against muddy color. The more loosely you paint, and the more paint you use, the greater the tendency that dirty color will creep into your painting. To avoid muddy color, you must have a clearly defined composition, an accurate sense of where your lights and darks are going to go, and you must use progressively more paint as you go along. If you use a sufficient amount of paint, it will sit on top of the layer beneath it. If not, if you try to spread your color too thinly, it will dig up whatever colors are beneath it, and, if you're not careful, you'll end up with mud.

## WORKING FROM THIN TO THICK

Working from thin paint to thick, that is, from transparent to opaque, is a well-known, time-honored procedure offering several advantages. Transparent paint, used to block in your painting, is easily correctable. You can wipe it down with a rag or paper towel dipped in turpentine, to a point where you can rework it with little trouble. You have none of the buildup of opaque paint to contend with. While you can make corrections in opaque paint, it takes more time and effort, and leaves you with an area that is no longer transparent. If you start with thinly applied paint for your block-in, it will dry quickly, allowing you to put clean color on top almost immediately. This color will also stay clean, picking up a minimum of pigment from the layer beneath it, provided you use enough paint. Especially outdoors, you must be able to work quickly, efficiently, and continuously. You really don't have time to wait for a layer of paint to dry. Working from thin to thick, or "fat over lean," is also safer for your painting in the long run. Due to the way oil paint dries and cures, applying layers of paint thinned with turpentine over opaque layers, which contain more linseed oil, can cause cracking in time.

# Keeping Your Color Clean

Although color preference is a personal matter, and artists tend to have strong opinions about what constitutes good color, I think most would agree that *clean* color is a very high priority. There are two aspects to achieving clean color: First, you must be able to recognize and mix clean color; second, you must be able to apply the color to your canvas in such a way that it maintains its purity, so that the hue you end up with on your canvas is the one you mixed, the color you have intended.

Half the challenge in mixing clean color is being able to identify it as such—by knowing what it *shouldn't* look like. There are times when muddy color is very recognizable, but sometimes it just looks like the wrong color. Very often a student will identify a hue correctly, choose the right colors to mix to obtain that hue, but due to bad work habits, lose or muddy the tone when mixing or applying it.

To become more aware of what constitutes good color, study paintings that you admire, analyze how that artist mixed and applied color, and try to duplicate the feeling that's been achieved. Beyond this, there are several technical considerations that will help lead to clean color:

- Keep your brushes clean. Anytime you switch color dramatically—say from blue to yellow—clean your brush thoroughly, getting rid of as much blue as you can with turpentine. Then, put yellow paint on your brush, and clean it well again. Your brush is still dirty, but now it's dirty with the right color.
- Some artists use two brushes of each size: one for light values, the other for dark. I've tried that, but in the excitement of painting, I invariably pick up the wrong one. I do, however, try to save one large brush for the sky, since clean color there is imperative.
- Avoid overmixing; keep mixtures as simple as possible. Try to identify the hue you want in terms of one or two colors on your palette. Then decide how it needs to be adjusted: warmer or cooler, lighter or darker in value. Add the color you think will most nearly accomplish this

change, but be spare—sometimes a touch of color is all that's necessary. A lot of dirty color comes from overadjusting, adding too much of too many different pigments.

- Clean your palette often. First, scrape the paint off with a palette knife. Then pour some turpentine on your palette and wipe down with paper towels. When you run out of room on it, clean it; don't try to mix a clean color on top of other pigments.
- Don't spread your color too thinly. Get in the habit of loading your brush with paint, making one or two brushstrokes, then going back to your palette for more pigment.
- When you reach for a color on your palette, be sure you get pure color, not color contaminated with other mixtures. It's better—and ultimately more economical—to scrape off contaminated paint and put out fresh color.
- Use plenty of paint, heavier as you go along. Otherwise, your brush will pick up pigment from the layer beneath, mixing it with the color you're applying. There are times when you might want that effect, but more often than not, you'll end up with mud if you try it.
- When dipping your brush in turpentine to clean it, don't touch the bottom of your container; it will stir up sediment and dirty your turpentine, making it more difficult to clean your brush. I use a soup can with at least two inches of turpentine poured in it, so that I can immerse the bristle totally without disturbing the bottom.
- If you paint every day, you needn't clean your brushes with soap and water, which I find makes a bristle brush too soft and takes away some of its resiliency. The best thing you can do for brushes is to leave paint on them—*but only if you paint every day*—because the oil in the paint keeps bristles from drying out. If not, clean brushes thoroughly with turpentine or paint thinner. If you don't paint for several days, you might clean them intermittently with turpentine to prevent stiffening.

# Brushwork

A painter's work may have many distinctive qualities, but there is no aspect more personal than his or her brushwork—as much a signature as the way an artist signs a painting. From the almost invisible brushwork of Vermeer, to the uniform, staccato brushstrokes of many of the Impressionists, to the fluid, descriptive handling of Sargent and Sorolla, there are any number of ways to put paint on canvas. Basically, it comes down to temperament and taste. Sorolla observed that if he couldn't paint quickly, he probably couldn't have painted at all. He recognized that the way he worked was based on his personality, as well as his particular preferences. The way *you* paint will likewise become a synthesis of who you are, with the development of your own subjective approach to painting. So follow your instincts. Whether you tend to work slowly and meticulously or quickly and with abandon is partially a reflection of who you are. There is certainly room for good work in any style. But again I emphasize that the more paintings you study and the more you paint, the more discerning you'll become.

Before reviewing specific tips on brushwork, let me note that when you do painterly work—work in which brushwork is important and strives to be articulate—you are painting according to a convention. You are intending the brushstroke to be a representation of form or light, rather than a literal translation of your subject, and it is accepted as such. This convention is hundreds of years old, passed from one generation of artists to the next. The interesting thing is that the convention is just as important, if not more so, than reality. When the Impressionist Claude Monet was asked whether he would choose museums or nature to learn how to paint, he replied that he would choose museums.

**MARKET DAY, RIBERAC**
Oil on canvas, 18 × 24"
(45.7 × 60.9 cm). Courtesy of
the Blue Heron Gallery.

This painting was done from one of many photographs I took of a market in a small town near Bordeaux, France. Between the flowers, umbrellas, and hundreds of people milling about, there was plenty of subject matter. But it was so congested, there were few places to set up my easel, so I felt more comfortable taking pictures, then did a series of paintings from them.

Detail of *Market Day, Riberac*. This detail shows the relationship between areas of quiet and lively brushwork. Selective brushwork allows for sections where brushstrokes are less noticeable, and can sometimes be more effective than flamboyant brushwork throughout the painting.

## BRUSHWORK DOS AND DON'TS

Don't be afraid to let your brushstrokes show. Many people know art primarily through reproductions in books, where paint application often looks smooth and flat when it is anything but. Visit museums and galleries to study the various textured surfaces of paintings.

Don't be too literal; let your brushstrokes represent, not replicate, what you are painting. Instead of painting each individual blade of grass in a field, create the impression grass makes when you look across the whole field. Be selective. Paint an area broadly to suggest its general color and value, then punctuate it with a few brushstrokes that define its specific nature.

Do vary your brushstrokes. There are two schools of thought here: One says uniform brushwork throughout a painting gives it a sense of unity; the other view, which I hold, is that varied brushstrokes make a painting more interesting and dynamic. I like to see quiet areas in a painting next to areas of great activity; a calm section enlivened by vivid brushstrokes. I also favor the contrast between thin and thick paint. A thick brushstroke on top of an area just stained with transparent paint evokes depth and excitement.

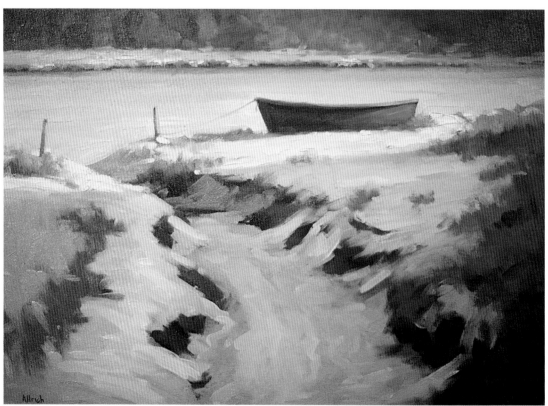

**ICED UP**
Oil on canvas, 16 × 22"
(40.6 × 55.8 cm). Courtesy
of the Blue Heron Gallery.

Bold application of paint gives this surface a varied, textural quality. Pieces of ice in the foreground are indicated by blunt, rectangular brushstrokes. I didn't attempt to refine them, because I think they accurately describe what's going on, and their roughness gives the painting a dynamic and immediate quality. The cold forced me to work quickly and broadly—the paint stiffens up considerably in winter, making precision difficult—which often contributes to creative spontaneity. Up close, the thick, broadly applied brushstrokes create a very abstract look, but as you back away from the painting, forms begin to emerge. Using thick paint sometimes causes wonderful "accidents," which should encourage you to be freer with your brush and *not* try to refine all of your brushstrokes.

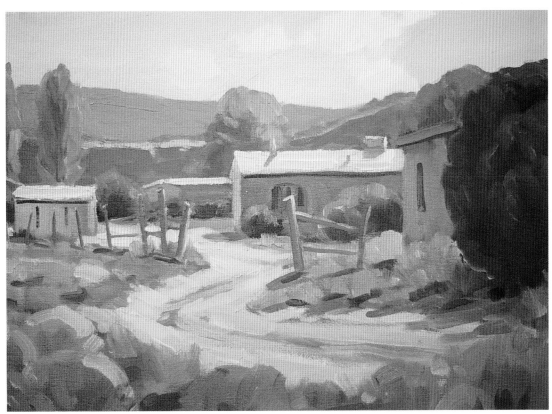

**NEW MEXICO LIGHT**
Oil on canvas, 12 × 16"
(30.5 × 40.6 cm).
Collection of the artist.

For the most part, the paint here has a "pasted on" quality. This was one of the first canvases I did in New Mexico, where the light is extraordinarily bright, and I was pretty much feeling my way through this painting. I put pigment on in a fairly deliberate manner, using brushwork to try to show the form and interpret its brilliant light.

Detail of *New Mexico Light*. I did a lot of drawing with the brush here; that is, individual brushstrokes are used to define the form. In many cases, one brushstroke represents the shadow side, another, the light side of a form. Some of the brushwork, particularly in the scrubby foreground foliage, has a patchwork quality that is somewhat stylized. I was more concerned with conveying a sense of light on the form than in painting a literal rendering of the form itself.

Do vary the amount of pressure you apply to your brush to create desired effects. In *Low Tide, Tonset*, I used heavy pressure at the top of my thick, vertical brushstrokes to indicate light grasses, and then eased up, lifting the brush gradually from my canvas, so that the paint trailed into the dark area below. I also lightly dragged quick brushstrokes of orange across the dark reflection—barely touching the surface—for a sparkling, drybrush effect.

Don't standardize your brushwork; let the subject determine how you paint it. My handling of paint is fairly consistent from painting to painting, but some themes demand other treatment. A very serene subject, for example, is not necessarily served by flamboyant brushwork. Be sensitive to the feeling you wish to convey, and don't be afraid to respond to it.

Do let your brushwork describe form. Brushstrokes that both follow and go against the shape of an object can convey a sense of roundness and volume. Brushstrokes and the shapes they make are an important element of your picture's design. Remember that even the most flamboyant brushwork should be descriptive and have a sense of structure behind it.

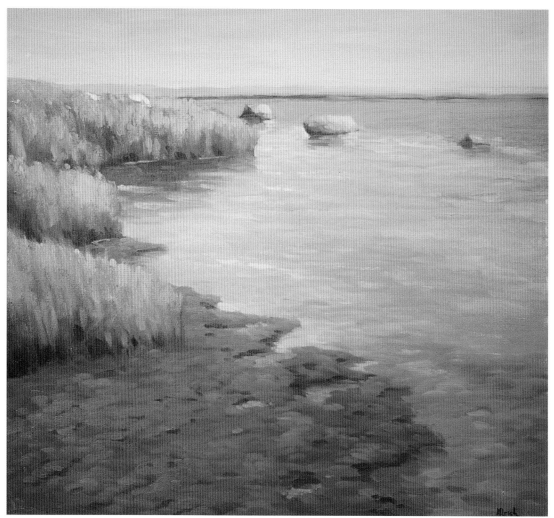

**LOW TIDE, TONSET**
Oil on canvas, 22 × 24" (55.8 × 60.9 cm).
Courtesy of the Blue Heron Gallery.

There are many paint textures in this waterscape, from thin washes to thick impasto. I think a variety of brushwork and textures adds vitality and interest to a painting.

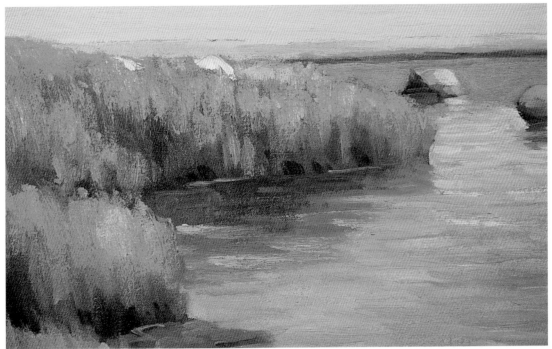

Detail of *Low Tide, Tonset.* Darks here are very thinly applied—just stained really—while lighter areas are thickly painted. Thick brushstrokes of yellow orange represent marsh grass seen from a distance, where the overall impression is one of color, shape, and texture, rather than of individual grasses. In the water, the darker, reflected color was thinly painted first, then lighter blues painted on top. These strokes were gently applied, using very little pressure, so that they wouldn't pick up the tone underneath. Rocks peeking through the grass were painted with a palette knife to ensure bright, clean color, since the paint underneath was thick and wet.

Detail of *Low Tide, Tonset.* There's a lot of broken color here in the water, mud, and foreground rocks. By "broken color," I mean adjacent brushstrokes of different color, which have an overall, rather than individual, effect on the viewer. It seemed the best way to capture a feeling of activity, with very little definition or structure. The water, just a few inches deep in the immediate foreground, shows a good deal of color from beneath the surface. The wet-on-wet paint application makes diffused edges easy, and allows me to show the colors from these two surfaces simultaneously.

Don't confine yourself to one size brushstroke; use the contrast between large and small brushstrokes to give depth to your painting. Large, thick, vertical brushstrokes in the foreground will tend to make that content come toward the viewer. Smaller, horizontal brushstrokes in the background will tend to push objects into the distance.

Do "prepare" an area for heightened brushwork. For example, if you're going to add a highlight, it's usually advisable to paint the surface beneath it first. I sometimes paint an object as a fairly flat area, then give it form and volume with one or two thicker, more fluid brushstrokes—perhaps one to indicate a highlight and another to imply reflected light. Suggest an object or area with quiet and deliberate brushwork, then define it and bring it to life with a more flamboyant brushstroke.

Don't forget to apply paint in layers, in sequence from thin to thick. Take advantage of the fact that layers underneath have an effect on subsequent applications of paint. A brushstroke of cool color on top of a warm tone, for example, will vibrate with light. Brushstrokes can also mix with the hues beneath them, so you can do a certain amount of color combining on the canvas. Optical blending is another alternative. A brushstroke of blue next to one of yellow will read as green from a distance. Become familiar with and take advantage of all of these opportunities to apply and mix paint in many different ways.

Detail of *Autumn Lane* (see in Chapter 2). First, the tree-trunk shapes were blocked in with a warm, dark value. Then, brushstrokes of lighter, cooler color were applied to indicate both local hues and reflected light. Some of these brushstrokes are vertical, others are horizontal, going across the trunk, as shown in this sketch to the right, of the dominant foreground tree and the one just behind it in *Autumn Lane*. A tree trunk—or any form—with all vertical brushwork can be both tedious and unnatural-looking.

# Painting with a Palette Knife

There isn't usually much palette-knife work on my canvases. There are people who paint with palette knives quite masterfully, but I personally am so enamored of brushwork that I'd almost always rather see a brushstroke. But sometimes I do use a knife to put down an area of color that has to be very clean on top of a section that already has opaque paint on it. If I were to use a brush in such an instance, I would most likely pick up color from underneath, whereas a palette knife allows clean color application without disturbing the surface. I'll lay down a broad knife stroke, then carefully diffuse the edges with a brush so that the area doesn't look pasted on or too foreign to the rest of the painting.

Palette-knife application can also create some unique textural effects, but I'd caution that a little goes a long way. Make a statement with a palette knife, then work it so that it isn't overly conspicuous. To use a palette knife broadly, load it with paint and keep its blade flat against your painting surface. Use a single stroke. Then, with a brush, adjust sharp edges that the knife may leave on your paint surface. If you need more precision, carefully accumulate a little paint on the trailing edge of the knife, and apply a stroke with the knife at a slight angle to the canvas (the edge without paint will be angled toward you). In either case, use a single stroke, then clean the knife and assess the situation before you apply another stroke. Sometimes if I find a section getting murky, or if I can't get a light area quite bright enough, I'll use a palette knife to make a bold color patch—sort of a wake-up call—that lets me see and use the hue in a fresh way.

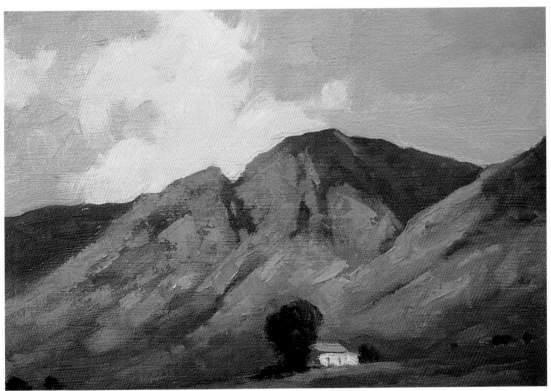

**HOUSE IN THE PYRENEES**
Oil on canvas, 9 × 12"
(22.9 × 30.5 cm).
Private collection.

There is some palette-knife work in the mountain here. I wasn't getting the effect I wanted, so I began laying on some slightly lighter values of color with my knife. It was just what the painting needed. I left one sharp edge on several of the knife strokes, and softened the other edges with a #4 bristle brush to simulate bare rock surfaces.

# Handling Edges

An edge occurs in a painting anytime one form meets another, or where any shape meets a background, and can vary from totally diffused to razor sharp. A sharp edge generally means that the form is turning quickly; for example, the edge formed by the corner of a house is sharp because it's the convergence of two planes at a right angle, and the planes meet and turn very abruptly. A soft edge usually means that the form is turning into the background more gradually. The edge of an apple against a background, for instance, is usually softer, because the apple curves slowly and evenly as it recedes. But there is more to the handling of edges than just observation. The way you treat an edge should be a combination of what you see and deduce about a form, and your desire to produce an artistic, painterly work.

The way different artists handle edges lends a lot of individuality to their work. Two artists might block in a painting of an apple in a similar manner. The first artist might paint the fruit as a group of obvious brushstrokes against a background, relying on the relationship of different abstract shapes to convey its form and position. The second artist, however, might paint the edges of the apple carefully into the background in an attempt to refine it and give it an increased sense of volume and space. Either method can be effective. Surprisingly, viewed from afar, the two paintings could even look quite alike. Textured brushwork, given values and drawing that are very good, can pull together quite nicely from a distance. The difference in the two works is the degree to which the artist has refined the edges in the composition. Like so many other aspects of painting, the handling of edges is a matter of taste and temperament. If you tend to work quickly, with a lot of emotion, you probably won't work your edges as deliberately as someone who proceeds slowly and methodically. The most important thing—however you paint—is to use a variety of edges on your canvas, to give your work a painterly, articulate feeling, and to avoid flatness, a feeling that things are pasted on the surface.

Think about using edges to control the dynamics of your painting. Sharp edges call attention to themselves; they come forward in the picture plane, becoming a focal point. A soft or diffused edge is quieter, will recede from the viewer and be noticed less. And a lost edge will totally elude the viewer. The way you combine hard and soft edges should be an integral part of the design of your painting.

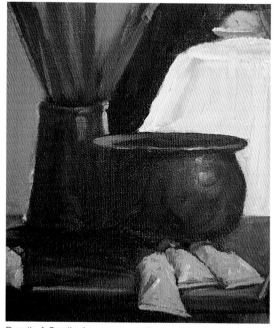

Detail of *Studio Arrangement*. The variety of edges here—from sharp to diffused to lost—allows the eye to travel into the picture. It's difficult to establish any sense of space in a painting if all the edges you use are too uniform. Notice that the distinguishing edge between the copper bowl and the brush jar has been lost entirely. I wanted them to read as a single, dark shape silhouetted against the white cloth in the background, so I eliminated the edge between them. I rely on subtle highlights and careful drawing to ensure that the viewer will have no trouble understanding their forms. Don't feel you have to define everything you see, especially in a shadow.

Detail of *Studio Arrangement*. The pitcher in this detail contains a variety of edges, both to help convey its roundness and to focus attention where I want it. The right edge, in shadow, is very soft, while the left edge is much sharper. Since sharp edges attract attention, the viewer's eye is drawn to the still life's center, where the pitcher meets the bowl of fruit. Notice that there is no delineation at all to the bottom of the pitcher, which disappears into shadow.

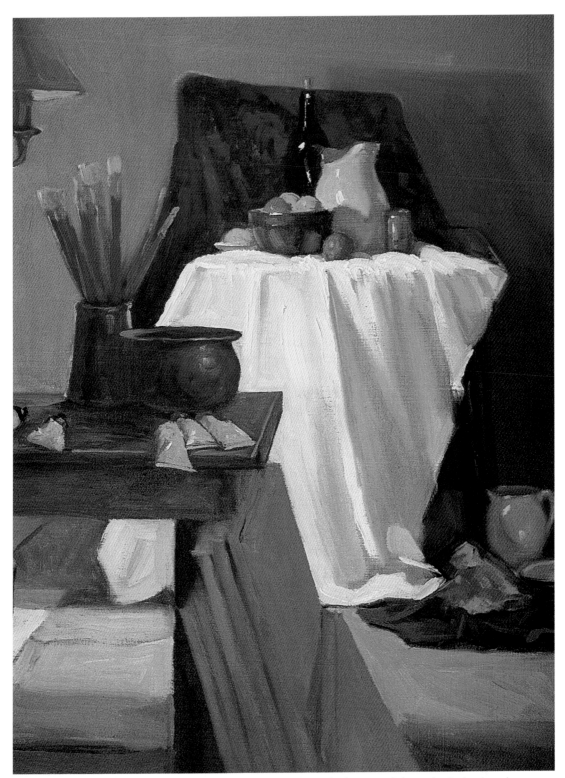

**STUDIO ARRANGEMENT**
Oil on canvas, 22 × 16"
(55.8 × 40.6 cm).
Private collection.

Although there's a lot going on here, the foreground shapes in shadow have been somewhat simplified, and the value range narrowed, so that the eye looks past them to the white cloth and brightly lit still life. Use the contrast in definition and feeling between shadow and light to make your paintings more dynamic, and to help direct the viewer's attention.

In general, a variety of edges is most desirable. An edge that is too sharp for too long will tend to give the form an artificial, flat look. By the same token, too many soft edges may make a painting murky and too uniformly diffused. Find ways to vary edges that go beyond what you see and help illustrate the concept of your painting. Let an edge be sharp for a distance, then soften it, then lose it entirely, and then pick it up again. This will tend to enhance a feeling that the form you're painting has space around it. If an object casts a shadow, try losing the edge between the object and the shadow completely.

There are several ways to soften an edge. Some artists do it with their fingers, and while this sometimes works, you might find that you lift off some paint when you try it, and leave a distracting mark that's foreign to the character of the surface surrounding it. So it's probably better to get used to using a bristle brush to obscure edges. Suppose you want to soften the shadowed edge of an apple against a dark background. Since I work wet-on-wet, let's assume that the paint in both areas is wet. Mix some of the shadow color of the apple and brush it along the edge of the fruit, making sure that the brush edge crosses over this edge into the dark background. Since both colors are wet, the shadow color near the edge mixes with the background color. This introduces a bit of background color into the shadow color of the apple, which softens the edge, and helps it turn into the background. It might be necessary to brush some of the background color back over this edge to get it just right, or to adjust the shape of the apple, which might become enlarged or distorted in the process. You should be prepared to go back and forth, painting the apple into the background, and then the background back into the apple, as many times as necessary to get the effect you want. Sometimes I'll paint the shadow side of an object right into the background, and then distinguish it from the background with one brushstroke of reflected light, leaving the rest of the edge obscure. Remember that there is space around everything, and a variety of edges is necessary to convey this sense of space.

Painting lost edges. I draw the shapes of the two objects individually, even though I'll be blocking them in as a single shape. I want to make sure to get the shapes correct.

For the block-in, I've ignored the separation between the two objects, considering them as a single dark shape. I've also blocked in the cast shadow with the same tone, painting right over the bottom edges of the objects. I let the tone of the canvas show through as an indication of both the rim of the bowl, and the light on the right side of the jar.

I work some color into the light side of the bowl, using a cool highlight to give it some form. The jar has bright light on the right-hand side, and a bit of edge light on the left. I've worked some shadow color from the surface into the cast shadow, being careful to leave the bottom edges of the objects indistinct. If I lift up on the brush toward the end of my brushstroke, the colors appear to blend. The left edge of the bowl gets totally lost, but the form is established well enough so that there is no confusion about it.

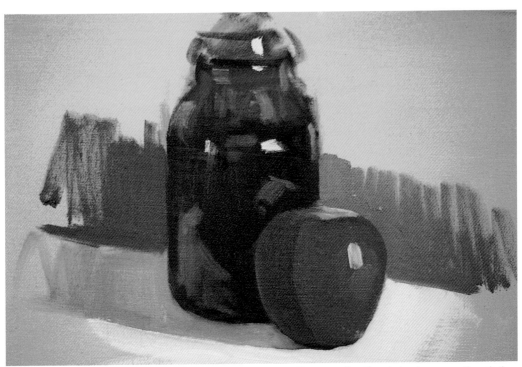

In this sketch, no attempt has been made to soften any edges. They are all uniformly hard, so even though the forms are accurately stated, they look flat. In essence, your eye doesn't really know where to look first.

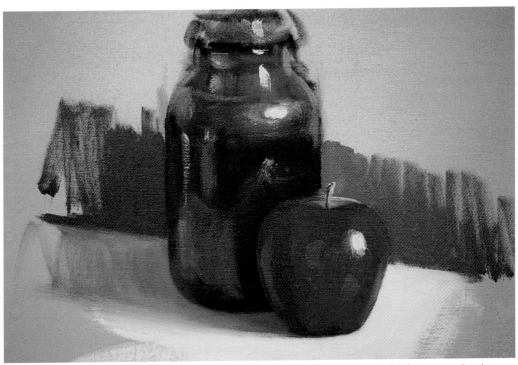

Here, both hard and soft edges have been developed throughout. The apple is rounder, because variety has been given to the edges—the one along the right side goes from soft at the top, to hard below, and then back to soft on the left side. The edge separating the light and shadow side of the apple has been softened, and no longer competes with the highlight. The edges of the jar and shadow cast by the apple on the white cloth have also been softened, drawing the eye within the forms, not to their sharp edges. The objects therefore appear rounder and seem to have more space around them.

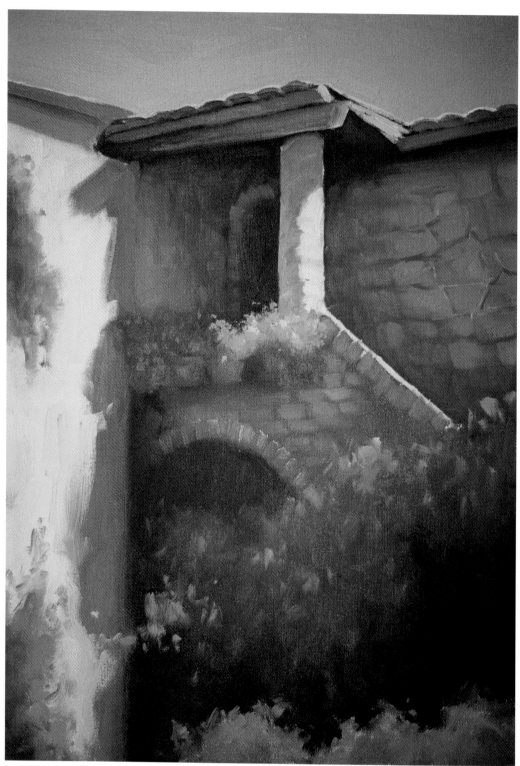

**STAIRWAY, SAN
GIMIGNANO**
Oil on canvas, 22 × 16"
(55.8 × 40.6 cm).
Collection of Ed and
Pegi Roy.

Note the wide variety of edges in this painting. Wherever a strong light meets a dark, the edge is sharp. The right edge of the pillar at the top of the painting is quite sharp, even though the form is rounded (the cast shadow across it and the cooler reflected light within the shadow establish contour). In contrast, the left side of the archway at the bottom of the painting disappears into shadow, and the edges in most of the dark areas are much softer and less defined. Varying edges will add depth to a painting by moving the viewer's eye into the picture plane as well as across it.

# Space and Volume

Paintings in which objects have a feeling of weight and volume, and in which there appears to be depth into the picture plane, have greater appeal than paintings which lack these characteristics. Achieving the illusion of three dimensions on a two-dimensional surface is one of the most exciting challenges for an artist, and can be accomplished by understanding and combining several factors that I have talked about individually. Let's review them briefly.

Pay careful attention to drawing and perspective. Objects drawn carefully and to scale contribute to a sense of depth in a painting. If the elements of a composition relate to one another correctly, a feeling of space is automatically established.

Use edges thoughtfully and advantageously. A combination of hard and soft edges will pull some objects forward, and push others back.

The juxtaposition of contrasting warm and cool colors creates a vibration caused by the tendency of warm tones to come forward and cool ones to recede. This dynamic can create tension, a feeling of push and pull in your paintings.

Use contrast and definition effectively. Don't define everything to the same degree. If you limit definition in the background, you give the foreground a chance to advance. Similarly, allow for a difference in definition between light and shadow areas. Defining one to a lesser degree allows the other to come forward.

Control the viewer's attention. To make an object round, you must make the viewer more aware of the center of the object than its edges. If the viewer notices the edges of an apple first, it will be perceived as being flat.

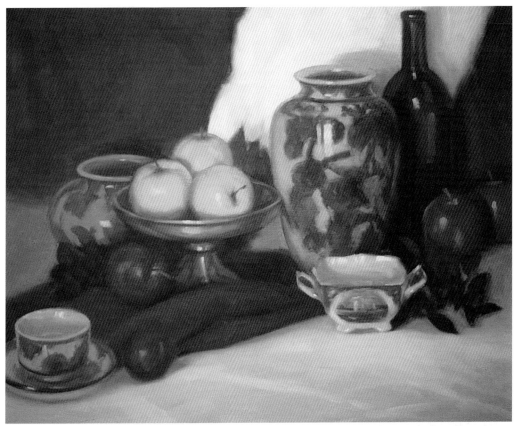

**STILL LIFE WITH YELLOW APPLES**
Oil on canvas, 20 × 24"
(40.6 × 60.9 cm).
Collection of the artist.

One of my goals in this painting was to give the objects volume, a feeling of roundness, and thus establish a sense of space in the picture. I was very careful with the placement of cool highlights, and tried not to let any edges compete with those highlights. Patterns on several of the objects also allow me to draw the viewer's attention to the center of the forms. I put a touch of yellow into the left edge of the tall central vase to make that edge appear to turn toward the yellow apples and away from the highlight. Notice the lost-and-found effect of the edges of this vase, particularly on the right-hand side.

# Keeping Your Paintings Fresh

There is no more disheartening feeling for a painter than to look back over a painting just completed and realize that it's overworked; that a promising start has been lost. Although such a painting can sometimes be "saved," it's obviously better to avoid belaboring it in the first place. Overworking is usually born of uncertainty about how you want your painting to look. Think about the kinds of paintings that appeal to you, and how those artists achieved the qualities you admire. I personally like painterly work, canvases that make creative and judicious use of brushwork. So in my own paintings, I'm careful to allow certain brushstrokes to remain very visible, not refine them, to let them create an illusion of the subject. I think it's better to quit too soon rather than too late. It's very easy to "one-more-thing" a painting to death. I've taken many canvases too far over the years, and still do occasionally. But I know what kind of a look I'm after, and when I think I've got the feeling I want, I quit. Once you've lost that loose, "sketchy" look, it's very difficult to retrieve it.

If you start with a strong concept, you can avoid overworking your painting. For example, if your goal is to achieve a sense of light, then stop once you have attained the *feeling* you want. Don't think that your painting must contain a lot of finished detail. The canvas is *your* interpretation of light, not anyone else's, and needn't be literal unless you want it to be. So before you begin to paint, consider carefully what you have to say about your subject. Dennis Miller Bunker—a brilliant American painter and friend of Sargent, whom the latter identified as the greatest talent of his generation—advised an artist to set up his easel next to his subject, pull up a chair, take out his watch, and then sit and think about how he was going to approach that subject for a good ten minutes before painting.

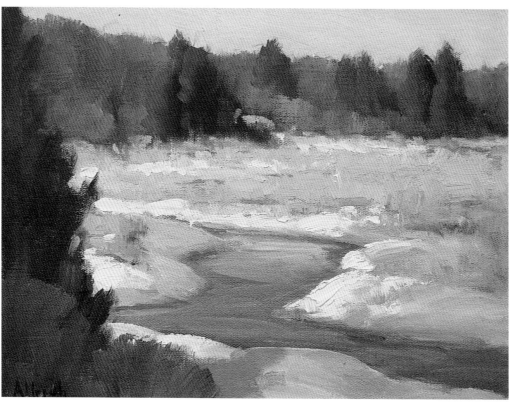

**CERULEAN STREAM**
Oil on canvas, 9 × 12"
(22.9 × 30.5 cm).
Private collection.

I had only a very short time to do this small painting, and there were a few more things I'd planned to add once I got back to my studio. But I was sidetracked for a couple of days, and when I finally went back to it, I decided it didn't really need anything more. In fact, I'd forgotten what had bothered me about it initially. You'll discover that when you put a painting aside before applying final touches—then take a fresh look a few days later—often that "unfinished" look is the best one after all.

# Establishing Good Work Habits

It's surprising to what degree good painting relies on establishing good work habits. Creative expression is difficult enough without making it tougher through carelessness. Good painters remember to do the little things right, so they can concentrate on the big things. Beginning students, on the other hand, often can't be bothered. They want to get on to the heart of it. Fundamental steps are often skipped over while the student looks for more profound truths. In our zeal to get started, we all go through this, but it just makes good painting harder to achieve.

Of course, there are indeed more profound truths to fine art than fundamentals, but to express them in a meaningful and articulate way, you need a thorough grounding in procedure and technique. Imagine trying to write a poem without a vocabulary. The idea is to learn the basics—whether they involve words or color—so well that you don't have to think about them, and can concentrate on what you have to say.

Good work habits are so fundamentally important for a painter that they bear repetition:

- Keep your brushes clean. Make sure that when you put a color on your canvas, it's the color you have intended.
- Clean your palette when you don't have a space to mix clean color.
- If you're not satisfied with your preliminary composition, don't continue in the hope that you can correct it later. Wipe it off, and try to make it better.
- Correct a mistake the moment you see it, before it gets worse, or it will lead to more errors in judgment.
- Back up frequently when you paint, to see your canvas from a normal viewing distance—at least eight to ten feet. Sometimes an effect that works well from a distance is difficult to spot up close.
- When you're putting finishing touches to a painting, it's easy to overwork it, so back away more often. You should spend as much time looking at your canvas as actually painting on it.
- The essence of painting is making comparisons. To judge a particular color, compare it to others on your canvas. How does it relate in terms of hue, value, and saturation?
- Treat each painting as a new experience. If you look for formulas, you'll make the painting experience routine, and your work will show it.
- Be fair with yourself. Don't be afraid to criticize your work when it's called for, but don't hesitate to give yourself a pat on the back when you pull off something good. To become a good painter takes time, and it can be counterproductive to be too easy *or* too hard on yourself.

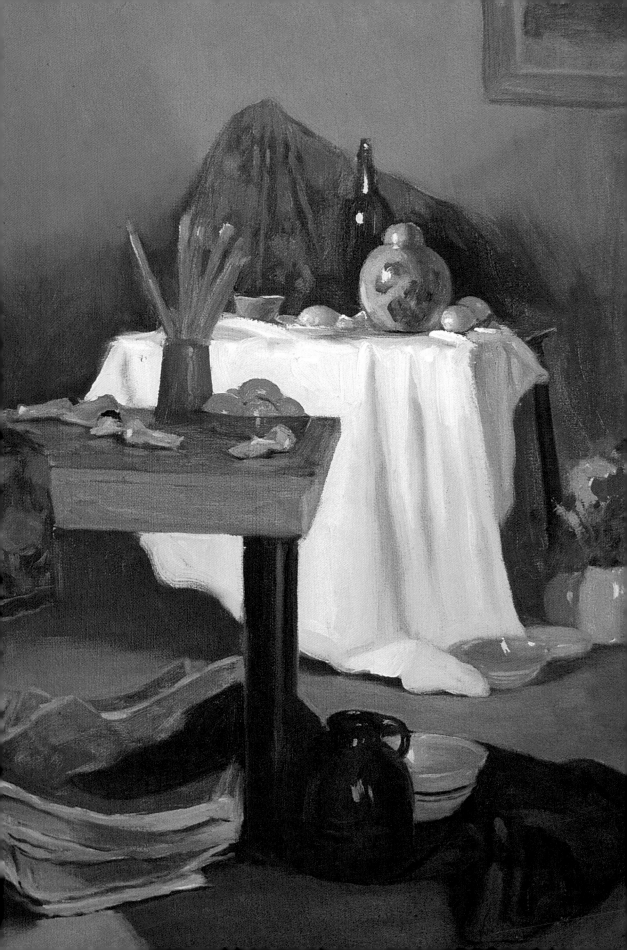

# Still Lifes and Interiors

Painting still lifes and interiors presents wonderful opportunities for learning, because you can exercise so much control over the entire painting process. The subject can be set up and made as simple or complex as you desire, and be endlessly rearranged to suit your concept. You can control the direction, intensity, and temperature of your light source—which can be fairly constant both on your palette and canvas as you work. And you have a virtually unlimited length of time to paint.

I try to take advantage of the many possibilities that still lifes and interiors present by choosing a wide variety of subjects; by painting more traditional arrangements as well as more unposed, casual setups; and by using different lighting sources—natural light, artificial light, backlight, and so on. In addition, I sometimes pose a specific problem for myself in order to focus on something that's causing me trouble. For example, I might ask myself: How can I improve the way light moves across the canvas? How can I show the forms of the objects in my setup to greater advantage? Thinking of painting as problem solving will enable you to learn from and grow with the process, as you exercise more control over your painting.

**STUDIO LIGHT**
Oil on canvas, 24 × 18" (60.9 × 45.7 cm).
Private collection.

This format is very similar to that of *Studio Arrangement* (in Chapter 3). It's one of my favorite motifs; I've painted several different versions of it. Some objects are different here, but my goal is the same: Take a complex subject and make sense of it by organizing it into areas of similar value.

# Setting Up a Still Life

The tradition of still-life painting is well documented, and a number of great artists, from Jean-Baptiste Chardin in the eighteenth century to Henri Fantin-Latour and Paul Cézanne in the nineteenth century, devoted a substantial portion of their energies to this genre. The American painter William Merritt Chase, whose large number of late-nineteenth-century still lifes often included a variety of sea creatures, quipped that he would most likely be remembered as a painter of fish. Although he is remembered for much more—including being the teacher of Georgia O'Keeffe and Joseph Stella among others—these are certainly some of his best works.

A typical pre-twentieth-century still life would most likely feature a cluster of carefully arranged objects, often allegorical or related by a theme, set against a dark background, illuminated by available natural light. Contemporary still-life painting has expanded these parameters in every direction, but particularly in the realm of composition. Today, a still-life painter might scatter objects in a seemingly haphazard manner across the canvas, or choose to paint items that seem totally unrelated to one another. It is the quest for informality, as well as the unconventional, that most often characterizes present-day still-life painting. But despite these changes in attitude—or perhaps because of them—there are still guidelines for composing strong still-life arrangements.

Choose a variety of compatible shapes of different sizes and textures for your still-life setup. If you select items that are too similar in size and shape, they'll compete for the viewer's attention, make your painting static-looking, and interfere with the way an observer's eye travels across your canvas.

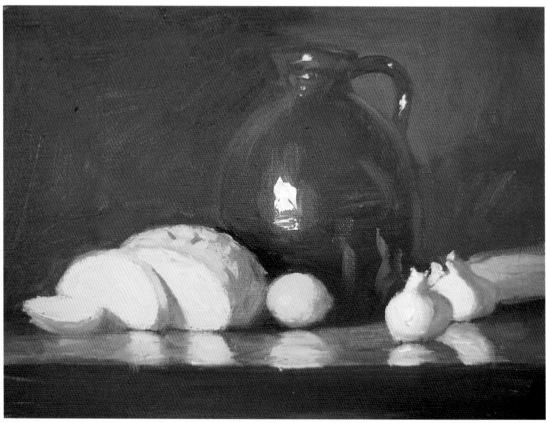

**STILL LIFE WITH BREAD**
Oil on canvas, 9 × 12"
(22.9 × 30.5 cm). Courtesy of
the Blue Heron Gallery.

The objects here range from the dark, reflective jug to the oval-shaped loaf of bread, to the smaller, oval lemon and spherical heads of garlic. These objects all possess a common, earthy quality which provides the painting with its straightforward character.

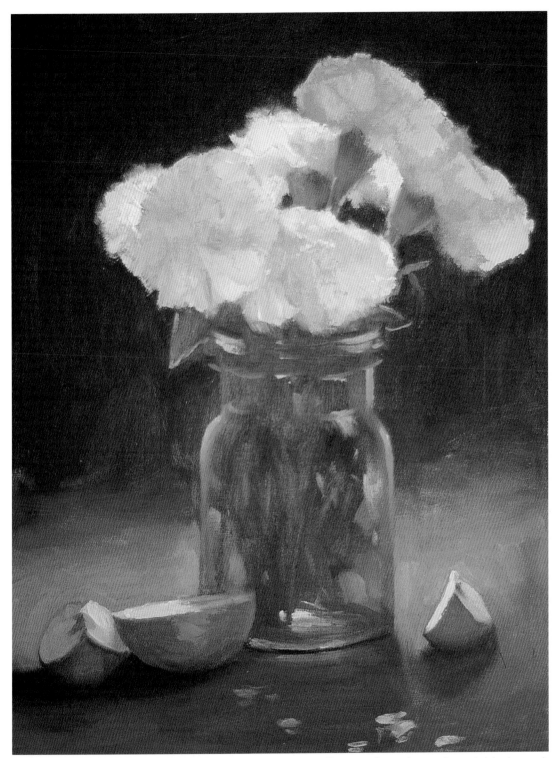

**WHITE CARNATIONS**
Oil on canvas, 16 × 12"
(40.6 × 30.5 cm).
Collection of Douglas
Powers and Doria Harris.

Here, I wanted to emphasize the brilliant silhouette of carnations against a dark background, so I kept the values in them very light. Even the shadows within the white flowers are lighter than anything else in the painting, so that the blossoms read as a single unified area of light value against an area of uninterrupted dark.

Make sure that some of the objects in your composition overlap one another. This helps to unify the painting and lets you take advantage of all possibilities your setup presents, by allowing light to reflect from one object to another and by having objects cast shadows on one another. Arrange the components of your still life in relation to your light source. Don't position everything and then turn on the light to see how it looks. Turn on your light source before you arrange things, placing them to take advantage of reflected light and cast shadows. Use light to direct the viewer's eye. In general, don't have the same amount of illumination on every part of the painting; save the brightest light for areas you want to emphasize—which the viewer will respond to first. I sometimes place something in front of my light source to cast a shadow across a part of a still life that I want to de-emphasize.

Mass areas of similar value together when you compose your painting, to strengthen its design. Try choosing the elements of your setup so that one family of colors predominates, then include that color's complement for emphasis. In *Still Life with Oranges* (opposite), the blue/blue-green color family dominates, while the oranges and red flowers provide vibrant accents. But try not to become too predictable in your arrangements. Nothing destroys the sense of spontaneity and vitality in your work more quickly than a feeling that it's based on a formula.

The objects are too scattered in this composition to allow me to take full advantage of the light. Also, the light itself is a little flat, having been placed too far forward.

In this version of the composition, the objects are arranged more cohesively, and my light source has been moved to create more shadows. The plate of lemons, moved slightly forward, now casts a shadow on the pitcher; notice how the color of the lemons is reflected back into that shadow. The pitcher, in turn, reflects its light into the shadow side of the lemons. The pear now overlaps the pitcher, creating a warm reflection in the shadow side of the pitcher. The blue drinking glass, now closer to the pitcher, reflects color into the pitcher's left edge. The introduction of color into one object from another, through cast shadows and reflected light, adds both interest and credibility to the still life.

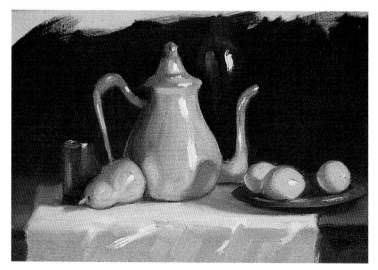

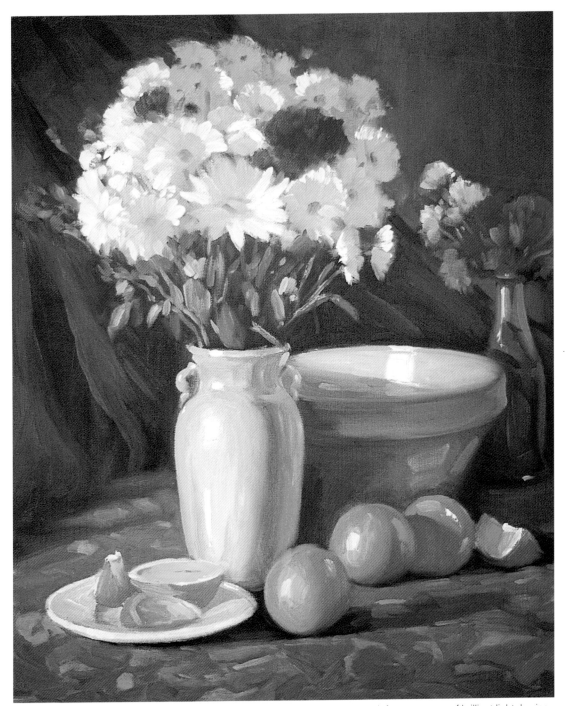

**STILL LIFE WITH ORANGES**
Oil on canvas, 24 × 18"
(60.9 × 45.7 cm).
Private collection.

Having the oranges reflect their light onto the vase reinforces an aura of brilliant light; having the middle orange cast a shadow onto the one next to it further ties them together. The light on the slice of orange to the right, emphasized by the cast shadow on it, is a key element of the composition. Cover it up and your eye doesn't travel as easily over the canvas.

Have one shape or mass dominate your composition, and relate other elements of the setup to it. Remember when you consider your layout that the viewer will read your painting from left to right. If all of the interest is on the left side of the canvas, the viewer will have no reason to look further. I often place the focus of my painting slightly to the right of center, and one or more secondary focal points to the left. Such an area might be nothing more than a spot of light or a flamboyant brushstroke, just something to attract and direct the eye. The viewer's eye will travel across the painting to the center of interest, then back to the area of secondary interest.

Let objects run off the edge of the canvas to emphasize a casual, "real-life" aura. Historically, it was deemed proper for the edges of the canvas to frame the objects in a still life. There is always a balanced margin of space, for example, around the elements of a Chardin still-life arrangement. Since the advent of Impressionism, however, compositions have become more informal, less posed-looking, and it has become increasingly "acceptable" to abandon the self-border layout and let elements of a still life be cropped off the canvas sides.

Finally, before you position your easel, after you've set up a still life, walk around and look at it from other angles. Sometimes it will look better from the side or the back. You may discover an interesting relationship among the shapes or a provocative lighting effect that wasn't apparent from your original vantage point.

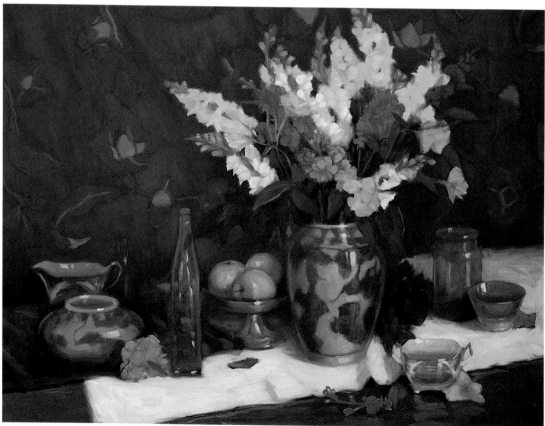

**STILL LIFE WITH SNAPDRAGONS**
Oil on canvas, 30 × 40"
(76.2 × 101.6 cm).
Courtesy of the
Blue Heron Gallery.

The large vase of flowers clearly dominates this composition, while the other objects are carefully arranged around it. The eye travels from the mass of flowers to the fellow blossom resting against the sugar bowl in the foreground (which breaks up the strong diagonal created by the white cloth and other objects), then to the pink flower on the left, up to the apples, and finally, back to the bouquet.

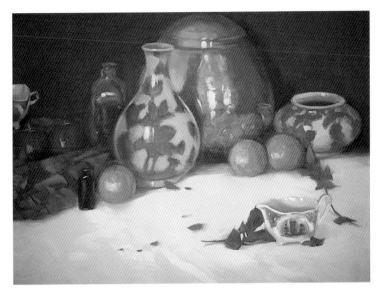

## STILL LIFE WITH BRASS POT

Oil on canvas, 22 × 28"
(55.8 × 71.1 cm). Courtesy of
the Blue Heron Gallery.

The focus here is the bright highlighted area of the brass pot, placed slightly to the right of center. The blue-and-white bowl cut off in the left background serves an important purpose for me: It keeps the composition from being too static. Without it, I don't think the eye can escape from the brilliance of the focal highlight and move across the painting the way it should.

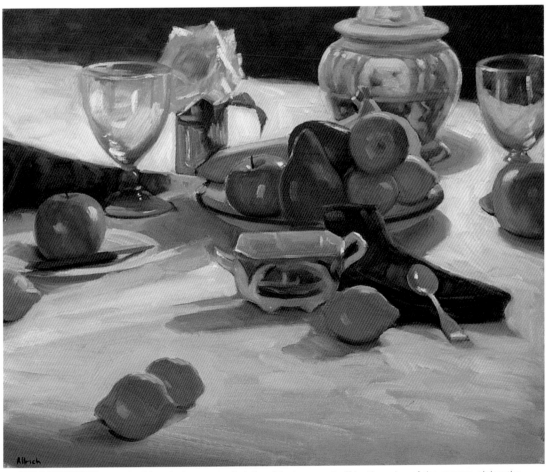

## STILL LIFE WITH BOWL OF FRUIT

Oil on canvas, 20 × 24"
(40.6 × 60.9 cm).
Collection of the artist.

In this painting, several of the objects are cut off by the edge of the canvas, giving the composition a more informal, unposed feeling. Here, my apparently haphazard setup actually took quite a while to arrange. I hope it conveys the casual, "slice-of-life" feeling I intended. While we're quite used to such layouts now, it was considered quite radical when the French Impressionists first introduced this technique. Edgar Degas, in particular, was fond of letting figures and objects disappear off the sides of his canvases.

# Choosing the Most Advantageous Lighting

There are usually several options available when it comes to lighting your subject. For example, if you wish to convey a certain moodiness, you might choose to use a rather dark, natural light. Conversely, bright ambient light or sunlight will connote an airier, warmer feeling. If you want to create a setup with high contrast or strong cast shadows, use a bright, artificial light source. In any case, decide what you want to achieve and how you can use light to define your concept, as well as compose your painting. Think of light as an element of your composition, a tool that you can handle and control.

## ARTIFICIAL LIGHT

Artificial light has the advantage of being convenient and most easily controlled. Relatively simple to use, a spotlight can illuminate your still life, is easy to maneuver, and allows you plenty of options: positioned closer to, or farther away from, your setup, or adjusted from side to side. Spotlight fixtures come on stands, or use the kind that clamps on a shelf, table edge, or stepladder. You can choose bulbs of different wattage and temperature, and even put a colored filter over the bulb. In general, artificial light—ordinarily an incandescent spotlight—is very warm, creates cool shadows, and offers lots of opportunities to model form. In fact, one of the main reasons we light a subject is to heighten contrast between light and shadow, helping us to describe the object's form. The contour of the shadow resulting from a direct light defines the shape of an object, since shadow follows form.

In general, placing your light source directly in front of your setup tends to flatten out your subject, as illustrated by the sketch at left. Direct frontal lighting diminishes both cast shadows and reflected light, making modeling a little more difficult. Putting light to the side, as I did for the sketch at right, produces more dramatic cast shadows and reflected light. You can tell that I moved the light a few feet to the left of my setup by the position of the highlight on the central, whole lemon.

The first sketch shows one lighting possibility—the light source is to the left of the objects. In the second sketch, my light source was moved behind the objects to produce a more dramatic effect. Backlighting results in strong silhouettes of light, which can be very attractive.

It's an element of still-life painting over which you have almost total control, so get in the habit of experimenting with different lighting schemes. One thing you'll want to avoid is putting a spotlight too close to your still life, which will result in a very harsh, artificial-looking light.

Moving your light source can alter the look of a still life dramatically, often giving it the appearance of an entirely different setup. When you're arranging a still life, get in the habit of shifting the light around to determine its most advantageous position. Try to silhouette an object. Try to create interesting cast shadows. Lowering the position of the light in relation to the subject will produce a longer shadow, sometimes adding a bit of drama to the painting. Remember that there are always numerous ways to paint any given setup, and it's both instructive *and* fun to consider several before finalizing your choice.

## NATURAL LIGHT

Natural light has strong historical precedence, since it was the light source of choice for the still-life artist for many centuries—the only alternative to daylight being candlelight. Even today, many artists still use only natural light on their subjects, believing strongly that artificial light is harsh and leads to garish color. Natural light creates a softness, an ambience that is very inviting. It's also much cooler in temperature, usually bluer, as opposed to the yellow of an incandescent light source. Since very strong contrasts between shadow and bright light are harder to find in natural light, versus artificial, the effects of natural light may be a bit more elusive and difficult to capture on canvas. But that shouldn't deter you from trying. Natural light forces you to make very subtle determinations of color and value, and can be very conducive to creating a mood.

**STILL LIFE WITH GREEN APPLES**
Oil on canvas, 22 × 28"
(55.8 × 71.1 cm).
Collection of Del Filardi
and Harriet Rubin.

The light in this painting came from a window to the right. To increase contrast and add drama, I darkened the background considerably. In the same manner, the white cloth sets off the cluster of objects through silhouette and contrast between them. I hoped that this somewhat unusual composition would enliven a familiar subject.

# Painting Light and Shadow

To paint light and shadow, you must understand their elements and establish the proper relationship between them. There are six components to be considered: light, highlight, halftone, shadow, reflected light, and cast shadow. Let's start with perhaps the most elusive.

## HALFTONE

Of these elements, the least well understood is the halftone, the color that acts as a buffer between the light and shadow in any rounded object, be it an egg, tree trunk, or human figure, and which ensures that the form turns smoothly. In many cases, the halftone is where you'll find the strongest color on the object. You can create a halftone by brushing the color of the light into the shadow, softening the edge and creating a value midway between the light and shadow. It's usually more effective, though, to mix a separate color for the halftone, applying it across the edge formed by the light meeting the shadow, and then working that edge as needed.

Step 1. Starting with simple, flat shapes, I then block in the shapes of various shadow areas with transparent washes, ignoring reflected light for the time being.

Step 2. I paint in light areas of the orange and bowl, scrubbing in color quickly and thinly, though I do use a little white as needed. I want to fill in spaces simply and accurately, establishing a base of local color into which I can work further variations of color and value.

Step 3. I work on the light areas, looking more carefully at hues, breaking up space and depicting how form turns from the light. I establish the color *beneath* the highlight first, and then lay the highlight on top of it. In the case of the bowl, the highlight is a single, thick brushstroke. A highlight stated very emphatically enlivens a painting and gives it a sense of warmth. If it becomes too dominant, you can always tone it down.

Step 4. Concentrating on the edge between light and shadow on each object, I select a halftone—a color whose value is about midway between that of the light and that of the shadow—to diffuse it. I want soft edges, since the objects are round, but I also want a clear and distinct delineation between light and shadow. If I diffuse the edge too much, I can restate the shadow against the edge, and try again. Now I paint in reflected light; light bounces off the white cloth and is reflected between the two objects into the shadows of both the orange and the bowl. Notice that the reflected light does not compete in brightness with the direct light.

## LIGHT

"Light" is a very general term. I talk a lot about achieving a *feeling of light,* which simply means showing the viewer a convincing depiction of the particular luminosity present in the situation you're painting. When I consider painting an object, I first define it simply in terms of light and shadow, ignoring for the moment other components (reflected light, highlights, etc.) that might be involved. Judging the color and value of light in relation to shadow is a matter of comparison. I generally paint light areas slightly brighter and warmer in temperature than I see them. I like to state lights very emphatically—really make the viewer feel their warmth. It's also much easier to tone down a light than it is to brighten it, so why not start out boldly? Chances are, it will enliven your painting, and you'll seldom have to tone down lights.

## SHADOW

When you consider the color of a shadow, regard it as you would any other area of color. Every shadow has some color and light in it (although we may not always choose to paint it as such). Compare its color and value with the adjacent light area, as well as with other shadows. Depend on direct observation, rather than rigid rule, as your first recourse when determining the color of any area. But if you have trouble identifying the color of a shadow, try to figure out what the color should logically be, which will usually help you to see it. By *logically* I mean: The shadow side of an object contains both the local color of the object and that color's complement,

which together read as a darker, grayed version of that hue. For example, the shadow side of an orange with a warm light shining on it contains both orange and blue, which, when seen together, usually make a warm, almost greenish gray. Consider the color of the light in conjunction with the color of the object to determine the shadow color. If you can determine what the color *should* be, it will often help you see it.

## CAST SHADOW

Cast shadows can contribute an undeniable sense of drama to a painting. The result of a strong light source directed on an object, thereby throwing its shadow onto something else in the picture, cast shadows help unify paintings by linking objects together, providing an uninterrupted flow of light across the canvas. Being responsive to the type of light you have chosen and the way it behaves is the key to understanding cast shadows and conveying a convincing feeling of light.

When painting a cast shadow, consider both the object casting the shadow and the surface onto which it is being thrown. When I block in a painting, I'll most often paint the cast shadow at the same time I paint the shadow side of the object casting it, usually with little or no differentiation between the two. In fact, I'll often block in both areas with the same color, and then paint first local color and then reflected light into the cast shadow afterward. My first concern is to make a connection between the two objects or surfaces in terms of space and form, and then establish their individual characteristics and particular quality of the light.

In this study, the objects are joined together by shadows they cast on one another. In fact, when blocking in the pears, I didn't distinguish between the shadow side of the farthest-right pear and the shadow it cast on the other pear. The cast shadow links the fruit in terms of space and light. Since a shadow follows the form on which it is cast, it can also be used to help convey form. The slice of fruit on the left disappears into the shadow of the pan. An interplay occurs between the shadow cast by the pan and by the reflection of the pear into that shadow. Note that the reflection stays within the shadow; that is, it does not compete in brightness with the light on the object.

## REFLECTED LIGHT

In strong light, objects have a pronounced effect on one another. Light shining on one object will bounce off it onto another, reflecting its light and color to some degree. The amount of light reflected is determined by the strength of the light source, and by the nature of the objects themselves. Highly reflective objects—a silver pitcher, a copper pot, a stainless-steel pan—often produce nearly mirror images of the objects around them and can be extremely challenging to paint. Other materials reflect to varying degrees; under the right conditions, almost any material will reflect a certain amount of light.

Reflected light is usually most noticeable in shadows. I'll usually paint a shadow as a flat area of color first, one which is not receiving any light. This helps to establish a correct relationship between the shadow and the direct light on the object, without the added distraction of reflected light. To judge the value and color of reflected light, squint your eyes, so you can see it more accurately, then compare it

with direct light on the object. Chances are, it's not as bright as it seems; as a rule, it's never as bright as direct light. Think of it as a component of the shadow. If your paint is too bright, it will make the shadow, and therefore the feeling of light, less effective. I like to work wet-into-wet, painting the color of reflected light onto the wet paint of the shadow, because it's easier to control the edges it creates and keep them softer. Often, when you apply color for reflected light, it will be muted as it picks up your shadow color, so you sometimes need to apply fresh paint to achieve the right amount of brightness. I usually mix a color for reflected light slightly brighter than what I see, so when it picks up a little of the shadow color as I apply it, it will be toned down to the right hue. Mostly, it's a matter of trial and error. If things get too muddy, you're often better off scraping the area down, restating the shadow, and starting over. It's important to make sure that the shadow color and reflected light remain separate—unmixed—and distinct if they are to read correctly.

**STILL LIFE WITH ANTIQUE TEACUP**
Oil on canvas, 12 × 16"
(30.5 × 40.6 cm).
Private collection.

The teacup in this still life is reflected into the surface of the dark jug. The strength of the reflection tells us that the jug has a highly reflective surface. Both the lemon and white cloth are also reflected into the jug, but on the left-hand side. Note that neither the reflection of the lemon nor that of the bowl is as bright or well defined as the object itself. Even the white cloth reflects into the shadow of the lemon.

You can use reflected light to say a lot about objects in your still life, about the texture of their surfaces. Texture, as well as the type of material an object is made of, can be conveyed by the careful observation of the amount of light a surface reflects. Also use reflected light to link objects together. Bouncing color between two objects unifies them with light, creating a harmony between them. The same light seems to illuminate both objects, which conveys a believable aura of luminosity.

## HIGHLIGHT

A highlight occurs anytime a bright light, artificial or natural, shines directly on an object with a rounded, faceted, or sufficiently reflective surface. The brightness of a highlight depends on the strength of the light and nature of the surface it's shining on. Directing bright light on a highly reflective object, like a glass bottle, silver pitcher, or a grape, will produce a brilliant, whitish highlight. Less reflective objects produce duller highlights, while very porous, nonreflective surfaces such as cloth produce none.

Understanding and painting highlights accurately can add spark to your work. Here are some ideas to consider when painting highlights.

A highlight occurs on a surface at that point or line closest to the light, and describes the turning of the form toward the light. In the case of a wine bottle, for example, there can be several distinct highlights that follow a line along the contour of the bottle. Along any flat stretch of surface, the highlight appears as a line; where the form curves around and toward the light, it will appear as a small circle or ellipse (or rectangle in the case of window light). Since highlights follow the form of an object, by describing a highlight's shape carefully, you also

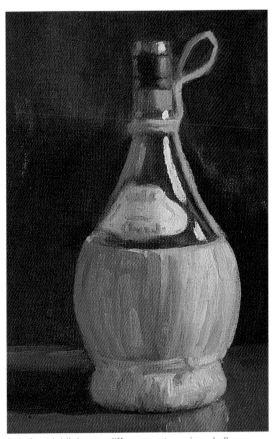

Painting highlights on different textures is a challenge— a very satisfying one when it comes out right. This Chianti bottle—an old art school standby—offers several different surface textures, and the nature of the highlights on these materials helps define them for the viewer. The dark-green reflective glass has the brightest highlight, a long, thick stroke of titanium white with a touch of cadmium orange, which follows the contour of the bottle. The basket has a bright highlight, too, but it's very close in value to the color beneath it. Straw is not as reflective as glass, but its brittleness and faceted surface produce a bright highlight. The pink label and purple seal at the top of the bottle are duller, their surfaces being more porous, and they don't produce highlights.

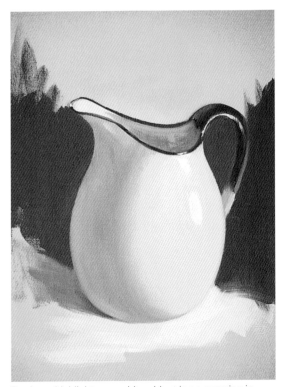

Putting a highlight on a white object is an exercise in nuance; painting a white object provides a good lesson in the study of subtle value relationships. In this case, I had to make sure that the light side of the pitcher was dark enough to show off the highlight. I put down a brushstroke for the highlight—titanium white with a touch of cadmium yellow light—sooner than I normally would, so that I could compare its value with those of the light and shadow sides.

help convey the shape of the object it's on. The shape of the highlight is also dependent on its light source. Notice that if a window provides daylight for your still life, you will have rectangular-shaped highlights.

Before you paint a highlight, paint the surface it sits on. It's a common mistake to paint the surface lighter than it actually is; it's the highlight that's confusing, making the surface seem lighter—which in turn makes it difficult to get the highlight as bright as it should be. Try to look beneath the highlight to determine the surface value and color.

The color of a highlight then depends on the color of the object it sits on, and the color of the light. A dull highlight contains a lot of the object's local color. A very bright highlight is close in hue to the color of the light source. A highlight from a window is usually a cool blue.

Highlights should never be pure white; always add a hint of color even to the brightest point of light. Sometimes I'll add a bit of the complement of the object's color to its highlight; for example, a hint of green to the highlight on a red apple really makes it glow.

Vary the brightness of highlights on different objects in a still life. Among similar objects, that closest to the light source will have the brightest highlight. Use highlights to describe the way the light behaves. If you see highlights from sources other than your direct light source—overhead lights, for example—don't paint them. They can create confusion for the viewer and disrupt the sense of unity in your painting. Choose a primary light source, and determine the highlight from that light. I will, however, often use a cool highlight in a shadow area, often from a window, to enliven that shadow.

A highlight should look like it dropped on the surface of an object; it should never look labored or fussy. *Try to make it a single brushstroke.* If you're having trouble getting it right, scrape it off, repaint the surface underneath, and try again.

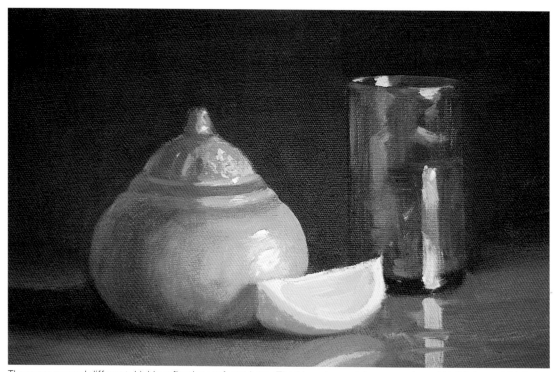

There are several different, highly reflective surfaces here. The blue glass catches a number of highlights, which help to describe its dimpled surface. The surface of the green jar is somewhat irregular, but very reflective. Its contour produces a round highlight, in contrast to the long, rectangular highlight on the blue glass. The metallic top to this jar has a dimensional pattern which comes across because of the numerous highlights on it. The lemon has direct-glare lighting on it, the result of its wet surface. Painting evocatively is a matter of careful observation and understanding.

# Demonstration: Floral Still Life

Flowers provide us with an infinite variety of color, form, and compositional range. The challenge lies in conveying the specific character of each type of flower, portraying that delicacy and fluidity so inherent to all flowers. Above all else, flowers should never look mundane, commonplace. In this example, the spider mums have a wildness and brilliance which I find very appealing. So first, I decide to keep my brushwork free and relatively loose to capture this feeling; and second, I place the flowers against a dark background to enhance their luminosity. My light source is an incandescent spotlight to the left of the setup. I want to introduce some strong, interesting light patterns into the shapes of the flowers, and take advantage of some cast shadows on a white cloth under the vase.

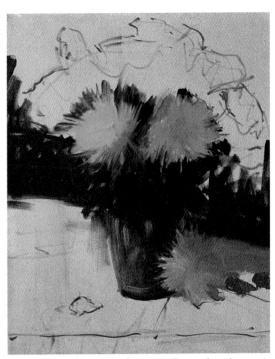

Step 2. The shape of the flower resting against the vase is blocked in, and I begin to mass in shapes of the other blossoms, using some local color. I keep the paint thin, choosing a value about one step darker than what I see at this stage, so that I can work paler values and reflected light into this section later. I also keep the edges of these shapes somewhat obscure.

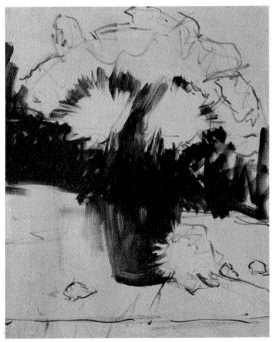

Step 1. With a brush, I draw in only the major shapes of this floral composition—no details. I just want to make sure that the overall elements are the right size, in the right place, and that I'm dividing up the space in an interesting manner, positioning both the vase and some of the flower masses correctly. Then I begin to lay in the dark shape of the vase and some of the background, using a wash of black with some cadmium red light, leaving the tone of the canvas to suggest the positions of the flowers. These blossoms are really brilliant, so I'm careful not to contaminate the spaces they will occupy with any dark paint.

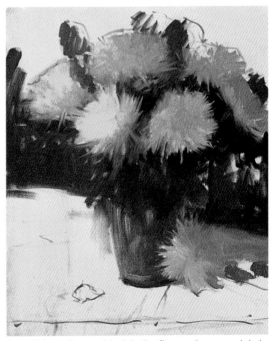

Step 3. I continue to block in the flower shapes and dark background. The application of paint here is still very thin, even in the lighter areas. At this point, one of my chief concerns is that I begin to convey a feeling of space.

**Step 4.** I finish massing in the background, suggesting a little definition in the flowers as I go. Then I begin to paint in the white cloth, using titanium white with touches of cadmium yellow light, cadmium orange, and cadmium red light. The whiteness of the cloth will set off the relatively dark vase.

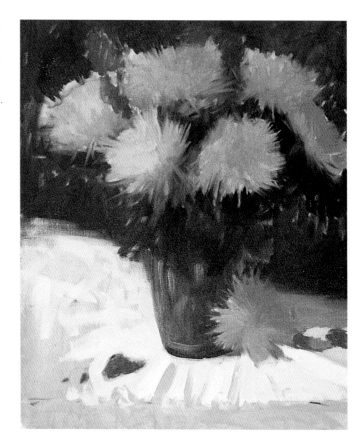

**Step 5.** I begin to introduce some lights into the flower masses with thicker, opaque paint. Since I've left the floral shapes rather vague, I now begin to indicate their forms more precisely by dragging brushstrokes into the background to suggest individual flower petals. To make this work, the dark into which I'm painting must be very thin, and I must use a substantial amount of paint to express the emerging mums richly. I also begin to define some of the leaves beneath the central floral mass. Since the light comes decidedly from the left, the leaves to the left are lighter and warmer than those to the right, and are nicely silhouetted against the dark background. I'm selective in defining both flowers and foliage, using areas with little definition to show off the detail I choose to include.

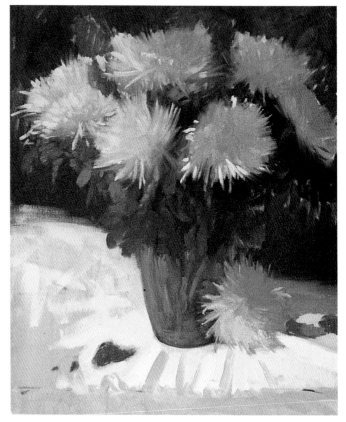

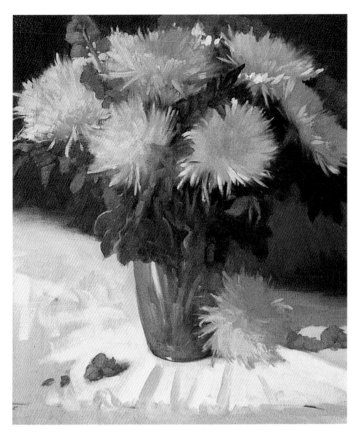

**Step 6.** Working some color into the vase, since it is translucent, I first paint what I see *through* the vase, keeping things rather vague, just suggesting stems and a few leaves as seen through the glass. Finally, a bright highlight helps to define both the surface of the vase and its contour, since the highlight follows the form. I also further refine the background. Note the use of counterpoint: On the left, light leaves contrast with dark background, while on the right, dark leaves contrast with paler background.

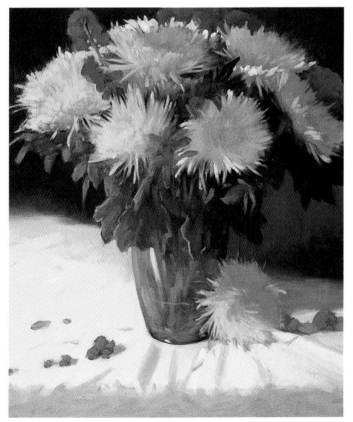

**SPIDER MUMS**
Oil on canvas, 24 × 20" (60.9 × 40.6 cm).
Courtesy of the Blue Heron Gallery.

I finish painting in the white cloth, keeping the back edge obscure against the background so that it appears to lie flat on the table; maintaining this strong diagonal adds energy to the picture. I make some final adjustments to the flowers and foliage. Notice that the lightest leaves never compete with the brilliance of the flowers, and that the leaves beneath the flowers form an uninterrupted mass. All of the blossoms, with the exception of the one white mum, are connected, adding unity and flow to the composition. The idea is to develop the painting as a whole without diminishing the strength of its major shapes. Whatever detail I choose to include should not detract from those shapes. Thus the vase reads as a mass of one particular shape and value, the foliage as another, the white cloth as another, and so on. Think of developing your painting as a collection of shapes, related to one another by value and color, within an overall design.

# Demonstration: Still Life with Ginger Jar

My objective in this painting is to create a feeling of light flowing across the canvas. I want the viewer's eye to travel over the painting to the single pear on the right, then back to the central grouping of fruit and ginger jar, and finally, to the highlight on the wine bottle. The overall triangular shape of the composition helps to guide the viewer's eye. I also want to convey a sense of the solidity of the fruit and ginger jar, and to distinguish surfaces of the different objects as reflective, transparent, opaque, and so on.

As you would approach any painting, base your still life on a strong concept and remember to paint your *idea* of the subject. If your canvas gets out of control, it's probably because your concept wasn't fully formed, or you changed your mind as the painting progressed. Remember, a good painting is the spirited rendering of a good idea.

**Step 1.** I draw in the subject, emphasizing the triangular shape of the composition. I want to establish flowing movement right away, from the wine bottle on the left to the single pear on the right. I begin to indicate some darks to show form and to solidify the drawing.

**Step 2.** After massing darks in the background while leaving a space for the white cloth that will be behind the fruit, I deliberately cover up my drawing of the wine bottle on the left. Since the bottle is transparent dark-green glass, I'll paint what's behind it first. With a paper towel, I wipe away a spot to indicate the position of a highlight on the bottle to remind myself that it's there.

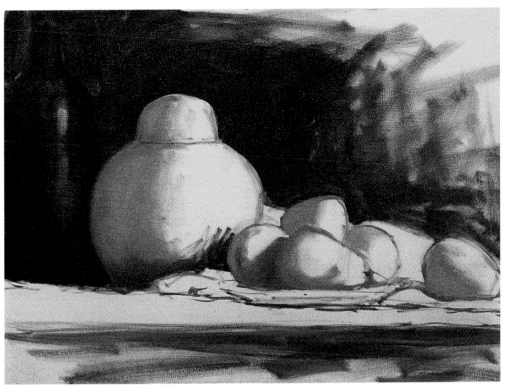

**Step 3.** I block in the shadow sides of all the objects. Notice that the shadow of the pear and the shadow it casts on the apple are painted at the same time, with little differentiation between them.

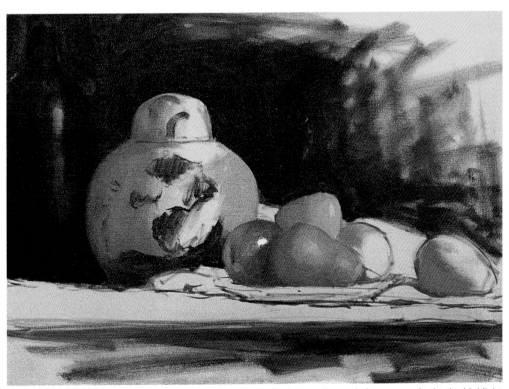

**Step 4.** The central group of fruit is developed. The cast shadow on the apple is very emphatic; the highlight next to it is the brightest light in the painting. I use it to judge the highlights on the other pieces of fruit, as well as the brightness of the white cloth. Next, I begin to indicate the pattern on the ginger jar.

**Step 5.** The plate beneath the fruit is established, as is the white cloth extending to its left, in shadow, toward the wine bottle. The bit of cloth beneath the ginger jar ties together with the plate to form a single shape. The table surface is painted in with local color: I want to be able to control the reflection edges by working them into wet paint, so that they don't get too bright or look pasted on. I continue to build pattern on the ginger jar, establishing a subtle differentiation between its light and shadow sides.

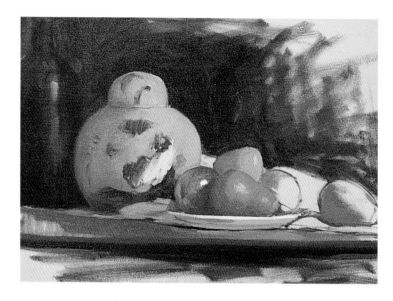

**Step 6.** I complete the central group of fruit and the single pear. The brightness of the white cloth, alternating with the dark background, silhouettes the fruit. I thought this would create a more dynamic feeling than a uniformly dark background, particularly since this is a relatively dark painting. I continue working on the pattern of the ginger jar.

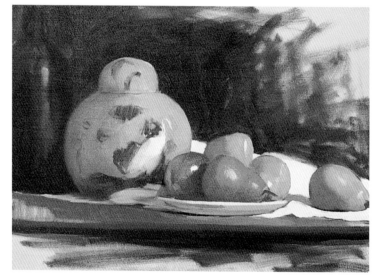

**Step 7.** The ginger jar is proving to be a real challenge; maintaining its roundness while developing its surface pattern is quite difficult. It's definitely a question of going back and forth, establishing the motif, then making it more obscure, looking for just the right balance. I show less definition in the pattern toward the edges of the jar, and make it more emphatic near the center. The position of the highlight helps to bring the center forward and push the edges back. And the bright, greenish reflected light on the upper left side helps turn that edge toward the dark-green wine bottle, further accentuating the roundness of the jar.

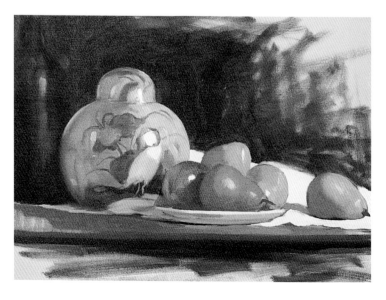

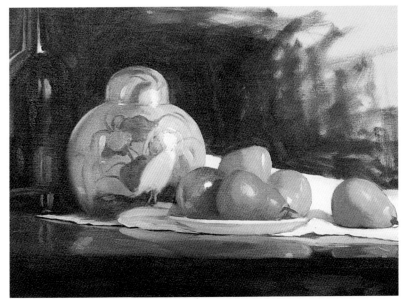

**Step 8.** The wine bottle is strengthened by the addition of a warm highlight at the base of its neck and cool highlights to help define its surface. Color from the ginger jar is also reflected into the bottle, which stays very dark (it's mostly in the shadow of the ginger jar) and transparent. Next, I paint reflections of the objects into the color of the table. The addition of some color from the fruit and plate onto the table will both link these areas together and enliven the painting. I keep the reflections subtle by painting them into the wet surface and losing their edges; I don't want these reflections to compete with the objects, but to enhance them.

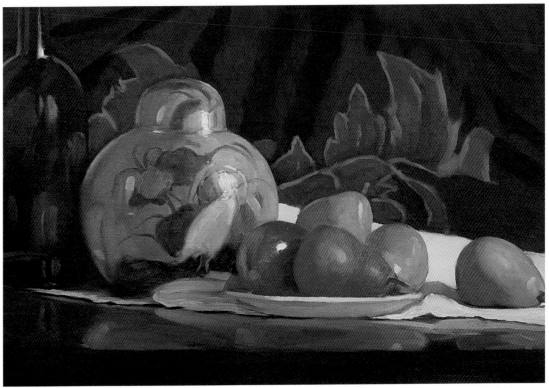

**STILL LIFE WITH GINGER JAR**
Oil on canvas, 16 × 22"
(40.6 × 55.8 cm). Collection of
Mr. and Mrs. Arthur Goldstein.

The background is completed with the introduction of a pattern on the dark-blue cloth. The colors here echo those in the objects, though they are darker. The textile pattern also creates a diagonal that runs counter to the triangular shape of the still life; cover the pattern, and the still life seems to head downhill. I add a hint of the pattern behind the wine bottle to accentuate its transparency.

# Painting Interiors

Painting interiors presents a somewhat different set of problems. Your subject, which may include an entire room or rooms, can be quite complex and may require accurate judgment of perspective. Good interior subject matter itself can be difficult to recognize. We tend to ignore subjects that are somewhat unorthodox, thinking that they don't possess qualities that "ought to" make up a painting. Such situations, however, often prove to be the most interesting and provocative. The key to recognizing good settings lies in thinking abstractly, in terms of shapes and patterns of lights and darks. The more we paint, the more we look around us, the easier it becomes to see potential subjects in unlikely places. This sense of discovery is one of the primary pleasures of painting interiors.

## ACHIEVING A MOOD THROUGH LIGHTING

Achieving a mood is primarily a matter of orchestrating light. But it's far more complex to light an interior composition versus a still life, because you're usually portraying a larger area, and casting consistent, believable light over extended space can be difficult. In many cases, working only with the available light in a room can be very appealing. Sometimes, it's a matter of just opening or closing a curtain to attain the amount of light you need to establish a desired mood. A lamp can provide a different, more dramatic type of illumination. Think about the feeling you want to evoke in your painting, then create the lighting to help you achieve it.

Although mood can be conveyed in a high key, I tend to gravitate toward darker paintings. Ideally, I like to take a semidark room and inject just the right amount and quality of light into it, perhaps by raising a shade or turning on a lamp. Sometimes I'll throw a sheet over a window to darken the room still more. In terms of the painting itself, nothing conveys mood like a dark area with little or no definition. There's a sense of mystery to a dark or dimly lit room that can be very compelling.

STUDIO CLUTTER
Oil on canvas, 24 × 18"
(60.9 × 45.7 cm). Collection of
Del Filardi and Harriet Rubin.

I had started painting a still life, but I couldn't stop looking at the collection of things that had been discarded from my setup. This haphazard arrangement just seemed so interesting and magnetic that I began painting it instead. The blue bowl on the white cloth makes a strong, natural focal point. I rearranged the dark cloths on the floor, and set up a small still life on the cabinet behind the chair. I was careful to keep the rest of the floor and the light wall in the upper left corner uncluttered so the composition wouldn't be too confusing.

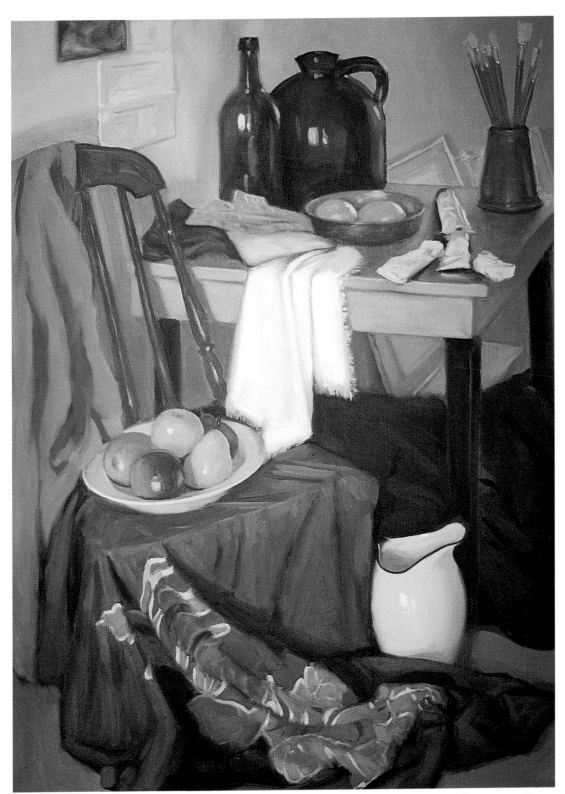

**STUDIO INTERIOR**
Oil on canvas, 40 × 30"
(101.6 × 76.2 cm).
Collection of David Friend
and Margaret Shepherd.

For this larger painting, I wanted to use the ambient lighting in the studio, in conjunction with an incandescent bulb just bright enough to illuminate some of the items on the table, but not the entire setup. I placed the light high up and far to the side to achieve this effect. I also tried to make the composition seem unposed, as though it might be a setting you'd happen upon entering a typical artist's studio.

**IN A HURRY**
Oil on canvas, 24 × 20"
(60.9 × 40.6 cm).
Collection of Karri
Somerville.

Working with available light for this painting, I felt that daylight from the windows behind me provided just the right glow. The objects on the dresser reflect cool window light, and there's enough light on the dresser to give it some form. I opened a drawer and draped some pale-colored clothes over the edge to break up the angularity of the dresser. The pink robe on the floor helps balance the composition. The natural light here has a softness that seems to envelop things and create space around them. The brightness of the clothes, flowers, and light from the next room give the painting some punch.

### INTERIOR WITH SUNFLOWERS
Oil on canvas, 22 × 28"
(55.8 × 71.1 cm). Courtesy of
the Blue Heron Gallery.

Here, a lamp provides backlighting, illuminating just the edges of the white vase. The dark mass of sunflowers in the center of the painting is silhouetted and defined by the light areas behind it. Although there is a lot going on here, the strong darks both unify the painting and help establish its mood.

### MY LIVING ROOM
Oil on canvas, 24 × 18"
(60.9 × 45.7 cm).
Collection of the artist.

I did this painting on a dark day, so the effect of the lamplight is quite intense. I like the way it illuminates the green cloth and pillow edges. The door to the bedroom is slightly ajar, showing a sliver of very cool light from within. Compare this painting with *Bedroom Light*, which is virtually the same subject with a different lighting scheme. Doing a series of paintings of similar subjects, in which you change only one or two variables, can produce interesting results and be a valuable learning experience.

# Demonstration: Painting More Complex Subject Matter

Whether for a still life or an interior, one of my favorite approaches is to incorporate a lot of information in a setting, and organize it so that it doesn't seem so complicated. To accomplish this, I carefully arrange lights and darks, and mass areas of similar value together to unify the composition. Without such cohesion, the painting will be confusing and difficult to read.

This demonstration actually combines still-life and interior painting—another of my favorite motifs. In fact, there are really four separate still-life arrangements within this interior. My approach to this difficult subject will be to think of the painting in terms of foreground (the bottom third of the canvas), middle ground (the center), and background (the top). Each area will have a separate and distinct value range. I want to convey a sense of distance between the foreground and middle ground, as well as a feeling that the central still life and white cloth are brilliantly illuminated, while the foreground is dimly lit.

What I've tried to accomplish here is to organize the painting into areas of similar value, then develop those sections enough to be interesting and convincing, without becoming confusing. Even though I might have seen lighter values and brighter colors in the foreground, my scheme wouldn't have worked if I painted them that way. I've defined things pretty precisely there, but kept the value and color range very narrow. When I squint my eyes, I want the foreground to reduce to a single, abstract shape. I'm hopeful that the viewer's eye will go right to the still life on the white cloth, and then be pulled to the foreground by the interest I've created there.

Many of the interiors I paint make use of both available natural light and an artificial light source. Natural light, which tends to be subtle and relatively cool, creates a wonderful ambience. For added emphasis, I often illuminate a portion of the interior, or a separate room, with a warm light from an incandescent source. The introduction of a little warm light into a half-lit room can heighten the viewer's interest.

**Step 1.** The subject is drawn in with a small brush. There is so much going on here, I must make sure everything is strategically placed. I'm looking straight across at the central still life, slightly down at the arrangement on the table in the foreground, and down even more at the objects on the floor: This makes for some very challenging perspective work.

**Step 2.** I begin with some thinly applied darks, using them to refine the initial drawing and to begin showing space and form. Massing in some of the shapes in the foreground, I include objects on the table to be silhouetted against the white cloth. I'm careful to keep that area, which will be very bright, free of any dark paint.

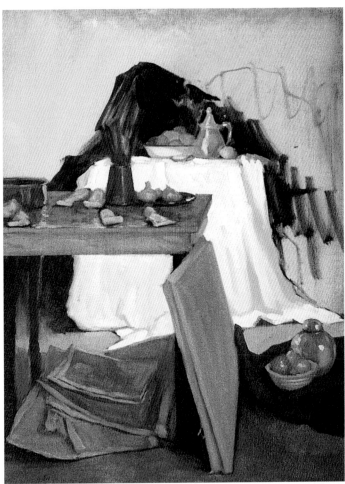

Step 3. As I continue massing in the foreground, I'm careful to keep everything there very closely related in color and value. I opt for values a step darker than those I see so that I can later work some lighter tones into them and define details a little more. For now, though, I want to make sure that the foreground reads as a unified, relatively dark area.

Step 4. I start to paint the cloth with titanium white, plus a touch of cadmium yellow light, aiming to make it as bright as I can. The contrast between the foreground and the still life on the white cloth is the focal point of the painting. I block in the objects on the cloth. They will be very brightly lit, making the cloth and still life seem equally luminous.

Step 5. I finish painting in the white cloth. Any darks in this area are still very light, so that they read as a single, light space. I paint in the lit area of floor beneath the cloth, which forms a silhouette against the dark items on the floor in the foreground, adding some definition there as I go, wanting it to be interesting, I'm also careful not to develop it too much. Some subtle, cool reflections from the window behind me then help to give the brush jar on the table and the two small bowls on the floor some form.

**Step 6.** I work some color into the drapery behind the still life to suggest a pattern. I also paint in the large dark area in the right background, which helps further to focus attention on the white cloth. Into this dark section I paint a few more discarded props, making sure that they stay within the shadow. I finish the still life on the white cloth, bringing out the shape of the dark bottle and adding some bright highlights.

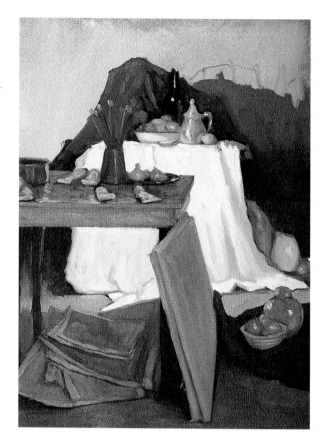

**Step 7.** Nearing my final step, I gray the background and add color accents here and there, being careful to keep the background more dimly lit than the middle ground, whose central still life holds our attention with its brilliant focus of light. Even with a lot of detailing added to smaller objects, if I squint my eyes again, the arrangement still reduces to clear areas of large abstract shapes, because I've kept separate value ranges for the foreground, middle ground, and background.

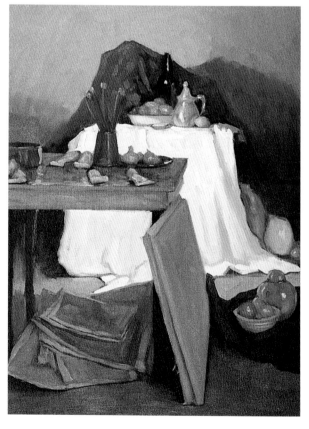

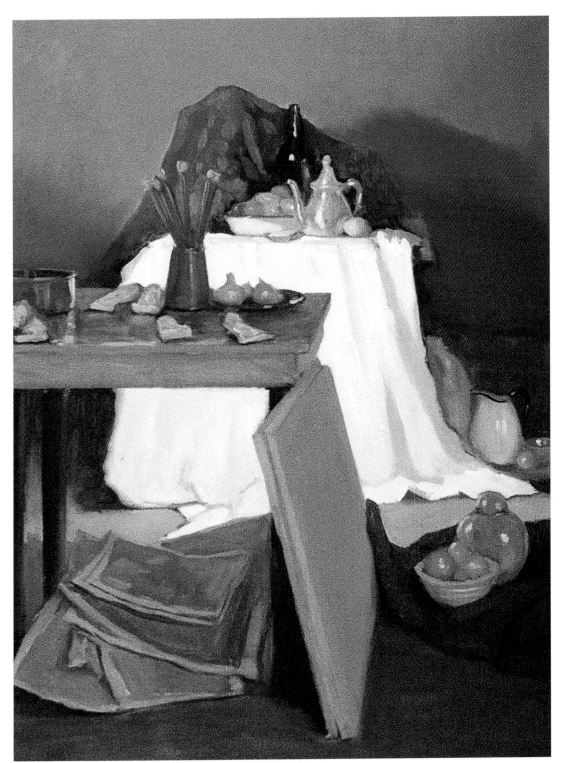

**IN THE STUDIO**
Oil on canvas, 24 × 18"
(60.9 × 45.7 cm). Courtesy
of the Blue Heron Gallery.

A warm tone commands the background wall. I want it to read as light—but also dark enough to show off the center of interest. I add more paint to some foreground areas that seem too dull and gray: a deep blue green to the rug, some violet to the stretched canvas leaning against the table, and some slightly brighter color to the discarded canvases under the table.

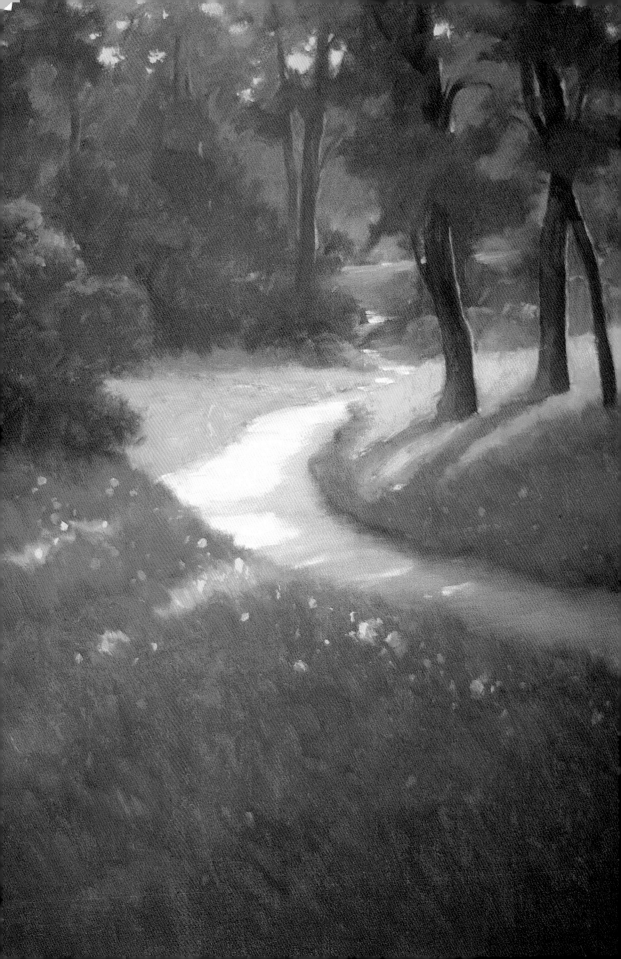

# Landscapes

Painting landscapes outdoors is one of the most exhilarating challenges an artist can experience. No other painting circumstance demands such an immediate, spontaneous response by the artist, or such total concentration, as *plein air* painting. Your subject and light can change so quickly, presenting instantaneous decisions and distractions to contend with, that you must become totally immersed in your painting to be successful.

Changing outdoor light is so critical that when John Singer Sargent was working on an outdoor floral canvas, he waited until the precise moment each afternoon when the light was just right, then painted feverishly for fifteen minutes or so. At that point, finding that the light had changed too much to continue, he would quit until the next opportunity. Similarly, Claude Monet would work on one painting outdoors for a short time, then proceed to another canvas that would document a different lighting effect. This sensitivity to changing light and the determination to portray it authentically has been the *raison d'être* for many artists, and remains a major challenge for all painters.

**IN THE WOODS**
Oil on canvas, 28 × 22" (71.1 × 55.8 cm).
Collection of Douglas Powers and Doria Harris.

Light falling across the field and onto the path in the woods made a compelling focus for this painting. I simplified the surrounding areas to intensify the light there for its dramatic effect. There was more foreground and background light, but I subdued it to hold attention on that strong middle-ground light. If you squint you'll see the triangular shape the light makes and how it relates it to other shapes in the foreground and background.

# Painting Outdoors

Are all landscape paintings created on location? Authentic landscapes can be painted in a studio, but every first-rate artist I know makes outdoor work at least part of his or her regimen—because the most convincing and compelling portrayal of light is achieved only through direct observation and experience gained by painting outdoors.

Many artists begin a painting outdoors and finish it in the studio. Others work from sketches done on location, sometimes in conjunction with photographs. I prefer to paint on location as much as possible, ideally, finishing the canvas on the spot. For me, each painting is a unique experience, a record of my reaction to the subject at a particular time and, as such, almost impossible to duplicate under other circumstances or at another time. I find that not only do my mood and feelings toward

a subject vary somewhat from day to day, but also that no two days are ever exactly alike in terms of light and atmosphere. Consequently, I'm driven to complete most paintings in a single session. If you opt for that routine, you must have a strong concept for your painting and good visual memory of the effect you are trying to capture, since it will most likely be radically changed by the time you finish. Selective memory is something you'll develop as you continue to paint—retaining those aspects of your subject that determine its visual makeup. Exactly what makes your subject look the way it does; which particulars do you need to remember, from all the information confronting you, to produce a singular painting? Making these determinations will enable you to paint a changing subject effectively, as you adopt a kind of shorthand

**WINTER POOL**
Oil on canvas, 16 × 22"
(40.6 × 55.8 cm).
Collection of the artist.

This painting was done on a mild winter day when the snow was beginning to melt, exposing just enough grass underneath to provide a nice complement to the blue snow shadows. Although I went back to this spot several more times, hoping to do a larger painting, it never again had quite the same feeling for me. One's initial impression of a place is the strongest, and familiarity can dull that sense of impact. That's why it's so important to put down your impression quickly and accurately.

with which to state the basic elements of your painting quickly and accurately.

## PREPARING TO PAINT OUTDOORS

Have your easel, canvas, and supplies organized for a quick getaway whenever terrific light, a gorgeous setting, or just the urge to go out and look for something to paint propels you into action. Simplify your materials as much as you can, so that you can carry everything to your painting site in one trip. You might have to walk a considerable distance, and you won't want to carry anything that isn't absolutely necessary. Make sure to take a trash bag in which to put your used paper towels or rags; leave the area the way you found it.

Once you're on location, having a direct, unencumbered response to your subject means that you can't afford to spend time worrying about materials, searching for brushes or tubes of paint (that you forgot to bring), or fumbling with your easel. You should have an organized approach to your materials. Get in the habit of setting up things the same way each time you paint; put your brushes in the same spot; make sure your tubes of paint are accessible; paper towels handy, etc. This should all become second nature, freeing you to focus on the task at hand, which will require all of your concentration. When I set up my easel, I'm not thinking about what I'm doing; I'm already absorbed in my approach to the painting; how I'm going to compose it, block it in, and what kinds of color and values will be featured. When I pick up my brush, I know how I'm going to approach my painting. Being prepared and familiar with my materials allows me to concentrate on reacting to my subject, which, for me, is the thrill of outdoor painting. I know that you, as a serious beginner, will also soon discover the joy that comes from painting on location—in the right place at the right time to capture some of nature's wonderful, fleeting effects of light.

**ALONG THE FENCE, WINTER**
Oil on canvas, 14 × 18"
(35.6 × 45.7 cm). Courtesy of the Blue Heron Gallery.

The sun finally came out one winter afternoon as I was driving by this spot. It seemed like quite a miraculous effect, streaking across the field, illuminating the tree in the center of the painting. I was definitely in the right place at the right time.

# Dealing with Changing Light

While unique pleasures await the outdoor painter, the landscape genre is not without its problems. Most of them involve light. Unlike your studio, where you usually have a single, controlled light source, outdoor light is constantly changing, and it comes from every direction. The sun is obviously the primary light source, but its light bounces off everything surrounding you, reflecting color onto your subject, canvas, and palette. Being aware of the tricky problems such effects cause will help you to avoid them when possible, or at least compensate for them when they are unavoidable.

How can you keep pace with the speed of changing light? In many situations, the sun will have moved enough to alter the light on your subject almost completely in less than a quarter of an hour. Early in the morning or late in the afternoon, an effect will sometimes last for only a few minutes.

Often, those are literally the most golden moments in which to paint. Trying to capture such fleeting effects, while certainly exciting, is also very challenging. The following should help you understand how to handle rapidly changing light.

Establish your composition and block in your lights and darks as quickly as possible, then stick with them. Don't chase the shadows around as they change. State them as first perceived, then leave them alone. You usually have about fifteen minutes to put down the most important aspects of the scene before light begins to change substantially. Learn to paint your *memory* of the scene as you first saw it— not the changes you see happening before you.

Light changes much more quickly at the beginning and end of the day. Light is warmer then; it's warmest in late afternoon. Long shadows, due to the sun's being low in the sky, and the resultant

**PATH IN THE WOODS**
Oil on canvas, 18 × 24"
(45.7 × 60.9 cm).
Collection of Robert and
Joyce Bramwell.

In this composition, shadows were running from right to left in front of me. Since the sun was moving to the right, the position of shadows really didn't change that much, and the light only got better as the afternoon went on. So the light was fairly consistent, and the scene remained relatively unchanged for a good long time.

strong contrasts between warm light and cool shadows, are ideal for high-contrast compositions. Around noon, light is flatter and cooler; shadows, which are somewhat grayer, are at a premium. The advantage to painting in the middle of the day is that lighting conditions may remain relatively unchanged for quite some time.

Since it's often the light that entices the painter to a setting, scout locations to find the best time of day to paint them. I've walked and driven by many spots, totally unimpressed, only to find them inspiring upon returning at a different time of day. If you know exactly when the light is best for a certain spot, you can get there fifteen minutes early and be totally set up and ready to go by the time the light is exactly right.

You might choose a subject that's minimally affected by changing daylight. Even in early morning or late afternoon, some settings remain relatively unchanged for quite a while, based on the position and path of the sun relative to that spot. In the morning or afternoon, for example, pick a subject that has sun traveling across it from side to side. Although shadows will lengthen or shorten, they will not change position too much, keeping the quality of light fairly constant. If you paint looking into the sun or with it directly at your back when it's low in the sky, light will change dramatically in a short time, and the landscape will either darken or lighten quickly. So when you choose a spot to paint, determine the path of the sun across the sky, and figure out how the subject is going to change. For example, if a group of trees casts shadows on your subject and the sun will soon clear those trees, your subject will change completely at that point. Plan accordingly.

Don't work on a painting for more than two and a half hours on location. By then, light has usually changed so dramatically that there is nothing more to refer to that will help you. You're better off taking it back to the studio and finishing it from memory with a fresh eye the next day.

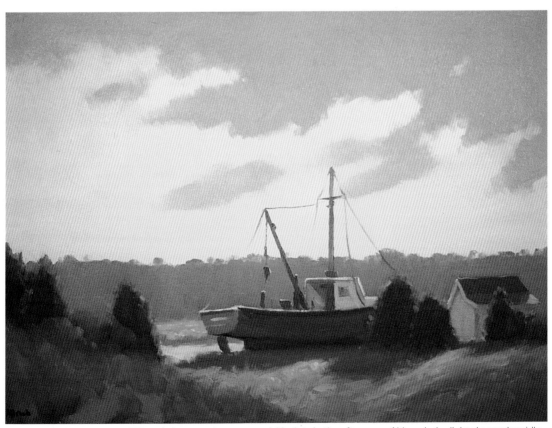

**QUIET AFTERNOON**
Oil on canvas, 16 × 22"
(40.6 × 55.8 cm).
Collection of Tracy
McVeigh.

This painting was done very quickly, late in the afternoon. Although the light changed rapidly, the scene made such a strong impression on me that I had little trouble remembering its important elements. I also did a lot of simplification, composing the painting with several large, simple shapes of flat color. I've painted here many times, doing canvases that are somewhat similar, but each time, something changes a bit—if only my mood—which makes for a unique painting experience each time.

# Choosing a Setting with the Right Light

When you paint outdoors you are constantly faced with situations and effects that do not occur in the studio. Indoors, you exercise lots of control over the entire process. Outdoors, you must improvise and cope with less than ideal working conditions. It's particularly important to consider *where you set up your easel* and what kind of light falls on your canvas and palette.

### MINIMIZING REFLECTED LIGHT

Light is reflected onto your canvas from everything around you. It will bounce off buildings, windows, cars, even your clothing, land on your canvas and cause glare, which is a major distraction when you paint. Sometimes, just turning your easel away from the source of the problem will alleviate it. At other times, the color reflecting onto your canvas is unavoidable; for example, if you paint on a beach, bright sand will reflect up onto your painting. Short of controlling light with umbrellas, which can be frustrating in anything more than a slight breeze, there's little you can do to avoid color reflections, except to adjust your easel to minimize them. And don't wear a white shirt when you paint on sunny days. It will reflect onto your canvas and influence the way you see your developing painting.

### AVOIDING DIRECT SUNLIGHT

Don't paint with direct sunlight on your canvas. You'll find that all of your painting decisions were based on having an impossibly bright light on your work. Indoors, your painting will lose lots of its impact. Sometimes you have to turn your easel at an awkward angle to get your canvas out of the sun. And if the sun falls on the back of your easel on stretched canvas, staple a piece of newspaper across the exposed stretchers to keep sunlight from shining through the back of your painting.

### PAINTING IN OPEN SHADE

The best place for your easel is in open shade. It's comfortable, there isn't a lot of strong color reflected onto your painting, and you have similar light on both your canvas and palette. If your canvas is in shadow and your palette is in bright sunlight, the colors you mix will look different when applied to your canvas. You can adjust them fairly quickly, consciously mixing the colors brighter to compensate. Put just a spot of your mixed color on your canvas to test it before applying too much of it. But to avoid this disparity, when possible, I'll turn my easel so that my canvas throws a shadow across my palette.

FARMHOUSE,
NEAR MALAUCENE
Oil on canvas, 12 × 16"
(30.5 × 40.6 cm).
Courtesy of the
Blue Heron Gallery.

I exaggerated the contrast between light and shadow on the building quite a bit here, because I knew the painting needed more impact than the setting actually provided. I also warmed the light area to have it vibrate against a cool sky, lending a heightened sense of drama.

# Exaggerating Landscape Colors

It's very frustrating to bring what you think is a successful painting back to your studio, only to find that indoors, colors look muddy and your picture lacks the punch you thought it had. What has happened? You have worked the painting under one set of lighting conditions, and then viewed it under totally different ones. The light on your canvas when you paint outdoors is always brighter than it is indoors. It is usually so much brighter outdoors than indoors, even on an overcast day, that if you go outside on a dark day and look back into a room with no lights on, it will look amazingly dim.

In order to compensate for the diminished brightness of normal indoor viewing conditions, you must learn to exaggerate color as you paint. Dimmer indoor lighting will make your colors look grayer, so you must intensify the warmness of warm hues and the coolness of cool ones when you work outdoors. I've painted what I thought was a very warm, yellow light outdoors, only to have it look cool and "whitish" indoors. A shadow that appears quite violet outdoors will gray up indoors. If you can identify the primary component in the color you're trying to mix, and exaggerate it slightly, your color will look truer—closer to your intention—when you bring it indoors. When you judge a light against a shadow in a green field, for example, slightly stress the yellow (warm) component of your mixture of green for the light, and the blue (cool) component of the shadow mixture. Actually, you're not really exaggerating; you're being more sensitive to the intensity of color that's really there. I think that sometimes you have to *paint* a color before you can see it in nature; that is, once you begin to put down bolder colors, you'll begin to see those colors around you. Initially, you may have to take it on faith and risk using stronger colors than you see. But bold statements made outdoors will read better indoors, and better reflect what's actually happening outdoors.

**HILLSIDE, TUSCANY**
Oil on canvas, 20 × 24"
(40.6 × 60.9 cm). Private collection.

In this painting, I darkened the value of the sky considerably to accentuate warm, late afternoon light on the hillside. You should always be willing to take liberties with the facts to produce dramatic results.

# Composing a Landscape Painting

As with still-life painting, many of the decisions facing you when you do a landscape should be made before you begin painting. Composition, in particular, should be established before you put brush to canvas. Although you may make minor adjustments to the painting's design as you go along, have a firm idea beforehand of how you're going to divide up the space on your canvas—where the major shapes will go. More specifically, in the realm of landscape painting, you must simplify your subject matter, altering it as needed for the sake of the painting; decide what to emphasize; choose the scale of objects in relation to one another; make sure your subject has a foreground, a middle ground, and a background; and establish vertical elements in your design. Addressing these considerations should become part of your thought process when you consider your subject and how to approach it.

## SIMPLIFYING YOUR SUBJECT MATTER

The most consistent reaction of students on their initial attempts to paint a landscape is that it is overwhelming. When you confront nature, your vision and emotional response are not limited to a small, well-defined rectangle. There is often so much to look at and take in, even trying to decide what to paint can seem like an exercise in futility. Then once you zero in on your subject, you have to organize it on canvas and translate it into paint.

Choosing a section of a landscape for your canvas from the vast expanse of information confronting you is the first step in the process of outdoor painting. Making this decision is highly personal, and should hinge on what grabs your interest as you look around you. What do you find compelling about it? It can be something as specific as the pattern of light falling on a tree, or as general as the feeling of a particular place. When you find your focus, something that excites you, build your painting around it.

Many artists use a simple viewfinder made from a scrap of matboard as a very helpful tool for composing a painting. Looking through the viewfinder (for example, a 3-×-5" frame) focuses your attention and vision on the segment of landscape in which you are interested, imposing borders and making it conform to the format of your canvas. (Similarly, I've found many compositions in the rearview mirror of my car.) You can then use your viewfinder to help compose your painting,

by moving it so that your focal point appears in different spots within the frame until it's positioned the way you want it.

Once you've chosen your subject, simplify it into a forceful painting by establishing a strong focus, then relate all the subordinate elements to it in a way that doesn't diminish the strength of that focus.

Begin by designing your painting around a single area of light, simplifying surrounding areas so that this light becomes one of just a few major shapes in the painting. Think of your subject as being *light*—rather than whatever you happen to be painting—and find the shape that it makes, then relate shapes around it to that one. Diminish contrast away from your center of interest; establish strong contrast at your focal area, then reduce it on the periphery. Bringing values closer together in peripheral areas lessens contrast, and is an especially effective way to direct the viewer's eye. When you narrow the scope of your painting by bringing the focus to one object or area, allow that area to take up a large portion of the picture plane, and greatly simplify the rest of the canvas.

Although some settings are paintable exactly as they are, it's more likely that you'll have to take artistic liberties with the facts. When you start, your subject is very important, but after a certain point, *your painting should become more important than your subject*. In *Retired* (opposite), for example, the post in the left foreground was actually directly behind me. But I wanted a vertical to cut across the horizontal planes of the painting and to echo the mast going into the sky, so I simply moved it into the picture. I actually paint very few canvases in which some fact is not altered to benefit the painting.

Most often, you'll simplify your painting by leaving things out: depicting a group of trees as a mass, omitting trunks and branches; painting a shadow as an uninterrupted shape, rather than showing everything you see in it. Consolidate effects or objects that are dispersed throughout your subject, organizing them into masses and patterns to suit your composition. There is a saying among painters that what you leave out is more important than what you put in. It's determining exactly how much is enough—*how little you can show and still define what is necessary*—that's important. Usually, an accurate translation of light and shadow, arranged into an attractive pattern, is enough.

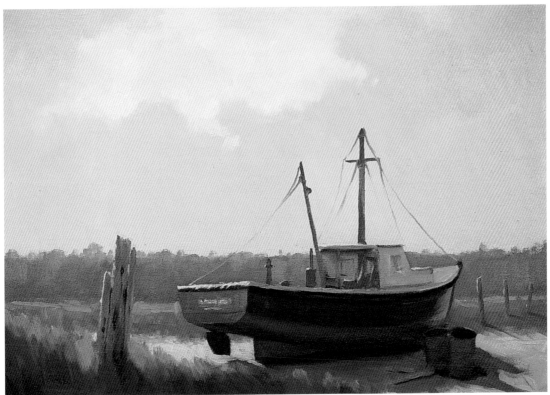

**RETIRED**
Oil on canvas, 16 × 22"
(40.6 × 55.8 cm).
Collection of Alan and
Dorothy Somerville.

Here, the strongest contrast involves the boat and its cast shadow as a unit, meeting the sand and sky. I painted the marsh much darker than it actually was, bringing it closer in value to the line of background trees, which were also treated in a very simplified way, as a single mass silhouetted against the sky. Combined, these effects feature the boat by bringing it closer to the viewer and pushing the background into the distance, unifying the composition and heightening the feeling of space in the painting.

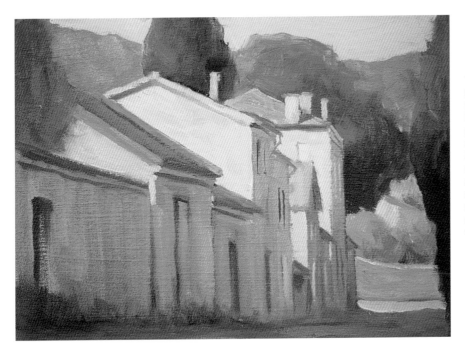

**STREET SCENE,
MALAUCENE**
Oil on canvas, 9 × 12"
(22.9 × 30.5 cm).
Collection of the artist.

This section of buildings, caught in early morning light, is the only part of the painting developed much beyond the block-in stage. Varying the amount and degree of finish in different areas of a painting serves to direct the viewer's attention.

## DECIDING ON THE SCALE OF YOUR PAINTING

Your decision as to the scale of your subject should be based on your intent. What is your concept, what feeling do you want to convey? By deciding *how much* of your subject will be portrayed, you'll help dictate the mood your painting will evoke. To convey intimacy, pull right in on your subject—let it fill up the canvas, as in *The Pigeon Coop,* opposite. If you're after a feeling of grandeur, pull back from your subject and let the viewer experience the full scope of it. In the painting *Tuscany* (page 132), showing the vast expanse of landscape and moody sky is meant to convey the sense of awe I felt when coming upon that majestic scene. Although you can show the immense scale of some landscape feature by having it reach, or almost reach, the top of the canvas, you must still pull back from it far enough for the viewer to understand what's happening. Between the two extremes, of zooming in on or pulling back from your subjects, you have lots of room to express the particular mood the scene inspires in you.

## FOREGROUND, MIDDLE GROUND, AND BACKGROUND

Students often begin a painting with two strikes against them when they choose subjects that are very difficult in the sense that they lack basic elements that constitute paintable subjects. Accomplished

artists make painting *look* easy, partly because they've developed an eye for good subject matter. Almost any situation *can* be painted (if the light is right), but it must contain sufficient information and interest if it is to provide the basis for a successful painting.

The most basic criterion for a landscape subject is that it have a foreground, a middle ground, and a background. If your painting lacks a credible foreground, it is difficult to establish the overall scale and to make your background recede into the distance. If your subject has no background, your painting is likely to lack depth, and will look flat and lifeless. Think about establishing tension between foreground and background through the use of contrasting warm and cool colors, and by graying (or "blueing") colors in the distance. This tension will bring a feeling of space or distance into the canvas.

Think of using the foreground—the bottom of your canvas—as a means to lead the viewer into your painting. There should be enough definition and activity there to make it interesting in itself. But you also want the viewer's eye to move *past* it into the distance. Where you establish the focus will vary, of course, from painting to painting. But you should always try to move the viewer's eye *into* the canvas as well as across it. When you compose your painting, think of defining a shape in the foreground that will direct the eye to a shape in the background.

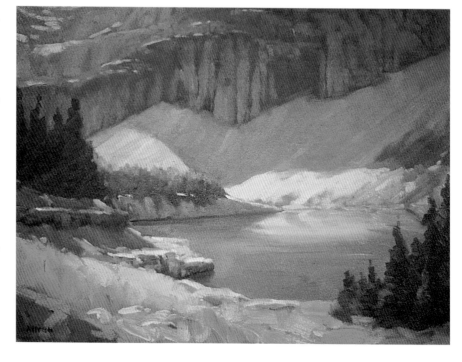

EMERALD LAKE
Oil on canvas, 12 × 16"
(30.5 × 40.6 cm).
Private collection.

This spectacular lake in Glacier National Park is surrounded by huge mountains. Pulling back from the lake to show more of them would have diminished its importance, so I decided to let the cliff behind the lake run right off the top of the canvas. Even this small portion of cliff dwarfs the large pine trees in front of it, leaving the viewer to wonder how massive it really is.

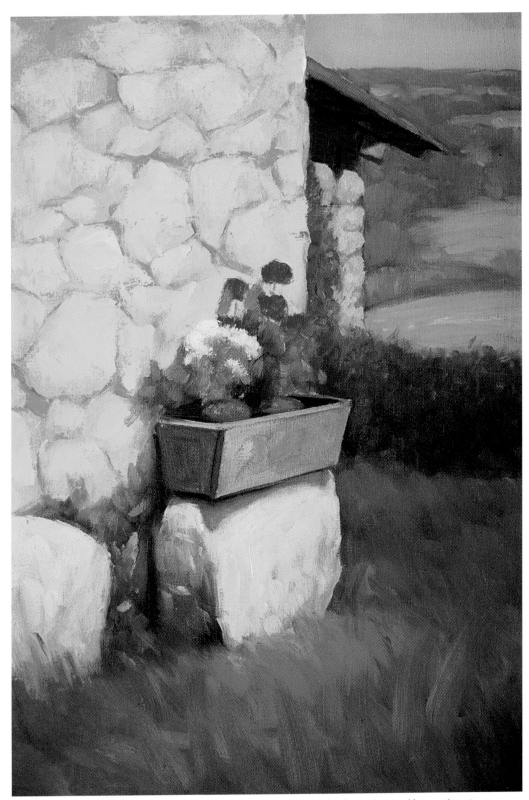

**THE PIGEON COOP**
Oil on canvas, 22 × 16"
(55.8 × 40.6 cm).
Private collection.

Here, I wanted to focus my attention on the flower box and interesting stone textures of this very old building. Shown in close-up, that section dominates the canvas. The activity in the foreground, together with the darks, red accents, and highly saturated color enable the fields to recede into the distance.

The foreground, as it relates to the background, also establishes the painting's scale. A tree in the foreground might disappear off the top of the canvas but contain a fair amount of detail, while a similar tree in the distance might be a fraction of that size and be reduced to a very simple shape, even a single brushstroke. Having a vertical element—a tree, building, figure—in the foreground or middle ground cutting across the horizontal plane of the background can be a very effective way to establish a relationship between these two often disparate areas, thereby creating a sense of scale and depth.

There are times when the foreground is devoid of interest and serves simply to lead viewers into the middle ground and background. Still, you have to make the foreground credible and bring it toward the viewer. In such cases, using more saturated color and larger, thicker brushstrokes in the foreground will help. The same rich color in the foreground will get lighter in value and bluer as it goes into the distance. Large brushstrokes of that color in the foreground, contrasted with smaller brushstrokes of the lighter, bluer color that it becomes as it recedes will enhance the feeling of distance into the canvas.

## HORIZON LINES

Vary your compositions enough to take advantage of a wide range of horizon lines. It's fun to push things a little to see if you can get away with a very high, or very low, horizon. Your only responsibility here is to watch your perspective. Particularly with a high horizon, it's sometimes difficult to get the landscape to *lie down;* that is, the foreground can seem to drop down, instead of coming toward the viewer. This problem can usually be solved by calling more attention to the foreground: with larger, more vigorous brushstrokes; with richer, more saturated color; or with increased activity or definition. Establishing a strong vertical, especially one that rises above the horizon line, can also help.

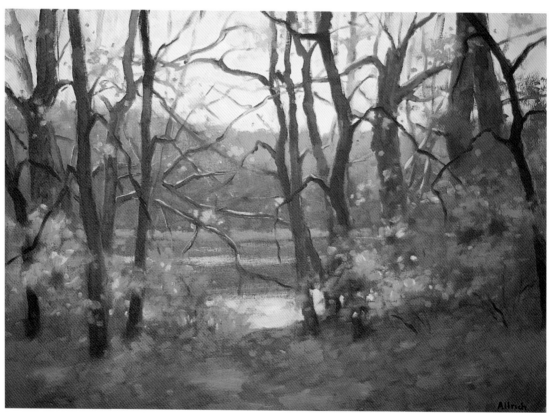

**ACROSS THE POND**
Oil on canvas, 16 × 22"
(40.6 × 55.8 cm).
Collection of the artist.

An overcast, slightly foggy day accentuated the feeling of distance across this pond. This well-developed foreground has lots of warm color and activity in the form of individual leaves and branches. The tree trunks, going right off the top of the canvas, pull the foreground toward the viewer, giving a sense of scale to the painting. The middle ground—the pond—is just suggested, mostly by means of color reflected from the landscape and sky. The background is a grayed blue green, considerably lighter in value than the foreground. It contains virtually no detail, so it recedes into the distance.

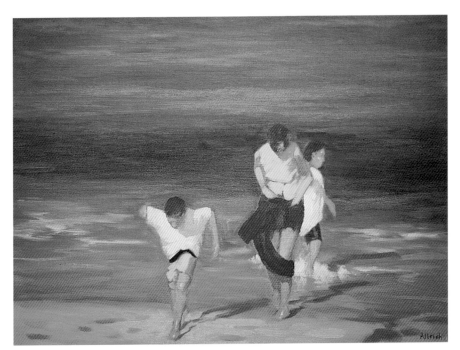

**KARRI, COLIN AND ALEX**
Oil on canvas, 16 × 22"
(40.6 × 55.8 cm).
Private collection.

The horizon line in this painting is off the top of the canvas, so one of my main concerns has to be that the water lies flat. The three figures provide strong verticals that, in conjunction with the warm sand color, pull the foreground toward the viewer. The background water is lighter in value and has little activity, which allows it to recede into the distance.

**TRURO OVERVIEW**
Oil on canvas, 16 × 22"
(40.6 × 55.8 cm). Courtesy of the Blue Heron Gallery.

Several different elements, including both linear and aerial perspective, combine here to make this high horizon work. Large foreground shapes of highly saturated color give way to smaller, grayer shapes, which are less well defined. The road narrows considerably before it disappears around the side of the central building.

# Perspective

Nothing inspires more fear in an art student than mention of the word *perspective*. Most students have looked at books full of complex diagrams, formulas, and rules, which usually leave them gasping for air. For me, it makes more sense to approach perspective as a matter of correct observation. If you understand what you're seeing and know that you must be aware of the effects of perspective, then painting these effects becomes a matter of looking carefully and making enlightened judgments.

For an artist, perspective involves translating the effect of distance on form and color as painted onto a two-dimensional surface. An obvious example of perspective is a house a hundred yards away that appears to be much smaller than one of identical size thirty feet away. It's a simple matter of making a comparison, of relating the size of the distant house to that of the nearer one. Other aspects of this phenomenon can be a little more difficult to judge. Take the building itself, which for the sake of simplicity can be represented by a cube. If it is situated so that we see two of its sides, we understand that one or both of these sides must recede into space to some degree. The side facing us most directly is the easiest to judge accurately, since it's closest to being square. The second side, and the top, if we can see it, go farther back into space, so we treat them as *different shapes* that we can judge by comparing them to the first side. The difficulty we encounter occurs because our head tells us that these sides are also square, while our eyes tell us something different. When we draw or paint, we tend to show too much of the receding sides, to make them squarer, even though they become smaller, and we see less of them, as they go back into space. The solution is to think of the cube—or any other form—as a collection of shapes of different sizes that relate to one another in a particular way, depending on their position. Thus, when you judge the second side, forget that it's square; treat it as an entirely different shape—and compare it in size to the first side.

The convergence of parallel lines to a distant point in space is perhaps the best-known effect of perspective, and when used with subtlety, can convey a nice sense of depth into the canvas. Again, careful observation—based on making a series of comparisons—is your best recourse. If you have difficulty judging the angle of a diagonal in your landscape, hold your brush at arm's length and sight along that diagonal with your brush, then carefully move your arm at the same angle over to your canvas. I'll sometimes try to judge such a diagonal, draw it, and then check it in this manner.

Many painters (myself included) learned to construct perspective in art school, but it's something I don't really believe in. Any mechanical device or formula you use to judge perspective—or anything else—is something you'll eventually have to set aside, since it actually *takes the place* of judgment. When we drew the figure in art school, we had to develop our drawing using the head as a unit of measure, relating the entire figure to that unit of measure. Although this is a time-honored method of learning, I think it's really counterproductive. I became so reliant on this type of measuring that I couldn't do any work without it. It was a real struggle to break away from it and get a sense of fluidity and spontaneity in my work. I think it's better to develop, and learn to trust, your powers of observation and judgment from the start—and make mistakes—than to rely on any mechanical device or system of measurement.

## ATMOSPHERIC PERSPECTIVE

Perspective also affects color as it recedes into space. Because of this atmospheric, or aerial, perspective, colors in general become lighter in value, less saturated (less intense, or grayer), and cooler in temperature as they move away from us, to a degree dependent upon atmospheric conditions. A tree that's quite green up close will often appear to be an entirely different color, a light blue, two miles away. Somewhat paradoxically, a light color will usually appear darker, so that value relationships become closer across a great distance. Edges are also blurred by atmosphere, making definition less distinct over distance. Since conditions vary from place to place and day to day, there are no formulas, and you must study and treat each circumstance accordingly. Understand the effect and its causes, but force yourself to really *look* at your subject to find the color. Comparison is the key; to judge a color in the distance, compare its value, intensity, and temperature with a similar color in the foreground.

**AFTERNOON SHADOWS**
Oil on canvas, 22 × 28"
(55.8 × 71.1 cm). Collection of
John and Catherine Lavrakas.

Here, several sets of parallel lines converge at a point near the center of the canvas; the road, the trapezoidal shape of grass, and the stone wall all diminish in size as they approach this point. Also notice that the sizes of tree trunks on the right-hand side of the canvas get smaller as they move into the distance. In planning this painting, I hoped it would have enough activity and interest so that the composition wouldn't seem too obvious.

**ORVIETO**
Oil on canvas, 9 × 12"
(22.9 × 30.5 cm). Collection of
Barbara and Paul Lavrakas.

One of the chief virtues of painting trips is that they keep your work fresh by exposing you to different lighting and atmospheric conditions. Here, the setting presented many very sharp edges and dark accents in the foreground. By comparison, the background shapes are close in value, and their edges are very soft. Note that their color is also somewhat muted. The careful observation and rendering of this combination of effects causes the obvious distinction between foreground and distance, creating a believable sense of depth.

# Painting Skies

I don't believe in talking specifically about how to paint water, grass, or skies. There is no one way to paint any of these things. Depending on light, time of day, and your concept, you might handle the same area of water in a different way each time you paint it. Furthermore, the same type of brushstroke and application of paint could conceivably represent water, grass, *or* sky. It's your job to translate an area of grass, water, or sky into an abstract shape, and let the context of the painting tell the viewer what that shape represents.

Skies, however, present some unique problems. It's very common to see the sky expressed as nebulous space that doesn't enhance the composition or mood of the painting. Skies can be difficult to paint because they're so changeable, the forms within them are so elusive, and the values and colors of clouds are often so subtle. It would be hard to determine tonality

even if clouds stood still and didn't change form. And to top it off, clouds have structure, but they're not solid. You must make the viewer believe that they can float—not sink like a stone. How can you overcome all of these obstacles?

Think of the sky as a collection of shapes that are as integral to your composition as any other area of your painting. Arrange clouds to your advantage, either to emphasize or counter the direction of other elements in your landscape.

The sky has depth, too. Near the horizon, it's farther away; overhead, at the top of your painting, it's closer to you. Cloud forms near the horizon are smaller, narrower, and have less value difference than those overhead. Since you're looking through more atmosphere at the horizon, the clouds there are often hazier, less well defined, and closer to the color of the sky itself. In fact, the sky is usually lightest near

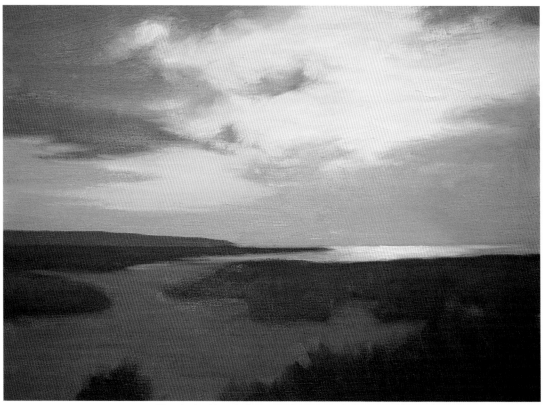

**EVENING CLOUDS**
Oil on canvas, 12 × 16"
(30.5 × 40.6 cm). Collection of
Douglas Powers and Doria Harris.

The sky in this painting comprises several shapes, which while diffused, are nonetheless distinct. Notice how the large, brightly lit cloud somewhat echoes the shape of the foreground sand in the landscape.

the horizon, and darkens as it rises. In general, it's a warmer, grayer blue (cerulean blue, often with a touch of cadmium orange or cadmium red light, although it can be much warmer, even pinkish) at the horizon, and turns cooler (ultramarine, also often with a little cadmium red light) above. If you're in a setting where you can see the sky at or near the horizon in every direction, notice that at the horizon, the sky changes color dramatically as you turn.

In terms of value, the sky is usually lighter than you think, and its value range is separate and distinct from that of the landscape. Even dark storm clouds may be lighter than anything in the landscape, although you can certainly darken them for dramatic effect. Judge sky values by looking at the landscape; that is, use your peripheral vision to look at the sky while focusing on the landscape. This will ensure accurate value judgments for both.

When painting a rapidly changing sky, wait for a marvelous moment that will enrich the composition and mood of your painting, even if you have to work out of sequence to take advantage of an elusive effect. I'll often work on the landscape until something special happens in the sky, then paint that section of the canvas. But don't try to capture every change you see. Find a pattern that you like, then stick with it. Remember to watch for vertical movement in the clouds as well as horizontal. And take into account that the lightest part of a cloud isn't usually at the edge where cloud meets sky. If you look carefully, you'll see a slightly darker value there, which helps soften the edge between a very bright cloud and the sky, and keeps the cloud from looking flat.

Whenever possible, reflect a little of your landscape color up into the shadow of a cloud, even if you don't see it. It will give clouds luminosity and help unify and relate sky to landscape. Also note that in paintings in which no direct sun hits your landscape *(Evening Clouds* and *Sunset),* the colors of the sky are reflected into the landscape.

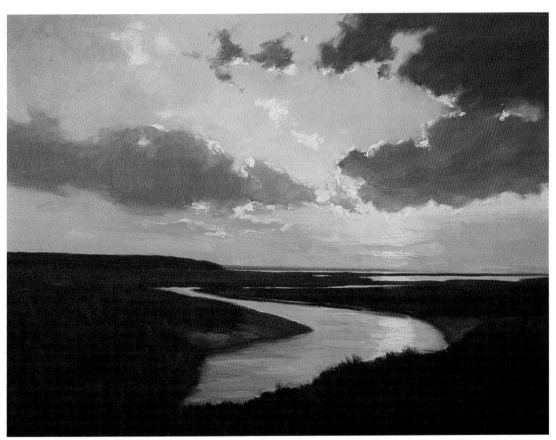

**SUNSET**
Oil on canvas, 16 × 22"
(40.6 × 55.8 cm).
Collection of Mr. and Mrs.
Douglas Faithfull.

Although clouds near the top of this sky are very dark, they are still lighter than anything in the landscape, with the exception of the water, which is reflecting the sky. Since I exaggerated the darkness of these clouds, I also painted the landscape darker in value than it really was to create a dynamic scene, and ensure that the values of land and sky, relative to each other, would remain true.

# Painting Reflected Light

Nothing adds credibility to a landscape like reflected light; light that shines directly on one surface, then bounces off it onto another. If that light lands on a surface in shadow, the effect is particularly noticeable, and capturing it requires careful observation and execution. First, since it's sometimes difficult to judge the color and value of reflected light, determine the source of the reflection, what color it is, and whether it's warm or cool in temperature. I'll usually block in the area with local color—the color of the area minus any external influences—and then paint the reflected light on top of it. I use enough paint for reflected light so that it sits on top of the shadow color instead of mixing with it. Both the shadow color and the reflected light must be visible at the same time to achieve the full and proper effect. Keep in mind that reflected light is a component of its shadow, and won't be as bright as the same color in direct light.

**STILL LIFE WITH ROSES AND APPLES**
Oil on canvas, 40 × 30"
(101.6 × 76.2 cm).
Private collection.

This still life, set up outdoors in bright sunlight, contains several examples of reflected light. The most obvious is the warm yellow green reflected up from the grass onto the white cloth, which is in shadow. The contrast between cool gray violet and warm green cause this area to glow. Grass also reflects onto the white pitcher on the ground, and the white cloth reflects up into the shadowed underside of the roses.

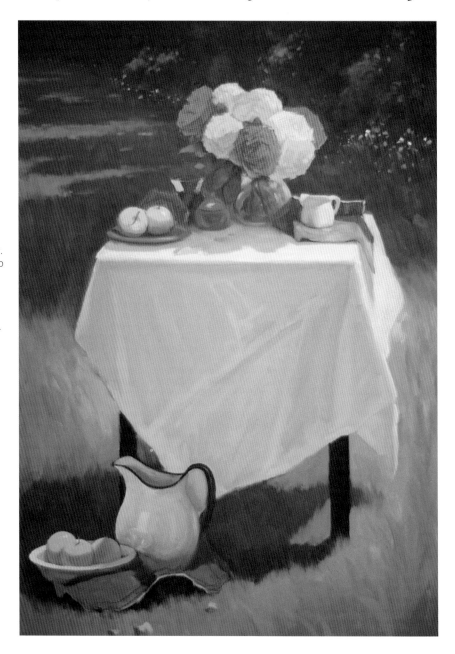

# Putting Light in Your Paintings

Achieving luminosity in your paintings is contingent on doing many things right, several of which I've already reviewed. High on the list is identifying the contrast between light and shadow, in the form of warm and cool colors; then effectively arranging those hues on your canvas. Remember that your subject *is* light and shadow, as defined by the section of landscape you've chosen to paint. Your aim is to express the drama of light against shadow in terms of color, as areas of light values against areas of dark values.

Think first about your light source and try to identify the color of that light. Sunlight is fundamentally warm, but its color varies according to time of day and prevailing atmospheric conditions. Learn to be sensitive to how weather conditions affect color. On overcast days, the color of light is very dependent on the color of the sky. On a sunny day, since your light source is yellow orange, shadows will have varying degrees of blue violet in them. I often block in shadows slightly darker and warmer than they appear, and then work cooler colors of lighter value into them. The juxtaposition of warm and cool in the shadow makes it seem lit up. Reflected light in a shadow makes it seem as though light is everywhere. Remember that it must stay within the shadow and not compete with direct light. As a rule, no light in a dark area should compete with anything in the light area.

Exaggerate the warmth of your lights and the coolness of your shadows slightly when painting outdoors. You can't compete with real sunlight, so to capture the feeling of light, you must give this contrast a bit of a boost.

**ROCK HARBOR, SPRING**
Oil on canvas, 9 × 12" (22.9 × 30.5 cm).
Collection of the artist.

The contrast between thin clouds near the horizon and larger shapes at the top of the painting creates tension, pulling the large cloud shapes forward and pushing the horizon back, accentuating the feeling of distance in the painting.

# Miscellaneous Tips for Outdoor Painting

Paint boldly. Subtle statements can often be lost when you take your painting inside, again due to the diminished brightness of indoor viewing conditions. In addition to exaggerating color, make sure to stress contrasts between light and shadow, between cool and warm, and to maintain the strength of your initial design.

Let circumstances and common sense dictate the size canvas you choose. If you know that the effect you're trying to capture won't last long—at dusk, for example—do a smaller painting. If it's very windy, don't attempt to paint a large canvas; it turns into a sail, and can easily topple your easel. If the day is calm and you have lots of painting time—and a subject that's not going to change too much—try a larger canvas.

Always wear a hat to protect your face and avoid eye strain. It's easy to lose track of time when you're painting; before you know it, three hours have gone by, you're sunburned, and you can barely focus clearly on your canvas.

There are endless distractions awaiting you when you paint on location: A sunny day will turn cloudy; wind will overturn your easel; you'll be attacked by swarms of mosquitoes. Not only will people stop to watch you paint, some will ask you directions or advice on any number of things. (I was once asked by someone who was dripping wet, wearing only a towel, whether I knew anything about electricity. It still scares me to think about it.) The list is endless. My only suggestion is to try to distance yourself through concentration on painting, and avoid getting angry about interruptions. You have very little control once you step outside your studio, so accept it as a given that you will have some problems and distractions. Once you become immersed enough in painting, you'll soon be oblivious to other activity going on around you.

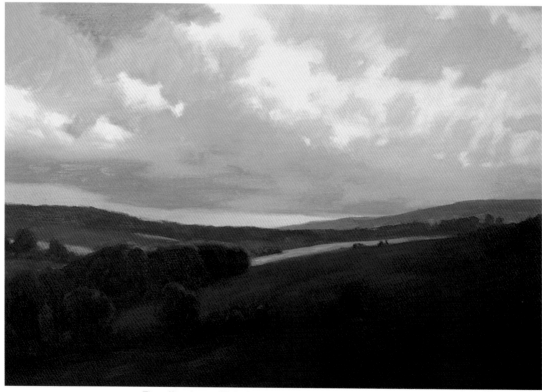

**TUSCANY**
Oil on canvas, 24 × 36"
(60.9 × 91.4 cm). Collection
of Tracy McVeigh.

The effect here of light breaking through clouds onto a landscape lasted perhaps a minute or two, much too brief a time to consider painting on the spot, especially on the scale I thought the subject merited. I was lucky enough to have my camera at hand and got a picture of it. I then did the painting in my studio, working from my memory of the scene and the photograph, as well as my knowledge of the area gained from having done many paintings on location there.

# Painting from Photographs

There are times when painting on location is impractical or even impossible. Sometimes, there's just no place to set up an easel. I've seen appealing sites where the only vantage point was from the middle of the road. Or on a painting trip, there might not be enough time to paint all of the many views that inspire you. Painting a large canvas outdoors can also be difficult if not impossible under some circumstances. Taking a photograph for reference is a workable alternative to on-site painting. Otherwise, you might miss your opportunity to paint many subjects that you've set your sights on.

Studio painting from photographs also allows you to work in a more controlled situation at your own pace. Some artists claim that working from photos frees them from the "tyranny" of nature; that is, from the overwhelming presence of nature, which has such an inhibiting effect on some artists, they are unable to alter it as needed to produce a good painting. Many notable artists have used photographs for reference: Theodore Robinson, the great American Impressionist, relied on them extensively; there is also evidence that Edgar Degas worked with them for some of his brilliant pastel figures. But let's remember that these men were accomplished painters, with years of experience behind them before they began using photographs.

For landscapes particularly, I don't recommend that people paint from photographs unless they've been painting from life over a long period of time. There is just too much important information lacking in a photograph, and if you're not aware of what's missing, your work will be deficient in several respects. Aside from distorting color, light, and perspective, photos provide no sense of depth, which is a key element in landscape painting. Reflected light is often absent. And the camera is not selective, as an artist must be. And generally, people with too little experience tend to treat a photograph with too much reverence. If you must work from one, use it as a reminder, something to jog your memory, and not as something carved in stone. If you need to change the composition, move a tree, make a house a different color, by all means, do so. Your only obligation is to do a good painting. And if you *do* work from a photo, work from one of your own. Having taken it yourself, you'll at least have some firsthand experience with the setting. And also try to do at least a sketch of your subject on location. Sometimes I'll do a small painting on location, take a photograph, and then paint a larger version of it in my studio, using the photograph to refresh my memory and to give me an added impression of the place.

**GARDEN, SAN GIMIGNANO**
Oil on canvas, 18 × 14"
(45.7 × 35.6 cm). Courtesy of
the Blue Heron Gallery.

The only place to stand to paint this beautiful, intimate garden was in the middle of the street, and painting in the middle of the street in Italy is inadvisable to say the least. Taking a photograph was risky enough, but my only recourse in my eagerness to paint this scene.

# Demonstration: Basic Landscape

This is a relatively simple composition, comprising only four major shapes: the light and shadow areas of the land itself, the sliver of water in the distance, and the sky. It's a very quiet vista, invigorated by the diagonal edge of a large foreground shadow. I wanted to convey the warmth of late afternoon light and a feeling of solitude while maintaining a simplicity of design.

Step 1. I sketch in the contour of the land and horizon line, and indicate the placement of shadow across the foreground. I also remind myself that there is a patch of sand to the left which I want to keep very light.

Step 2. I begin by blocking in the shadow, making it darker than I see it, so that I can work color and texture into it later; it's a mixture of varying amounts of ivory black, cerulean blue, cadmium yellow light, and a little cadmium orange. Then I place a value of the light area of the landscape next to the shadow to help me judge its value. I also develop the contour of the bluffs as they recede into the distance.

Step 3. I finish filling in the area of shadow, keeping it transparent and quite dark at this stage. The light area beyond it is scrubbed in with a mixture of cerulean blue and cadmium yellow light with a bit of cadmium orange, thinned down with turpentine so that I can cover the area quickly. I want to establish a feeling of light against shadow immediately. The relationship of these two large, abstract shapes—their color, value, and size—is very important.

134

**Step 4.** I add some cadmium yellow light and cadmium orange to the edge of the bluffs to convey light, and begin to develop specific features of that contour. I then paint in the triangular shape of water beyond it. Now the block-in is complete. I have established the design of the painting, and have a base of transparent color into which I can work additional layers of paint.

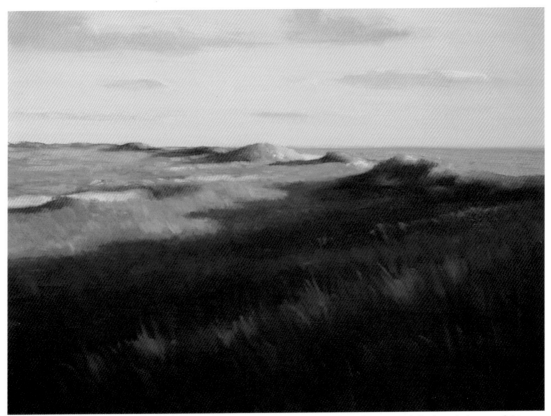

**BOUNDBROOK, AFTERNOON**
Oil on canvas, 18 × 24"
(45.7 × 60.9 cm). Courtesy
of the Blue Heron Gallery.

I paint some cool greens into the dark value of the foreground shadow, being careful to maintain the darkest darks underneath the bluffs, which don't receive as much reflected light as the open areas. Then I work some warm greens—basically the same colors I used in the block-in, but heavier on the cadmium yellow light and cadmium orange—into the light area. The shapes of light sand break up the area of green, and reinforce the diagonal created by the shadow's edge. Some indications of texture and light are added to enliven the shadow—it's a very large area, and I felt it needed more interest. Next, I paint in the sky. I've decided to accentuate the green I see in it, which will help it relate to the landscape. I paint in a few warm clouds—though it was a cloudless day—to break up the space, and to echo some of the shapes in the landscape. Lastly, I refine the edge of the land mass against the water and sky.

# Demonstration: Winter Landscape

Winter is just about my favorite time to paint outdoors. The feeling of solitude I experience when I paint, that sense of being enveloped by the landscape, seems to be enhanced by the presence of snow and cold. Opportunities to create vibrant landscapes are abundant. Blue-violet snow shadows against ochre and rust-colored winter grasses and green pine trees are perfect complements to one another. The sun is low in the sky for most of the day, providing you with long shadows and an almost perpetual aura of dusk. So although the days are short, you have good light all day long.

A word of caution: If you paint outdoors in the winter, dress very warmly, in layers, and wear a hat with earflaps. Since you won't be moving around much, you'll get very cold very quickly if you're not dressed properly. Don't worry about how you look; maybe your attire will help keep the curious at bay. Some artists wear gloves, but I've never been able to adjust to them, so I paint barehanded. I find that if I keep my feet warm and dry, I can usually endure the cold. In very cold weather, I wear rubber boots with felt liners. I take the liners out and put them near heat ahead of time to get them good and warm. If I'm painting close to my car, I'll start it up and climb in occasionally to warm up. (If the temperature is below freezing, you must pay attention to your body signals. When exposed flesh starts to hurt, it's time to warm up. If it gets to the point where you can't feel your fingers or toes, you begin to risk frostbite, and it's not worth it. After all, you want to be able to come back to paint another day!) I also put my tube of white paint near the heater to keep it warm, and then in my pocket. Another cold-weather trick: If you add a little linseed oil to your white paint and whip it in with your palette knife, it will keep the paint from becoming too stiff.

What drew me to paint this scene is the contrast between the way light hits upright planes—particularly the foreground rocks and edges of snow facing the viewer—and the horizontal planes of snow and ice. Since the sun is low in the sky in winter, it tends to illuminate vertical planes intensely, while skimming across horizontal planes, giving them a sense of being half-lit. This effect, when captured skillfully, exudes a wonderful luminosity that has inspired many fine winter landscapes.

**Step 1.** I lay out the big shapes of this landscape, forming an "s" from the background, to the zigzag edges of snow, to the line of rocks in the foreground. I begin the block-in, using darks to define foreground rocks and background houses.

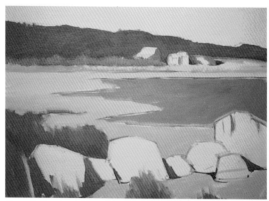

**Step 2.** Laying in transparent color quickly, I use a little white for the snow color in the middle ground, making sure to thin it well with turpentine. I establish the shadows the rocks cast on each other, making sure they're good and dark. At this point, I want the picture's pattern to have a thin application of local color.

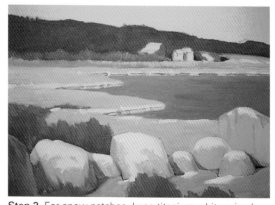

**Step 3.** For snow patches, I use titanium white mixed with a touch of cadmium yellow light. I paint in the rocks and work reflected light into the cast shadows. I also indicate direct sunlight in the middle ground, and begin to add color to the water—ultramarine and cerulean blue with a little cadmium red light.

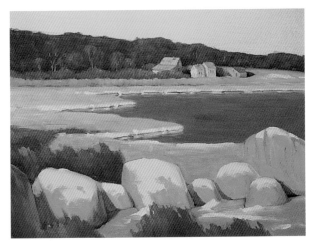

**Step 4.** I develop the background houses, keeping them pretty simple, since they're quite a distance away—basically a collection of shapes of different values, with subtle indications of windows and chimneys. I begin to work some slightly lighter and warmer greens into the background trees. I want to keep the trees fundamentally dark, but the space needs to be broken up a bit, so I suggest some individual trees and tree trunks. When I develop an area like this, I'll often paint in a certain amount of detail—tree trunks, branches, and so on—and then paint most of it out. I want only to *suggest* what's going on in the area; too much detail would destroy the feeling of mass.

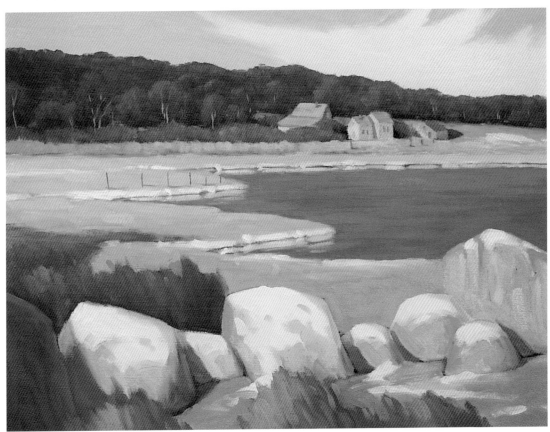

**LATE WINTER DAY**
Oil on canvas, 18 × 24"
(45.7 × 60.9 cm).
Collection of the artist.

I paint in the sky with cerulean blue plus a touch of cadmium red light. As I was working, it began to cloud up, so I took advantage of the cloud shape creeping across the sky, painting it in with a mixture of titanium white and cadmium orange. After I paint the sky, I have to make some adjustments, particularly in the middle ground, where I lighten the values in the snow. I usually paint the sky near the end of the painting, for three reasons. First, I want to establish a feeling of light in the landscape portion of the painting, without the benefit of the light the sky provides. Second, I don't always know what color I'm going to paint the sky until I'm almost finished, so I adjust my sky colors in accord with those I used in the landscape. And third, I like the "mystery" that comes from painting the sky last. While I might have to make adjustments to the landscape that would be unnecessary were I to paint in the sky earlier, for me it's worth it to wait. I don't specifically recommend that students follow this method; it's a peculiar habit that I've developed (every artist has them) that makes sense to me. It's up to you to find your own methods: Good work is the only justification you need!

# Demonstration: Autumn Landscape

The focus of this autumn scene is bright light falling on two small buildings, which cast their shadows across a narrow road. But the real subject of this painting is a contrast between warm and cool—the warm, yellow-orange foliage and the cool, blue-violet shadows in the buildings and across the road. The relationship between these two families of colors is a very attractive, harmonious one. The challenge is to organize all the information into a cohesive pattern of lights and darks, and to simplify the background tangle of trees and bushes, so that it stays, despite its warm color, behind the buildings.

**Step 1.** I draw in the buildings and a faint indication of their cast shadows. The road provides a diagonal that runs counter to these cast shadows, creating a sense of perspective as well. I show the placement of several tree masses in the background. I then begin blocking in large, dark areas, quickly scrubbing in transparent paint with a #12 brush. Shadow areas begin to show the buildings' structure. Notice how the dark shape above the smaller building defines sections of the roofs of both buildings.

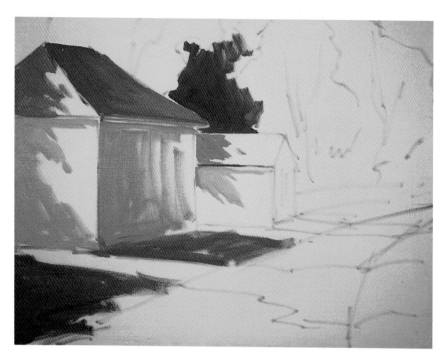

**Step 2.** I continue to lay in large areas of color, using the canvas tone to show light areas of my composition. It helps me to see and establish a pattern of light and dark more clearly if I can see the light as I apply the shadow.

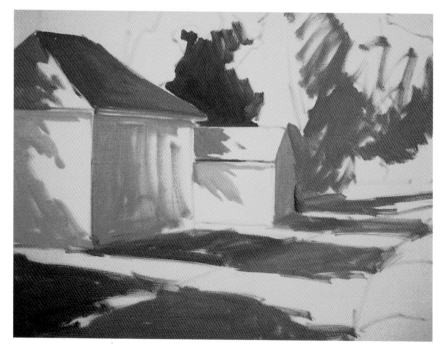

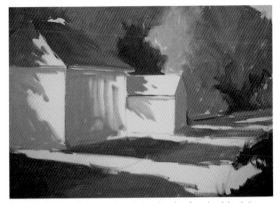

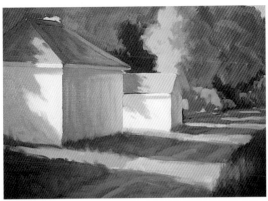

**Step 3.** I complete the block-in. Again, for the block-in, I've used a value a step darker than what I actually see, so that I can work color and reflected light easily into the shadows. For the block-in, I ignore whatever light I see in shadows, establishing them instead as fundamentally dark areas. I've also painted the shadows across the road much warmer than they are in reality.

**Step 4.** I begin to apply opaque paint to the light areas, starting with the two buildings. I want to establish a strong sense of light, so I slightly exaggerate the contrast in color temperature between the light and shadow sides of the buildings. For the lights, I use titanium white with a touch of cadmium yellow light; for shadows, I start with ultramarine blue and cadmium red light, plus white.

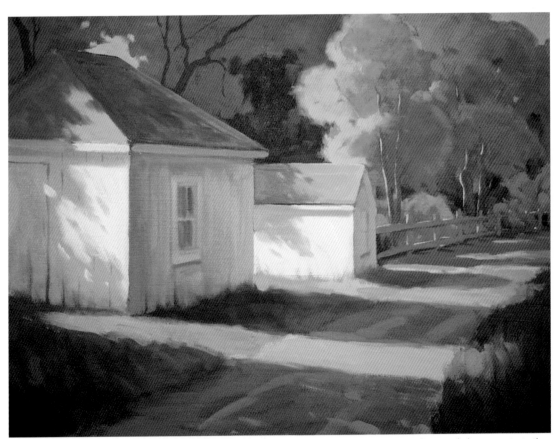

**PINE POINT LANE, AUTUMN**
Oil on canvas, 18 × 24"
(45.7 × 60.9 cm).
Private collection.

I develop the larger building in the foreground, adding a window and some darker accents to the shadows. I also add an invented fence and some tree trunks to break up the large background masses. The roof color reinforces the warm/cool pattern of the painting. The shadows are cool blues, which relate to the shadows across the road; the lights are warm greens, to tie in with the light areas of grass in the foreground. A few blue patches of sky break up the mass of background foliage. I aim to include just enough information to depict a credible scene, but not so much that the painting will look busy. Notice that there is quite a bit of activity in the shadows, while the light areas are almost completely uncluttered. In many cases, a strong light will in effect "bleach out" detail and color.

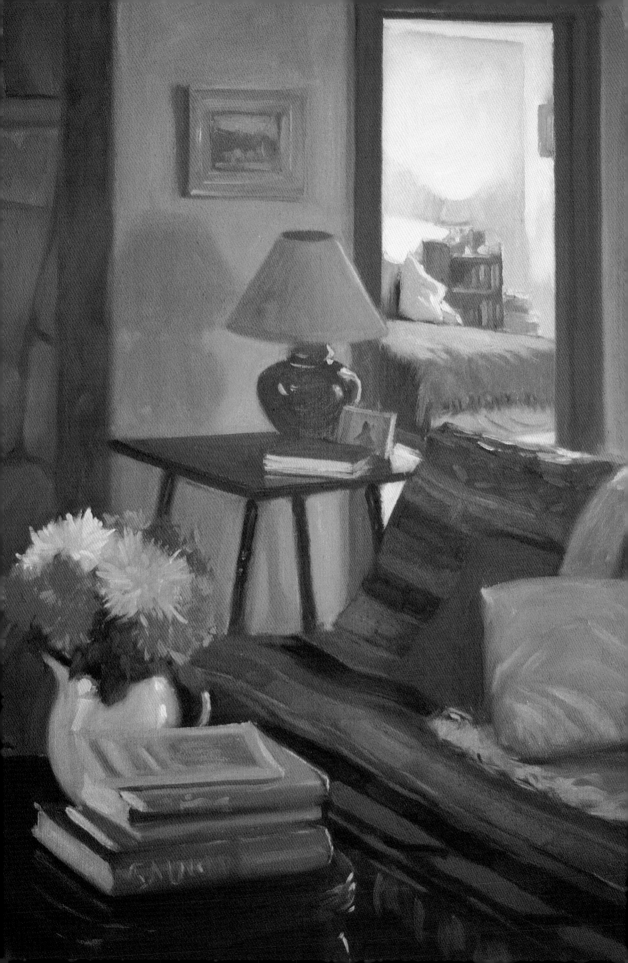

# Afterword: Making Painting a Career

As a serious painter, even though you may be a beginner now, why not look ahead to the day when you may want to turn professional? Managing the business side of painting is for many artists far more difficult, and much less satisfying, than painting itself. But since most painters welcome a certain amount of recognition—at the very least, the respect of their peers—and many want or need to derive income from their art, a certain amount of business acumen is helpful. I've probably thought about the business side of art as little as anyone, and have certainly made my share of bad career decisions, but I've worked very hard, have always been motivated by the love of painting, and have been extremely lucky in many ways. I've had good relationships (although not always sales success) with several galleries, and have had lots of other opportunities open up to me to promote my work, many of which I've been able to take advantage of. Someone said that luck favors the well prepared. I've always been sure that if I failed at painting, it wouldn't be for lack of effort.

**BEDROOM LIGHT**
Oil on canvas, 24 × 18" (60.9 × 45.7 cm).
Courtesy of the Blue Heron Gallery.

One of my favorite motifs, looking through one room into another, enables me to use two entirely different lighting schemes. Here, the foreground room is in half-light; by contrast, the bedroom is illuminated by a lamp whose brightness is very sharp in relation to the dim foreground. The compelling mood here was achieved by closing some window blinds to reduce the amount of foreground light so that the bedroom light glowed distinctly brighter.

## FINDING A GALLERY

Dealing with galleries can be a positive and civilized experience, but finding the right one for your work requires some research and often a bit of luck. If possible, visit any gallery in which you're considering showing your work. See if you think your paintings are compatible, in terms of style and quality, with those on display. Do you like the ambience of the gallery? Is the work shown in an appealing way? Notice how the staff treats customers; how did they greet you initially, before knowing that you're an artist? If you have a positive impression but are unfamiliar with the reputation of the gallery and its owner, attempt to contact one or more of the artists whose work you see there and ask if they've been happy with the way the gallery has represented them. Then if you decide to give it a try, identify yourself, explain that you're impressed with the gallery and are looking for representation, and ask to whom you should send slides of your work. Most galleries are happy to look at slides of new artists, but don't like to be put on the spot, so in general, it's not a good idea to show up out of the blue and ask them to look at your work or slides. But play it by ear. Over the years, several gallery owners have asked, after finding out that I was an artist, whether I had any slides with me, so take some along just in case.

More commonly, though, you'll end up mailing slides. Use a plastic slide sheet that holds twenty pieces—enough to show that you can come up with many paintings consistent in quality—labeled with name, title, size, and medium. With your slides include: a cover letter, saying that you have visited and admired their gallery (if you've made earlier contact, refresh their memory) and are seeking representation; a résumé, which should include a brief biographical statement, a list of shows you've participated in and awards you may have received, and note (or photocopy) any mention of you or your work that has appeared in print. Be sure to include a stamped, self-addressed envelope for the return of your slides. (Often galleries will keep your résumé, even if they can't show your work at that time.) If you haven't heard anything in a month's time, a follow-up call is not out of line.

Once you land a connection, a good gallery will work very hard for you. After all, it's in their best interest to sell your work, so show your professionalism by meeting them halfway.

Galleries have differing policies. The artist/gallery split of a painting's retail price can vary from sixty/forty to fifty/fifty. In your initial dealings with galleries, until you have established a sales history for your work, the retail price will often be set by mutual agreement between you and the gallery owner. Determine at the outset who pays for advertisements and show expenses; you don't want any surprises later on. Most dealers will issue you a consignment sheet, detailing their own and the artist's respective responsibilities, as well as payment schedules, insurance for your paintings, and other gallery policies of which you should be aware. (For example, some galleries let clients borrow work "on approval," allowing them to take a painting home to live with it for a specified time before purchasing it.)

On the question of framing, it's often hard for artists just beginning to show their work to justify spending money on frames. But if you want your work to look as good as it can, the right frame can really boost a painting's impact. To my way of thinking, a good frame makes a painting not only look better, but seem more important. If a buyer thinks that *you* take your work seriously, he or she will respect it more. Visit galleries to see the frames that other artists use, and decide which appeal to you (most artists will be happy to share their frame sources with you). Galleries will usually expect you to frame your own work, although some will do it for an artist, then deduct the cost from the sale. Be clear about framing costs from the beginning to avoid unpleasant surprises.

## ENTERING COMPETITIONS

Of course, as a *total* beginner, in approaching galleries, you won't have a list of shows to submit, which brings up the question: How can I build enough background as a painter to put together a professional résumé to send to galleries? The answer is that it takes time. Start by entering local shows and competitions; most art centers sponsor a number every year. Enter everything you can. It gets your name out there, and increases your odds of being accepted into shows where you can start winning awards. Then expand your horizons. Check the "bulletin board" section of *American Artist* magazine every month to find out about upcoming regional and national competitions. You can't afford to be shy about showing your work. As hockey superstar Wayne Gretsky once said, "One hundred percent of the shots you *don't* take don't go in!"

A list of prestigious shows and awards looks good on a résumé. And all of these credentials—awards,